100 SYMBOLS

THAT CHANGED
THE WORLD

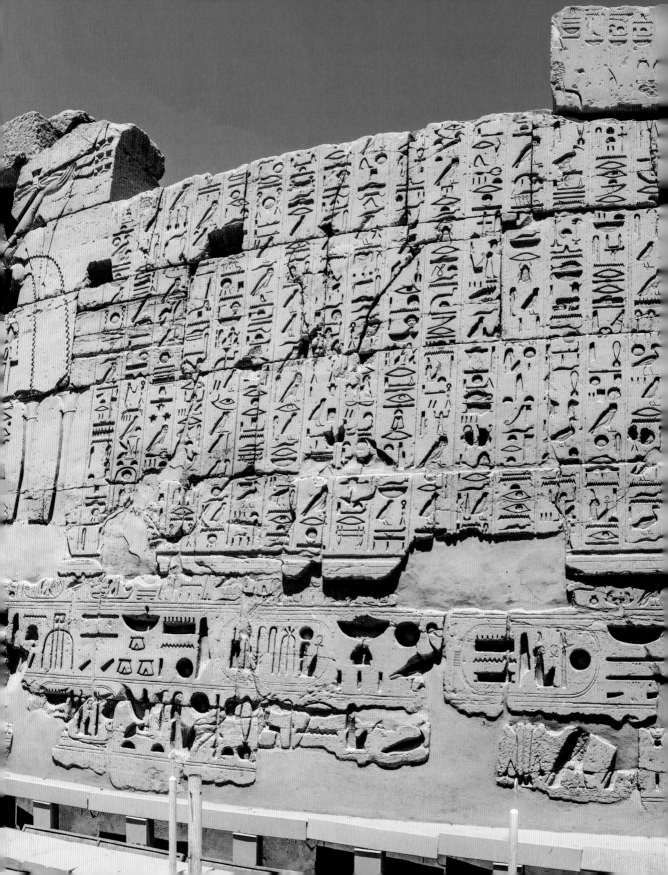

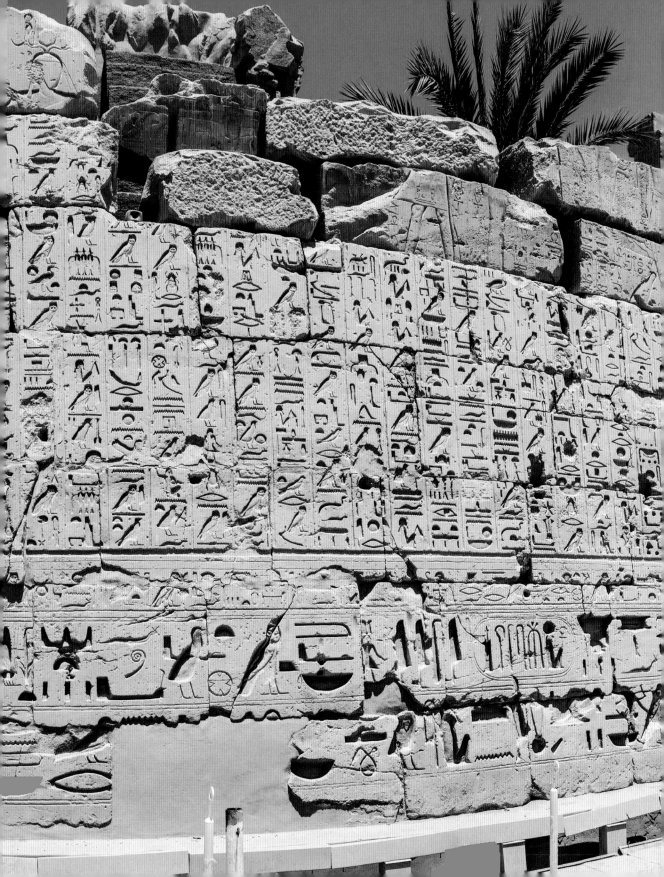

Pavilion
An imprint of HarperCollinsPublishers Ltd
1 London Bridge Street
London SE1 9GF

www.harpercollins.co.uk

HarperCollinsPublishers
1st Floor, Watermarque Building
Ringsend Road Dublin 4
Ireland

10 9 8 7 6 5 4 3 2 1

First published in Great Britain by Pavilion, an imprint of HarperCollinsPublishers Ltd 2022

ISBN 978-1-911216-38-4

MIX
Paper from
responsible sources
FSC™ C007454

This book is produced from independently certified FSC™ paper
to ensure responsible forest management.

For more information visit:
www.harpercollins.co.uk/green
Printed and bound in China by RR Donnelley APS

PREVIOUS SPREAD: *After the closure of pagan temples in the fifth century CE, knowledge of hieroglyphic symbols was lost for centuries. It was the discovery of the Rosetta Stone, written in three languages including hieroglyphics, that helped Egyptologists decipher these epic texts.*

100 SYMBOLS

THAT CHANGED
THE WORLD

COLIN SALTER

PAVILION

Contents

OPPOSITE: A Harrison Fisher poster using President Woodrow Wilson's quote to raise money for the Red Cross in 1918. Founded by a Swiss national, the Red Cross was an inversion of the Swiss flag.

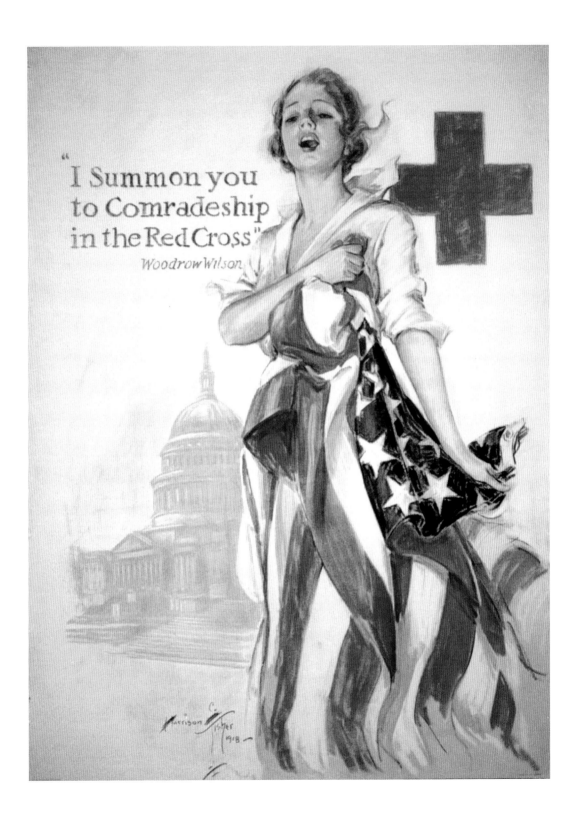

Introduction

We live in an Age of Symbols. International trade and travel have done away with barriers of geography and language. Now there is a symbol for everything, removing the need for words.

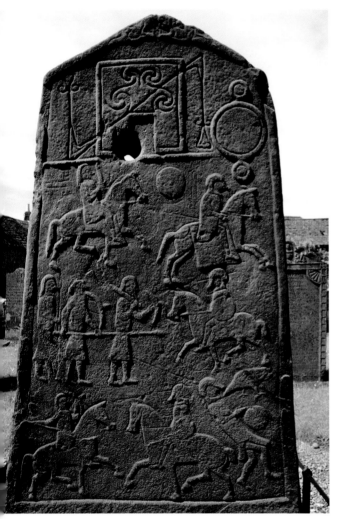

ABOVE: A Pictish standing stone from Aberlemno churchyard in Tayside, Scotland.

A symbol, by definition, symbolizes an idea – it is a quick, simple communication. The symbol's object is to communicate an instruction, a direction, an identity or a clear warning without confusion. Someone's life may depend on interpreting a symbol the correct way. Symbols help us to know where we belong, where we are going and what to do (or not do) when we get there.

Symbols are an integral part of our world. Almost half the entries in this book were designed in the twentieth and twenty-first centuries; but just under a fifth of them are more than two thousand years old. Modern symbols may displace written language, but some of our oldest symbols were created before writing existed – or, in the case of hieroglyphs, are the roots of written language.

In some cases a symbol's original meaning has been lost. The vanished civilization of the Picts in Scotland is recorded only in a few hundred mysterious symbols carved in stone. Some symbols have found new uses and meanings. The oldest symbol in this book, the swastika, was a symbol of peace and good fortune for 20,000 years before its positive legacy was destroyed by Nazi Germany in a mere twenty-five years.

Like other symbols the swastika became associated with a short period of use, with the loss of a much longer history. The clenched fist, now closely identified with the Black Lives Matter movement, is actually more than a hundred years old, with its origins in labour protest. The most recent entry here is arguably based on the oldest and most natural sign of all, the rainbow. Long a sign of hope after storms real and metaphorical, it was pressed into new service during the Covid pandemic as a way of thanking UK health workers for their sacrifices.

A symbol is a uniquely human thing to create. It is easy to understand why American Indians first drew pictures, for example, of themselves hunting animals, or the Spanish conquistadors arriving on horseback. But they also developed a symbolic shorthand, as can be

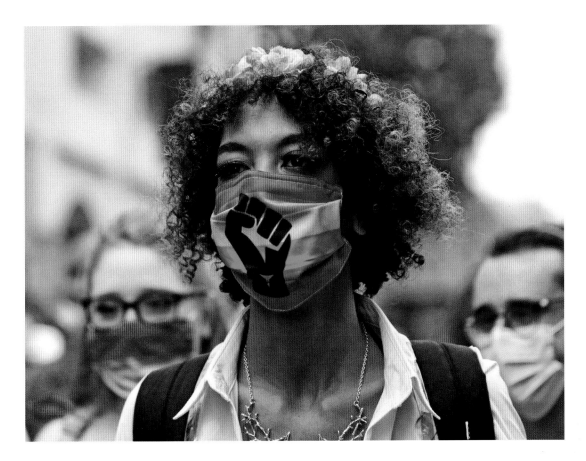

viewed at ancient petroglyphs, such as the Newspaper Rock in Utah.

But a symbol embodies more than mere representation. It can be a metaphor, a reference to abstract concepts associated with the symbolic object. Many of the older symbols in this book have spiritual connotations which give them a power beyond mere depiction. Saints and gods are symbolized by objects associated with them, from Hermes' caduceus to the many forms of the Christian cross. The Tree of Life, the Wheel of Life and the Yin-Yang symbol are all metaphors for views of the human condition.

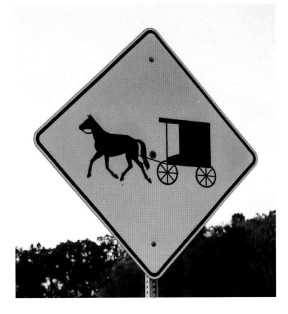

TOP: *Two striking symbols in one photo, the Pride rainbow superimposed with the Black Lives Matter clenched fist.*

RIGHT: *There are many different traffic symbols from around the world – this one warns of encountering Amish horse and buggy rigs.*

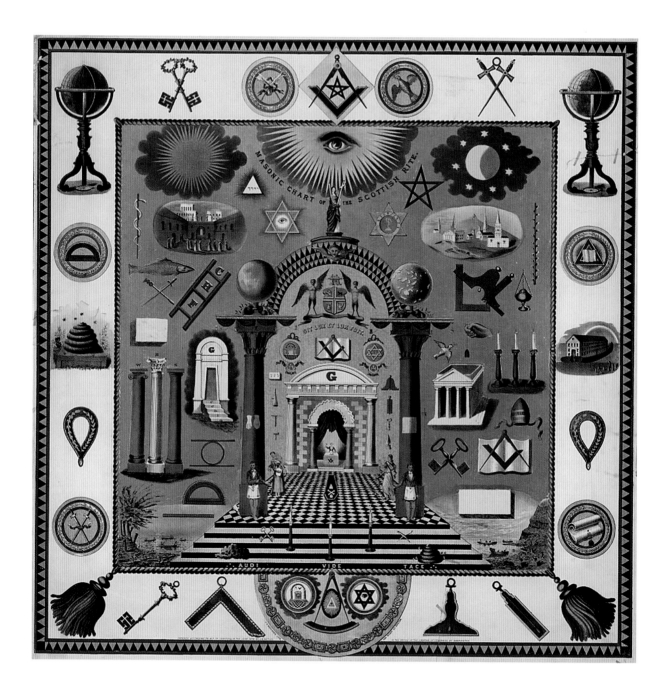

ABOVE: Freemasonry is an institution rich in symbolism, as evidenced by this chart of the Scottish Rite.

Not all symbols are so esoteric. While religious symbols help demonstrate allegiance to particular beliefs, others show loyalty to more earth-bound authorities. Heraldic symbols began as ways of identifying the households and property of powerful families and became badges by which their friends and enemies could recognize them. On a larger scale such symbols become signs of national identity – flags, national flowers and the like, which stir pride in their citizens. Identity is at the root of military insignia on everything from uniforms to aircraft. It claims allegiance to a state and its laws – or in the case of the pirates' skull and crossbones, to neither.

Heraldry no longer has any practical function except in anachronistic pageantry. In the modern world company logos are the new coats of arms, and club badges the new uniforms worn by football supporters. Political parties and organizations such as NATO and the United Nations commission icons which they hope will confer dignity and authority on them just as the coats of arms of royal families did.

Commercial companies face a harder task in choosing a symbol to represent them. It's true that some businesses benefit from claiming a lineage and a history – whisky distillers and clockmakers, for example – but most want to project an impression of modernity, a sense that its

BELOW: *The original Windows branding from 1985 to 1989, where the words were more significant than the symbol. The design of the window element became more and more important.*

products are new, exciting and better than the rest. This gets harder the longer a corporation survives in its industry. Microsoft's Windows, for example, constantly reinvents its four-square symbol in order to prove that each version of its software is better than the last; and even newcomer Android has undergone several changes in the fifteen years of its existence. Apple, on the other hand, has had the same bitten apple for nearly half a century, although the multi-colour stripes are long gone.

What makes some symbols more effective than others? Graphic designers and others with a professional interest in symbols learn a complex visual language which can be

BIOHAZARD

RADIOACTIVE

HIGHLY FLAMMABLE

POISON

SLIPPERY FLOOR

DANGER

CAUTION

IRRITANT

used to reinforce a symbol's message. Different colours, for example, have different effects on the viewer. Red, the colour of blood, almost always spells danger, while green evokes nature, growth, abundance and renewal. So red means Stop and green means Go. Blue, the colour of the sea and sky, implies infinity, space and opportunity; and yellow, historically associated with illness, is often used to convey warnings. Simple flags of different colours have been effective signals for centuries, at sea, on the beach, or at the race track.

Traffic signs are colour-coded according to the sort of information they are sending out, and they are also coded by shape. In most countries direct instructions such as speed limits are circular, while advice about conditions ahead, such as junctions or bends, is in a triangle. Although drivers may not think about such distinctions, they tend to recognize them subliminally and to react differently to the different shapes. Especially

ABOVE: An array of warning signs that instantly convey a sense of danger.

when ignoring the wrong kind of shape can result in a hefty fine...

While most symbols are intended to announce something, there are a few whose purpose is to conceal. Military aircraft insignia started life as a visible declaration of nationality; but now the need to pass undetected over foreign airspace has seen some air forces paint their roundels in grey on grey. In a previous age alchemists devised their own secret symbols for the materials with which they tried to make gold out of ordinary metals, out of fear that, if successful, a rival could steal their ideas. It was an early version of today's digital encryption.

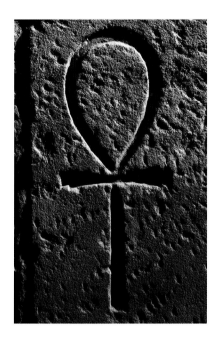

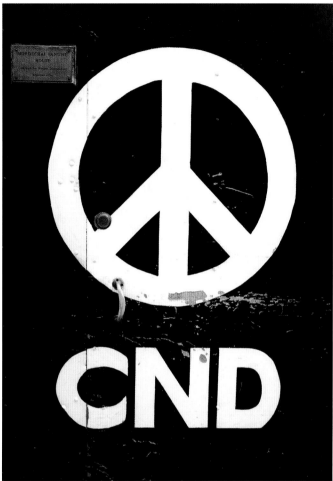

In any list of a hundred symbols that changed the world, almost everyone will agree about fifty of them and disagree strongly about the rest. The symbols in this book are drawn from every part of life – from religion to recycling, from peace signs to pandas, from politics to playing cards, from the swastika to science. Some will be all too familiar; others will be new discoveries. Most of them are still in use, still communicating ideas to us in a language which crosses borders and bypasses barriers. Long may we continue to read the signs.

TOP LEFT: The ankh, an Egyptian hieroglyph and symbol of everlasting life.

TOP RIGHT: What better way to paint the door of the headquarters to the Campaign for Nuclear Disarmament than with Gerald Holtom's outstanding symbol from 1958.

RIGHT: The symbol for a USB connection is one of many computer icons that have become familiar.

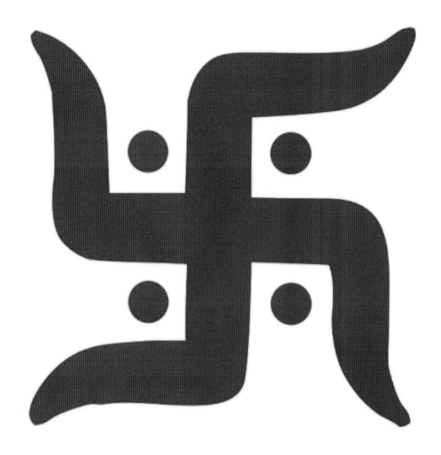

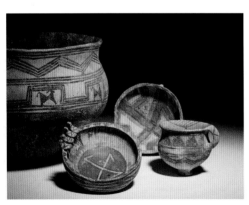

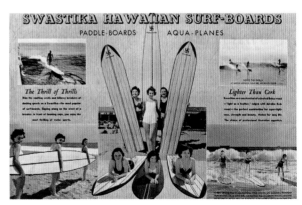

TOP: *A classic Hindu swastika.*

ABOVE LEFT: *Bronze Age pottery displaying a swastika, discovered in Iran and dating to 1200–800 BCE.*

ABOVE RIGHT: *Swastika Hawaiian Surf-Boards had to go in for some rapid re-branding after December 1941.*

OPPOSITE: *The Nazi symbol still has the power to shock and offend.*

Swastika

(c.18,000 BCE)

Until 1920, the swastika was a universally recognized symbol of wellbeing and good luck, found in cultures throughout the world. One man's use of it in the mid-twentieth century tarnished the positive legacy of millennia.

The oldest known swastika, a cross with hooked arms, exists as a repeated pattern on the carving of a bird made from a mammoth's tusk. Discovered beside phallic objects at the rich Palaeolithic site of Mezine in Ukraine, its original meaning may have been connected to fertility. Swastikas were inscribed on stone walls in Iran some nine thousand years ago, and painted on pottery made eight thousand years ago in Bulgaria.

They are most widely associated, historically, with Hinduism and Buddhism, and the earliest examples in the Indian subcontinent have been dated to around 3000 BCE. The word 'swastika' is Sanskrit for 'wellbeing'. It is from these Asian roots that the swastika began to acquire more specific religious connotations. In Hinduism, for example, the symbol is often placed over doorways and at the start of financial documents to confer good fortune. A clockwise swastika (one with the hooks turning to the right) represents the sun, an anticlockwise one (sometimes called a 'sauwastika') the night and the goddess Kali.

From India the swastika began to spread around the world to northern Europe, eastern Asia and Africa. In pagan graves in eastern England it is a regularly recurring decorative motif; it occurs on trading weights of the North African Ashanti Empire; and it forms the basis of the classical 'Greek key' frieze found on architecture in ancient Rome and Greece.

Several examples were found during the excavation of ancient Troy, Greece's old enemy, by the archaeologist Heinrich Schliemann. Schliemann began his dig at Troy in 1871, the year that a united Germany came into being. He was fascinated by the swastika and researched its history. He came to the false conclusion that the swastika was Aryan in origin – that is, from the Indo-European

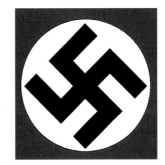

culture which was believed to have sprung from the steppes of Russia and spread through northern Europe.

Thus, Schliemann argued, the Aryan race was the origin of the German people and the swastika was therefore a symbol of German identity. His theory gained currency in the new German nation and when Adolf Hitler was looking for a logo for the Nazi Party in 1920, the swastika presented itself: easily identifiable and already loaded with symbolism. The party grew in popularity on a wave of national sentiment borne of the punitive conditions imposed by the victors after World War I. Abhorrent acts were committed under the new German flag, a black swastika in a white circle on a red background, driven by xenophobia and anti-semitism, plunging Europe and the world into a second world war.

After the war the use of the swastika and other totalitarian iconography was banned in many European countries including Germany and Austria. Hungary relaxed its ban on the swastika, and on the Soviet hammer and sickle in 2013, the same year in which Latvia introduced one.

In the febrile Politics of the Extreme which characterizes the early decades of this century, the swastika has been revived as a symbol of hate by groups on both the far right and the far left. Many of those who stormed the US Capitol ahead of President Biden's inauguration in 2021 wore swastikas and other neo-Nazi images and slogans.

Faced with the rise in racism and fascism that followed the collapse of communism, the European Union tried and failed to introduce a Europe-wide ban. It was persuaded to drop it after a concerted campaign by European Hindus, who argued that a quarter century of misuse by Hitler should not outweigh millennia of positive meaning and influence.

Triskelion

(c.4400 BCE)

More than six thousand years old, the triskelion is both a visual puzzle and a philosophical one. It's a sophisticated triangular geometric pattern of spirals and its original meaning is long lost. New interpretations have, however, ensured its use by a variety of groups in the twenty-first century.

All that can be said with any certainty is that the triskelion's origins are in the pre-Hellenic cultures of the Mediterranean. Of its association with many Mediterranean islands, the earliest spiral examples are on Malta and may have been carved as long ago as 4400 BCE. It also occurs on pottery of the Mycenaean civilization in southern Greece and, rather surprisingly, on the kerbstones of the Newgrange passage tomb in Ireland, some 3,500km to the northwest. Newgrange was built around 3200 BCE, and there are later examples in Brittany, northern Iberia and other Celtic cultures.

If its meaning is lost, so too is its real name. Triskelion is a diminutive form of triskeles, which means 'three-legged' in Greek. But that name was only given to it in 1835 by an enthusiastic French amateur archaeologist, Honoré Théodoric d'Albert de Luynes. This modern name was taken up by numismatists (coin collectors) in the nineteenth century, whose interest was in the coins of the ancient state of Lycia and its neighbours on the southern Turkish coast. These monies were stamped with a triskelion not of spirals but of legs bent at the knee. This variation also occurs on Greek pottery from the sixth century BCE.

In heraldic terms the leg version was first used by the kings of Syracuse, a city state on the island of Sicily. Sicily was known to the Greeks as Trinacria, 'the three-cornered island' and perhaps the adoption of the bent legs sign was a visual reference to that. For British audiences it is best known as the symbol of the Isle of Man, which was variously ruled by Norse, Scottish and English kings from the seventh to the sixteenth century. The triskelion was first associated with the island in the thirteenth century, and a sixteenth-century island motto may explain why. Translated from the Latin it says, 'Whichever way you throw it, it will stand.' Perhaps the three-legged triskelion is a sign of stable society, just as a tripod will stand on any uneven surface.

The spiral form of the triskelion bears a superficial resemblance to the so-called Troy mazes of England – not mazes in the modern sense, with high hedges and opportunities to get lost, but complex circular patterns made with a single footpath which leads the explorer eventually to the centre and back out again. The origins of Troy mazes are as obscure as those of the triskelion; but it has been suggested that walking a maze was a form of meditation. A similar path can be traced with the eye along the outline of the triskelion to the centre of a spiral on one side of it, then back on the other to the next and so on. Perhaps the spiral triskelion was an aid to self-hypnosis. It is evocative of swirling currents of energy.

Throughout Europe, Christianity displaced pagan beliefs and adopted many of its sites and customs. The triskelion became an illustration of the Holy Trinity and little more than an architectural feature on Gothic cathedrals. In the nineteenth century, de Luynes, who devised the term triskelion, argued that the three-legged symbol was a reference to Hecate, a Greek goddess usually depicted in triplicate.

Hecate, who inspired Shakespeare's three witches in Macbeth, ruled over three kingdoms – in the sky, on earth and at sea – and had power over magic, the night and the souls of the dead. Neopagans in the twentieth and twenty-first centuries have therefore enthusiastically adopted the triskelion in their worship.

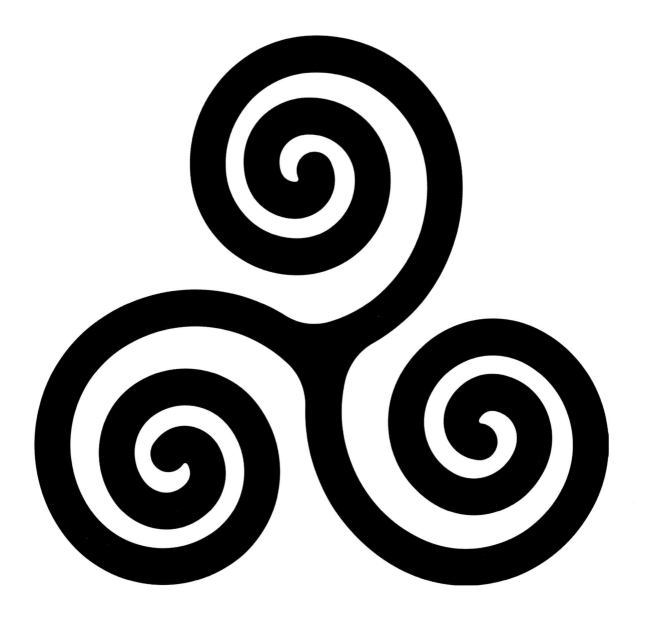

ABOVE: A simple Celtic triskelion.
OPPOSITE: The symbol of the three armoured legs, each with a golden spur, against a red background, has been the flag of the Isle of Man since 1932.

100 Symbols That Changed the World_____19

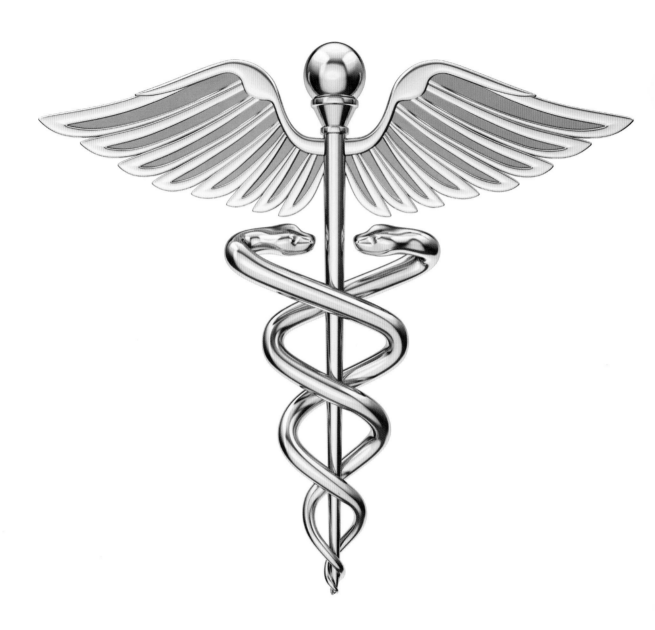

RIGHT: The caduceus is the staff carried by Hermes in Greek mythology and also by heralds such as Iris, the messenger of Hera, goddess of women and childbirth.
OPPOSITE: A statue of Hermes holding a caduceus outside Michaelsberg Abbey, Bamberg, Upper Franconia, Bavaria.

Caduceus

(c.3500 BCE)

The caduceus is the symbol of the Greek god Hermes and his Roman counterpart Mercury. They were the messengers of the gods and therefore the protectors of communicators and travellers of all kinds.

By extension Hermes and Mercury also oversaw exchange and commerce, whether by quick-witted merchants or by thieves. Neither of them was ever a god of medicine or of healing, although the caduceus has been a symbol of transitions between wakefulness and sleep, life and death, and vice versa. The ancients believed that a touch from a caduceus was enough to make a dying person's death a peaceful one, and to bring a dead person back to life.

The symbol, two snakes entwined around a staff, predates its Greek incarnation. The earliest known examples of it are in association with Ningishzida, the god of the Mesopotamian underworld between five and six thousand years ago, and a messenger between his realm and the living. Snakes represent immortality, life after death, because when they shed their skin they seem to be leaving their dead selves behind and continuing to live.

The oldest references pairing Hermes and the caduceus are in hymns written in around 700 BCE. Before that, a prophet called Tiresias is said to have killed a female snake with his staff. He was immediately transformed into a woman and only became a man again seven years later when he used his staff to kill a male snake. The staff later came into the possession of Apollo, who gave it to his

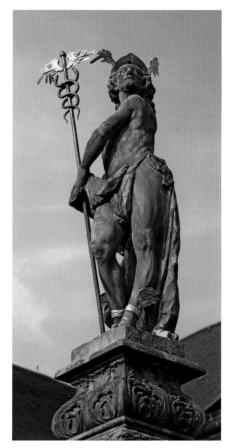

half-brother Hermes in return for playing music. Hermes later used it to separate two fighting snakes, and thus the caduceus also represents arbitration and peace.

The caduceus also appears on coins of the Indian emperor Ashoka the Great. This may be the root of its association with commerce and financial dealings. With that connotation it can be found on the heraldic symbols of historic trading centres – for example on the flag of Brisbane in Australia and, crossed with a horn of plenty, on the shield of Kharkiv in Ukraine. Crossed with a key it represents trade with security and features in the badges of customs organizations in China and Belarus. The Russian Customs Service crosses the caduceus with a flaming torch, shedding much needed light on imports and exports.

From ancient origins, the caduceus today symbolizes eloquence and trade, two important forms of exchange which serve the cause epitomized by Hermes' first use of it – the pursuance of peace.

The association of the caduceus with the healing arts is a relatively recent phenomenon, the result of simple confusion with the Rod of Asclepius by an American officer charged with designing a badge for the US Army Medical Corps. The mistake has stuck, but the caduceus has a longer and richer history.

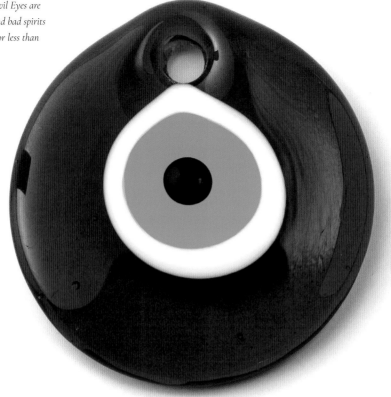

BELOW: These days Evil Eyes are produced in bulk, and bad spirits can be kept at bay for less than a euro.

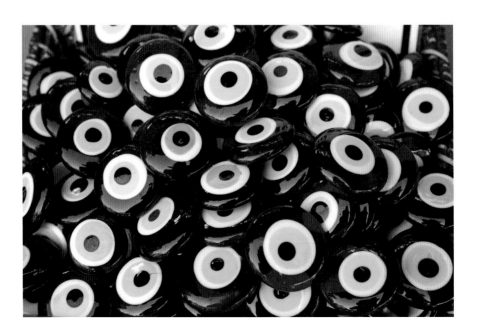

Evil Eye

(c.3500 BCE)

The primitive belief in the power of a menacing look or a malicious glance occurs in many cultures and religions. If the eyes are the window of the soul, then what curse lies behind the Evil Eye? Mankind's ancient fear of the malevolent stare may be rooted in a very modern emotion – envy.

Jealousy of someone else's good fortune is a strong but self-destructive emotion, one of the traditional Seven Deadly Sins. To be on the receiving end of an envious stare can be an uncomfortable experience.

The philosopher Plutarch believed that those in possession of the Evil Eye could transmit harmful rays of energy potent enough to cause illness and even death. He thought that some groups of people – often migrants or other strangers to the area – were more malevolent than others, particularly those with blue eyes (which were genetically less common in countries around the Mediterranean Sea, such as his native Greece).

The superstitious defence against the danger of the Evil Eye was to carry a charm with the power to ward off the Eye's destructive rays. The oldest known such amulet, found during an archaeological dig in Syria, has been dated to 3500 BCE – a piece of alabaster carved with eye motifs as if to reflect any curse back to the sender. Two thousand years later, thanks to advances in glass-making techniques, the first blue glass eye charms began to be made around the Mediterranean. They can still be seen today not only in the homes and businesses of those who believe in the Evil Eye but in a thousand tourist souvenir markets.

The Evil Eye appears in many folk tales and legends – for example in the mythical gorgon of Greek antiquity, whose look turned anyone who saw it to stone. Some see

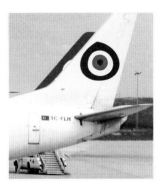

the power of the Evil Eye as a plague on the possessor as much as those who fall beneath the gaze. A traditional Polish story tells of a man with such a dangerous ability to curse others with a glance that he eventually blinded himself rather than inflict further misery on those with whom he came into contact. There is an echo here of the story of King Midas whose own curse was that everything he touched turned to gold – even his own daughter.

The use of a symbolic Eye to ward off evil became a more general practice to avert misfortune. Ships in the ancient cultures of Greece, Egypt and China are all known to have been decorated with eyes. Even today, Turkish airline Fly Air decorates its tailfins with a *nazar boncuğu*, a blue Evil Eye charm. In ancient Egypt, pharaohs were buried with a *wadjet*, a pendant in the shape of the Eye of Horus, to protect them in the afterlife. In eastern and southern countries on the Mediterranean rim, protective amulets often take the form of a hand with an eye painted in the centre of the palm, called a *hamsa*.

People will continue to seek external causes for their misfortune, to blame others and to seek protection from the Evil Eye and other curses. How many taxi drivers in the twenty-first century still hang a *nazar boncuğu* from the rearview mirror?

ABOVE: *Turkish airline Fly Air may carry a* nazar boncuğu *on the tail fin but still observe all their statutory obligations of keeping passengers safe.*

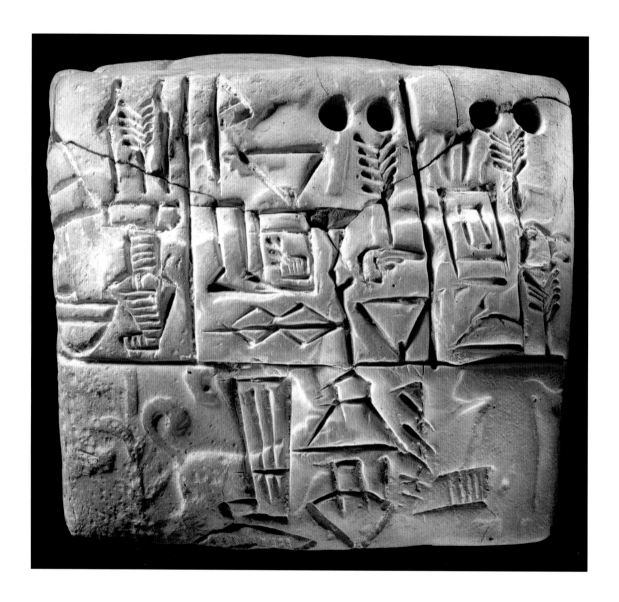

Cuneiform

(c.3400 BCE)

History begins with the invention of writing. Before that there are no records, no histories of people and events. Writing begins with the need to place things on record – transactions, ownership, the status of rulers, the code of law. And writing begins with cuneiform script in Mesopotamia.

All scripts are symbols. We speak words, and writing is a way of representing those words. The earliest writing is pictographic. Sumerians were the early inhabitants of Mesopotamia (modern-day Iraq, Iran and southeastern Turkey); if a Sumerian soldier wanted to place an order for arrows in 3500 BCE, he might draw a picture of an arrow, with a tally of the required number beside it.

Pictograms form the basis of cuneiform script and over a period of two thousand years one can trace their development from representative images to more stylized marks. They were drawn on soft clay which would become a permanent record when dried and fired in a kiln.

Literacy was not common, and as the use of cuneiform writing became more widespread, a class of trained scribes emerged who enjoyed considerable status. At first they drew with simple round-ended styluses but by around 2500 BCE they were using a new, wedge-shaped tool to make their marks – the word cuneiform is derived from the Latin word *cuneus*, a wedge.

As it happens the word for 'arrow' in Sumerian, *ti*, was very similar to the word for 'life', *til*. Scribes began to use the same symbol for both, since it was usually clear from the context which word was intended. In time the symbol for 'ti' came to represent not only an arrow or a life but any 'ti' sound. Now, multi-syllabic words could be expressed by symbols which no longer represented their meanings but merely their sounds. Cuneiform, not a language but a system of record, could therefore

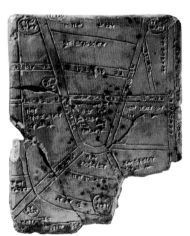

be used to write words in any language; and it is known to have been used by at least fifteen different Middle Eastern languages over the course of its existence.

The most recent cuneiform tablet so far rediscovered has been dated to around 75 CE. While its use may have persisted for a century or two beyond then, cuneiform and the languages which used it disappeared. In the eighteenth century a new interest in the landscape of the Bible brought European archaeologists to the Middle East, where they found mysterious artefacts with wedge-shaped marks on them. By recognizing repeated series of syllables they began to identify words. Comparisons with histories of the region in other languages allowed them to pick out the names of kings. The discovery of multilingual inscriptions on vases and monuments in the nineteenth century was a breakthrough for more complete translations of cuneiform writing.

Today, around half a million cuneiform texts survive in museums around the world. They include the preserved libraries of kings and the everyday transactions of accountants. There are globally important records of astronomic observations and medical practices, letters of complaint and recipes for pigeon pie. Cuneiform documents have transformed the early history of law, science and even history itself. The oldest work of literature, *The Epic of Gilgamesh*, is written in cuneiform and contains a description of a devastating flood very similar to, but much earlier than, the biblical account of Noah's Ark.

Egyptian, Mayan and Cretan hieroglyphs

(c.3200 BCE)

Writing can be alphabetic, syllabic or pictographic, where symbols are actual representations of the objects, actions or creatures to which they refer. Hieroglyphs belong in this last category, of which there are many world examples.

It takes a great many different hieroglyphs to describe every object in the world – there are over a thousand known Egyptian hieroglyphs, compared for example to the Roman alphabet's 26 different characters. And although it may be relatively simple to draw a pictogram for many items or events, abstract concepts may be harder to depict – how does a hieroglyph symbolize notions such as 'distrust', for example, or 'companionship'?

In spite of these limitations, hieroglyphs are the obvious starting point, before the development of alphabets, for anyone wishing to write anything down. The best known examples are the Egyptian hieroglyphs which were in use for some 3,600 years. Their evolution illustrates the development of the written word: what started as direct pictograms of simple words became syllabograms, representing the sound of the original words, which could be combined to form other multisyllabic words with the same sounds as the originals. In use since at least 3200 BCE, the hieroglyphs mutated into scripts which were more recognizable forms of handwriting, known as hieratic, then demotic, then Coptic, and ultimately Arabic.

The most recent Egyptian hieroglyphics are on a monumental inscription carved in 394 CE. The tradition was kept alive by priests, and when the temples closed down in the fifth century their knowledge was lost. Hieroglyphics remained unintelligible for 1600 years until the discovery of the Rosetta Stone in 1799, one of the most important archaeological finds in modern history. The stone carries three inscriptions of the same royal decree of 196 BCE, carved in three different languages – Egyptian hieroglyphic, demotic script, and ancient Greek. Nineteenth-century scholars with a knowledge of Greek were able to decipher the meaning of the parallel hieroglyphic and demotic texts and could at last read the large body of hieroglyphic records of ancient Egypt.

At least ten other hieroglyphic scripts are known to have developed around the world, independently of each other, many of them in indigenous civilizations of the Americas. Among them, the elaborate hieroglyphs of Mayan culture are now considered the oldest forms of writing in the region. They are a combination of logograms – symbols representing whole words – and syllabograms, and they were in use for 1,900 years until the Spanish conquests of Latin America in the sixteenth and seventeenth centuries.

Spanish bishop Diego de Landa destroyed many Mayan writings as part of his missionary work to eradicate native religion. Landa was, however, instrumental in transcribing Mayan into Roman script; and the survival into modern times of the language in this form led to breakthroughs in the understanding of ancient Mayan hieroglyphs in the late twentieth century.

Not all hieroglyphic systems have been so lucky. During the Minoan era the Mediterranean island of Crete had its own, gleaned from around 270 surviving artefacts, all dated within a relatively short timespan of only four centuries. Although their evolution into scripts called Linear A and Linear B – which are the predecessors of the Greek alphabet – is understood, the language and meaning which they represent is probably lost forever.

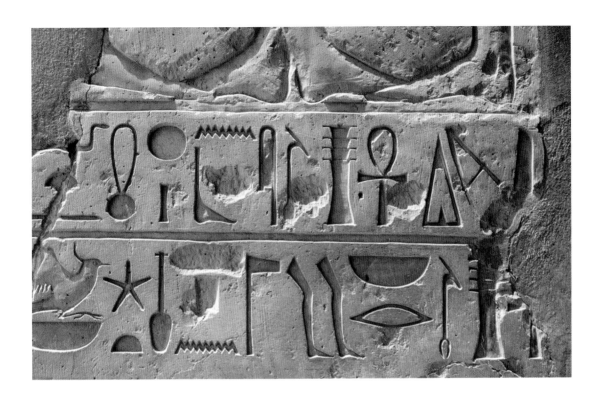

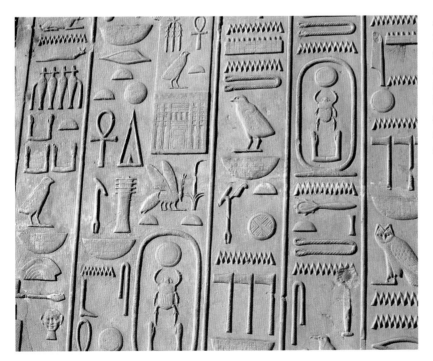

ABOVE: *Hieroglyphs from the Temple of Queen Hatshepsut, near Luxor.*

LEFT: *Part of the Great Karnak Inscription, an ancient Egyptian hieroglyphic epigraph discovered at Karnak in 1828–1829 and considered one of the standard texts of Egyptology.*

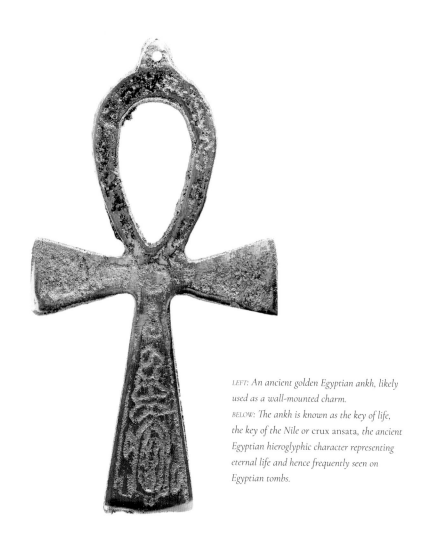

LEFT: *An ancient golden Egyptian ankh, likely used as a wall-mounted charm.*

BELOW: *The ankh is known as the key of life, the key of the Nile or* crux ansata, *the ancient Egyptian hieroglyphic character representing eternal life and hence frequently seen on Egyptian tombs.*

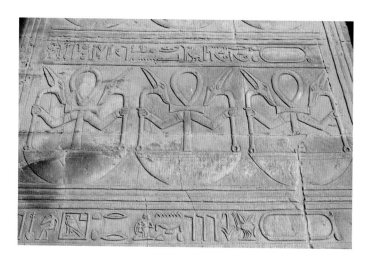

Ankh

(c.3000 BCE)

Life, whether eternal or temporal, was the greatest gift of the Egyptian gods, represented by the ankh symbol. Although scholars are agreed on the meaning of the symbol, and even on its pronunciation, there are wildly differing theories about its root and evolution.

The ankh symbol was adopted by Middle Eastern early Christians because of its resemblance to a cross as well as its associations with eternal life. It is an Egyptian hieroglyph, and it predates Christianity by some thirty centuries. The earliest examples come from the time of the First Dynasty of kings of a unified Egypt.

Hieroglyphic writing uses a mixture of simple letters (single vocal sounds), syllabic signs (representing sequences of sounds), and pictograms (stylized representations of the meaning of a word). Ankh is an example of the latter two. It is a sequence of three sounds, of which 'ankh' is an approximate pronunciation – the actual syllable is not found in most European languages. It probably originated as a pictogram of the word for a particular object and was then used in other words of which the sound of that word was a syllable. Thus the ankh symbol also appears in the spelling of the words for a bouquet of flowers and a mirror.

But 'ankh' is also a word in its own right. Its meaning of eternal life is clear from its use in depictions of kings and gods, and as part of an everyday greeting at the start of letters and announcements, along the lines of 'health and long life to you' – the equivalent of 'best wishes'. From the use of this greeting in the taking of oaths, ankh also came to mean the oath itself.

The symbol's origins as a pictogram are obscure. Some scholars think that it represented the knot used to hold a sandal onto a foot. Early examples show the lower bar as two strands like the ends of shoe laces. If this is true, then a knot could become emblematic of a bond, a closed circle offering protection; and if that is protection from death, then ankh comes to mean eternal life. Indeed, the hieroglyph for Tyet ('protection') is very similar to ankh.

Another theory suggests that ankh illustrates a meeting of male and female, the literal source of life. Ankh is often found alongside two other hieroglyphs, Djed (a pillar representing 'stability') and Was (a sceptre meaning 'dominion'); and some believe that this trilogy represented the reproductive power and dominance of Apis, the sacred bull worshipped during the First Dynasty.

Ankhs are most commonly depicted as objects in the shape of the symbol being given by gods to men, usually pharaohs. Ankh-shaped amulets were worn by ordinary Egyptians as protection in life, and left with the bodies of the dead as a summons to the afterlife. Their use reached its peak during the era of the pyramids of the Old Kingdom, 2700–2200 BCE.

From Egypt, the symbol spread to neighbouring regions north and south of the empire, reaching Canaan in around 1500 BCE. Jesus's disciples will have been familiar with the sign and its meaning; and as Christianity spread outwards from the Middle East, the ankh was even adopted by Egyptian Christians. In the modern era it was, like so many ancient religious symbols, rediscovered by the soul-searching counterculture of the 1960s.

As a symbol with fifty centuries of history, it should not be surprising that it has once again acquired new meaning. The ankh has been taken up by African Americans as a sign of their inseverable bonds to the continent of Africa. Roots give life, and perpetual roots, it seems, nourish eternal life.

Tree of Life

(c.1500 BCE)

Who can fail to be inspired by a tree? Its growth from a tiny seed to a towering giant, its connection between the ground and the sky, its provision of shelter and fruit while growing: it is no wonder that Trees of Life are at the heart of many of the world's origin myths.

The oldest known examples of the Tree of Life symbols are in decorative panels from Assyria, an empire which ruled Mesopotamia for two thousand years until around 600 BCE. Its precise meaning is unknown because there are no references to it in surviving Assyrian writings. And for such a universally adopted symbol, it is open to a broad range of interpretations.

At its most mundane, the tree is a useful metaphor for genealogy, with its roots and branches. Ruling dynasties use the lineage of a family tree to demonstrate their right to the throne. It's as true of the British royal family today as it no doubt was for Assyrian kings. A connection to the heroes of legend was often claimed in such trees, however speculative such a claim might be. In this way the Tree of Life was expanded to encompass not only one family but all the major figures of history and – for the most ambitious rulers – the gods as well.

From there it's a short leap of imagination to believe that all life springs from a single special tree, the Tree of Life. Traditions from northern Scandinavia to southern Central Europe incorporate such a Tree. In early Slavic cultures a mythical Tree grew above a rock from which the well spring of life originated. Some Germanic and Norse societies revered specific ancient trees – for example Donar's Oak in Hesse, which was cut down by St Boniface in the eighth century and the wood symbolically used to build a Christian church. There was a tree called Irminsul in Bavaria, a Sacred Tree in Uppsala and the legendary pan-Scandinavian Yggdrasil – a giant tree where the gods hold their parliament, whose branches contain the nine worlds of Norse mythology, reaching to heaven, and whose three massive roots tap into three sacred springs.

It has been suggested that the concept of a Tree of Life began in Indonesia and spread by way of China and Asia to Europe. In Chinese mythology the Fusang is a

tree guarded by a dragon, which confers immortality on those who eat its fruit; in Buddhism, the Sacred Fig (*Ficus religiosa*) is the tree under which the Buddha sat to receive enlightenment. Hinduism has five sacred trees, called Kalpavrikshas, which between them can grant all our wishes in life. Turkic tradition tells of a Tree of Life which is often a central motif of the region's carpets.

There is some overlap with the tradition of a Tree of Knowledge, and while Islam describes only one tree, the Tree of Life, in the Garden of Eden, Christianity's Book of Genesis mentions both the Tree of Knowledge from which Adam ate the apple, and a Tree of Life beside it. The Tree of Life returns in the last book of the Bible,

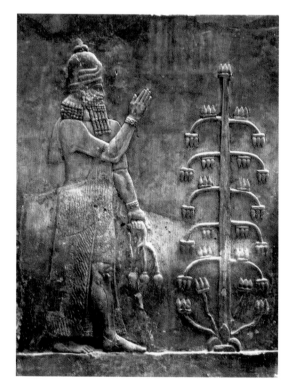

Revelations, as a reward 'to those who overcome'. The Jewish Book of Enoch promises similar rewards to those whose names are in the Book of Life. The rods on which the Torah is scrolled are called the Trees of Life.

There are Trees of Life in the belief systems of the Iroquois and Sioux nations in North America and in the pre-Columbian societies of Central and South America such as the Maya and Aztec. In the Serer religion of Senegal, the Somb tree was the first thing created by the supreme god Roog. It is regarded as the source of all life and of immortality.

There is a veritable forest of Trees of Life in the mythologies of the world, their roots and branches connecting everything with everything. Perhaps, given the vital biological role that trees play in the Earth's endangered climate, there may indeed be more to them than myth and superstition.

ABOVE: *The symbol of a tree of life occurs in many cultures, across many ages.*
OPPOSITE: *A protective spirit with a tree of life featured on a seventh-century BCE wall relief in Babylon.*

TOP: *Modern musical notation has changed little since the eighteenth century.*

ABOVE LEFT: *A close-up of an ancient codex book in Latin, with the musical score of Gregorian chant in the Cathedral of Astorga, Spain*

ABOVE RIGHT: *A close-up of the Seikilos Epitaph*

Musical symbols/notation

(c.1400 BCE)

How does a singer learn a song if the composer is not there to play it for them? The ability to write down music in symbols which could be read and understood by someone else made cultural exchange possible, first within societies and then across borders and across time.

The evolution of language and art depends on visual, verbal and aural record. Like so many human innovations, the earliest surviving written music comes from the Middle East. The Hurrians of northern Mesopotamia lived in the Bronze Age and had a system of symbols for indicating the intervals between notes. Fragments of cuneiform tablets written in around 1400 BCE were discovered at a Royal Hurrian Palace in the 1950s and 1960s with the symbols marked below the lyrics.

The oldest genuinely complete piece of music to be recorded is known as the Seikilos Epitaph. Carved on a stone column memorial found in western Turkey near Ephesus and dedicated to a man named Seikilos, it is dated to between 100 and 200 CE. It bears a poem about the fleeting nature of life written in Greek, with the notes chiselled above the words. The notes are shown by letters, in a system devised by Pythagoras some 700 years earlier, with further abstract symbols beside them giving other instructions. We know that the sixth-century Romans also used a lettering system for musical notes, although to date no surviving Roman musical manuscripts have been found.

By the beginning of the seventh century the profusion of new music for the Christian church made some sort of system essential. Plainsong and Gregorian chant began to be annotated with squiggles which indicated whether the next note was higher or lower than the last, although not by how much. They were called neumes, and they filled similar functions to the extra symbols of the Seikilos Epitaph.

So far musical notation was all relative – there was no indication of a fixed key in any of the Hurrian, Greek or Roman systems. That changed at the end of the first millennium when a Benedictine monk called Guido d'Arezzo drew a straight line above the words of the music and labelled it either F or C, indicating the starting point for the music, the key to understanding the neumes which followed. The neumes were then placed along the line above the relevant words. With this notation the music had a fixed starting note and fixed intervals by which the tune moved away from or towards that note. It was the first step in the development of modern music scores.

Guido's system was widely adopted and improved. Extra lines were added and eventually there were five lines in a stave. Neumes were replaced by square dots placed within the lines, giving a visual aid to the intervals between them. So far there was no indication of rhythm; but by the fourteenth century there were symbols to indicate time signature, duple or triple. Even more helpfully, the black notes now had different shapes or squiggles which showed how long each note lasted.

As music and instruments became more complex, symbols for shorter notes had to be devised, and more and more instruction about how to play them included. By the seventeenth century, composers were adding bar lines to guide musicians and over the next hundred years they began to make notes above the stave about volume and style, and about phrasing and attack. During the eighteenth century music began to be printed and not just copied by hand; and this mass production spread music and the symbols for it further than ever before. The symbols became standardized and sheet music looked more or less as it does today.

Music, however, does not stand still any more than spoken language or visual art does. With the arrival of concrete, abstract and microtonal music, new ways of writing down music have become necessary. Like any language, the language of music moves with the times.

Om
(c.700 BCE)

Om is a word which is also a symbol, and perhaps the only symbol you'll ever need, because it encompasses the entirety of existence. Picked up by hippies searching for spiritual meaning in the 1960s, it represents to western eyes a general sense of oneness and inner peace.

Most familiar to western eyes as it is written in Devanagari (the alphabet used in Sanskrit), Om is a word in many other eastern languages. From its origins in Hinduism it has been taken up by Buddhism and Jainism too. It is a symbol of the undefinable vastness of the inner soul (*Atman*) and the outer universe (*Brahman*). The goal of Hinduism is to be at one with these states of perfection, something achieved through prayers and incantations all preceded and concluded with Om.

Om first appears in the Upanishads, some of the most ancient Sanskrit scriptures of the religion. They are notoriously difficult to date, but were probably written somewhere between 800 and 600 BCE. From the outset the word was a symbol, one intended to encapsulate an abstract sense of being which could not otherwise be put into words. For example, Hindu writings discuss at length the music within the word and the meaning of each element of its sound – A, U and M. A represents creation, U manifestation, and M destruction. Alternatively they are the mind, the body and the spirit, which Om is intended to unify.

Different attributes are ascribed to each of its curves:

- The lower left curve represents the conscious, waking state of being;
- The top left curve is the unconscious state;
- The lower right curve is the dream state – the state between the waking and the unconscious;

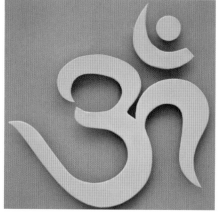

- The semicircle is illusion, the great barrier to spiritual development;
- And the dot beyond it represents the highest state of spiritual consciousness.

There is considerable overlap in the symbolism of Om in other religions. In Buddhism, Om also represents oneness, specifically a sense of connection and compassion with one's companions and surroundings. In the Shinto architecture of Japanese Buddhism, pairs of figures – usually lion-dogs, or warriors – guard the entrances and appear to be saying the word Om. The right-hand figure is styled with an open mouth as if beginning the word, and the left-hand one a closed mouth as if completing it.

Sikhs who believe in the unity and oneness of God display a similar symbol in their temples, where it means *Ek Onkar*, 'God is One'.

When the hippies of the 1960s sought some sense of spirituality beyond the conventional, some found it in eastern religion, and for a time the Om symbol was as ubiquitous in counterculture as tie-dye T-shirts, flared jeans and the peace symbol. At best it led many to spiritual enlightenment; but over time Om, peace and tie-dye have too often been relegated to fancy-dress memes in party shops.

For Hindus, however, that one small word captures everything that is to be desired and a state of being beyond all words.

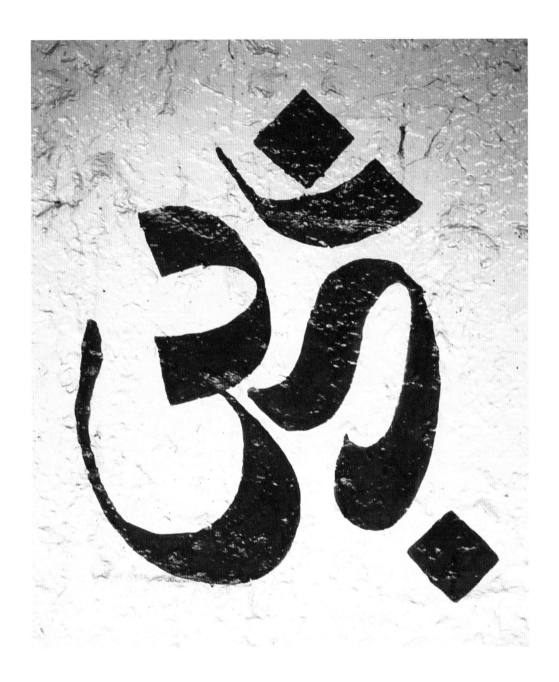

ABOVE: Om as painted on the wall of a Hindu temple in Pune, India.
OPPOSITE: The Om symbol represents unification within Hinduism. Om is a way to bring the three parts of the self together – the mind, the body and the spirit.

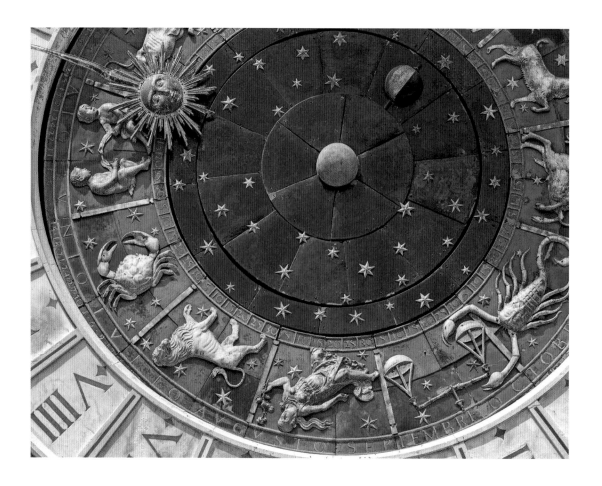

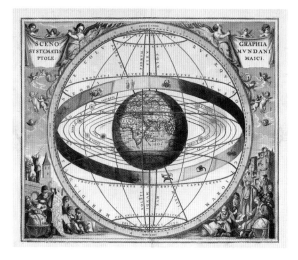

ABOVE: *Details on a Renaissance clock tower in Venice with zodiac signs of Gemini, Cancer, Leo, Virgo, Libra and Scorpio.*

LEFT: *A plate from Andreas Cellarius's best-known work, the* Harmonia Macrocosmica, *which was first published in 1660 and is one of the most spectacular cosmographical atlases of the period. This is his engraving of Ptolemy's map of the heavens.*

Astrology signs

(c.600 BCE)

The belief that the lights in the night sky affected life on Earth goes back nearly three millennia. Since the stars and planets seemed to follow an annual cycle, the ancients reasoned that a scientific study of them would allow humans to anticipate events here on our planet.

For hundreds of years, astrology and astronomy were interchangeable words for the study of the night skies. In ages when life was precarious and humans superstitious, the cyclical movement of the stars and planets dictated the seasons and the tides. And if it could dictate them, then perhaps the study of the heavens might predict them.

We talk of the movement of the heavens, although in reality it is the Earth which moves through space, changing the apparent position of the stars in the sky. The Zodiac is the path along which the Sun and certain constellations of stars seem, from our point of view, to travel every year. Because the year divides into roughly twelve month-long cycles of the Moon, the first astronomers divided the Zodiac into twelve equal sections, named after the constellations across which the sun passed. They are Aries (the ram), Taurus (the bull), Gemini (the twins), Cancer (the crab), Leo (the lion), Virgo (the maiden), Libra (the scales), Scorpio (the scorpion), Sagittarius (the archer), Capricorn (the goat), Aquarius (the water carrier) and Pisces (the fish).

The word 'zodiac' is derived from the ancient Greek for 'circle of small animals', a reflection of the fact that many of the constellations were named after animals. The Greeks already had some knowledge of the stars when Alexander the Great conquered Babylon in 330 BCE. The conquest gave him access to the astrological knowledge of the Babylonians which by then was at least two hundred years more advanced. The amalgamated observations of the Greeks and Babylonians were further codified by the Romans and the characteristics and functions of each sign of the Zodiac were definitively set down by Ptolemy in his great work *The Almagest* in the second century CE.

Divination and prophecy using knowledge of the stars was a common practice in Greece and Rome. Byzantine star catalogues contain the earliest surviving collected examples of the zodiacal symbols with which horoscope readers are familiar today, but some are known to have been reproduced in Babylonian times. They were used as a shorthand, along with comparable symbols for the planets, when drawing up the charts from which those with 'the knowledge' could predict the future.

The symbols may seem meaningless at first glance, but many of them are simply abstracted pictograms of their subjects. Aries, the ram, is represented by a stylized pair of horns. Capricorn, traditionally part-goat, part-fish in Babylonian culture, has the horns of the ram and the tail of a fish. Leo the lion is a face with a flowing mane behind it. Scorpio has many legs and a sting in the tail.

With the fragmentation of the Roman Empire and the rise of Christianity, prediction fell out of favour in Western Europe. It survived in the Middle East and Asia, however, and from the tenth century CE onwards translations of Islamic and Hindu works on the subject made their way back into Europe. It was this renaissance which led to the rediscovery of the zodiacal symbols. By the thirteenth century, divination through the stars was widespread and as columns in many newspapers and magazines today testify, it has remained popular ever since.

Unfortunately, because of an astronomical process called precession by which the Earth gradually shifts on its axis, the constellations are about a month out in relation to the traditional astrological dates assigned to them. Thus, when for example the Sun should be crossing the constellation of Taurus according to the astrological calendar, it is in reality crossing Aries. Proof, indeed, that it's all nonsense.

Medical sign –
the Rod of Asclepius
(c.450 BCE)

The Rod of Asclepius is incorporated into the insignia of medical institutions all around the world, including the World Health Organization. Asclepius, son of the sun god Apollo, was according to one legend given the secrets of the healing arts by a snake.

Opinions vary as to who was in charge when the US Army Medical Corps adopted the ancient symbol of the caduceus – two snakes entwined around a winged staff – as its insignia in 1902. Whether it was Colonel John R. van Hoff or his subordinate Captain Frederick P. Reynolds, it was an embarrassing error. The caduceus, with its wings and slippery snakes, is traditionally associated with Hermes, the Greek messenger of the gods. Either Hoff or Reynolds confused it with the Rod of Asclepius, a wingless rod with a single snake wrapped around it, which had been used by medics for millennia.

Asclepius, son of the sun god Apollo, was supposedly given the secrets of the healing arts by a snake who whispered them in his ear. Snakes were associated with healing and resurrection in ancient Greece because of their ability to shed their skin. Another story found Asclepius imprisoned until he could heal the Cretan prince Glaucus. In his cell, Asclepius accidentally killed a snake with his staff. A second snake came later and placed a herb on the head of the first, which immediately came back to life. Asclepius tried the same herb on Glaucus, who also recovered.

Thus it is the Rod of Asclepius which represents the medical profession, not the caduceus. The Rod is not his only legacy to medicine: one of his daughters was named Panacea, from which we get the name for a universal remedy; and another was called Hygieia, from which the word hygiene comes. Asclepius was worshiped in temples called asclepeions, of which archaeologists have found over 300 examples. The oldest was built in around 450 BCE.

One of the largest asclepeions is on the island of Kos, where it is said that Hippocrates, the father of modern medicine, began his career. The Hippocratic Oath, taken by newly qualified doctors swearing to uphold ethical standards, is named after him, and in its full form begins, 'I swear by Apollo Healer, by Asclepius, by Hygieia, by Panacea, and by all the gods and goddesses, making them my witnesses, that I will carry out, according to my ability and judgment, this oath and this indenture.'

Medicine has undergone many changes since Hippocrates' day. Asclepeions were home to a species of non-venomous serpent known today as the Aesculapian snake which slid freely around the temple and was used in healing rituals. Physician-priests at the temples also used healing dogs to lick the wounds of the old. Perhaps these treatments worked, because temples relied for their income on donations from survivors.

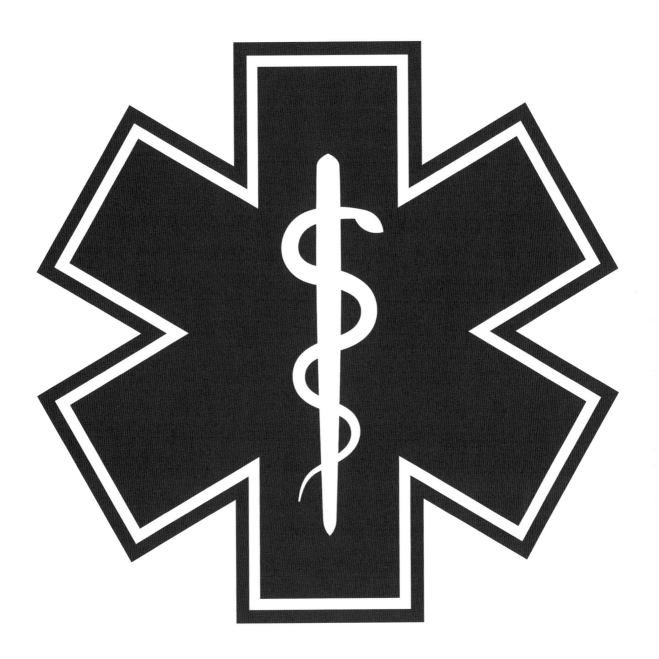

ABOVE: The six-pointed Star of Life symbol, which contains a Rod of Asclepius at its centre, is used to identify emergency medical services. Although not universally adopted, it is found on ambulances, medical personnel uniforms, and other objects associated with first aid.

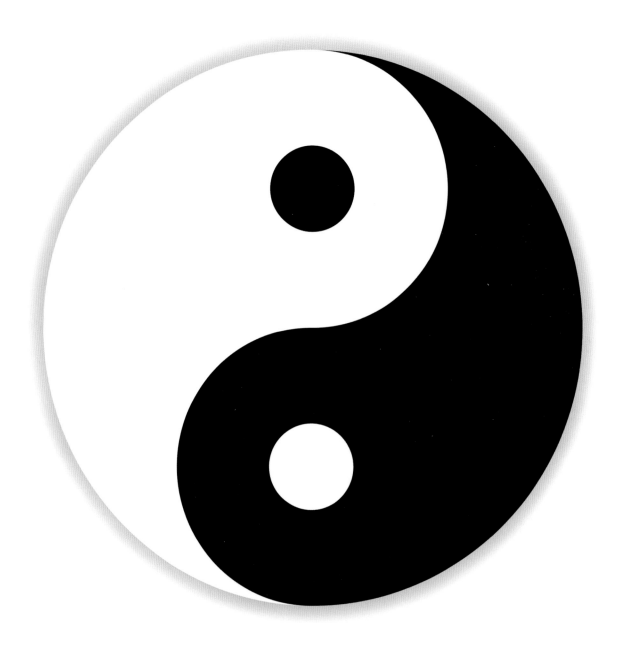

ABOVE: *The principle of yin and yang is represented by the Taijitu symbol. Yin is the black side, and yang is the white side.*

OPPOSITE: *Though a beautiful representation of a Taijitu, with the sides of the symbol only differentiated by shades of green, this horticultural display fails to meet the Taoist principle of strong contrast – sunlight and shade.*

Yin-Yang

(c.350 BCE)

An ancient symbol with its roots in Taoism has become a universal representation of balance for those of all faiths and none. Its metaphor of dark and light, intertwined and complementary, can be applied to a multitude of worldly and spiritual conditions.

The concept of yin-yang – literally, 'bright-black' – is a core principle of Taoism, which had emerged by the fourth century BCE. But the idea of cosmic balance is much older, and Chinese philosophers believed that the chaos at the start of time resolved itself into yin and yang, from which all matter, including life, was created.

The yin-yang symbol illustrates this with two tear-like forms, one dark and one light, which fit alongside each other to make a perfect circle, representing the whole universe. As one tear gets wider, the other diminishes. But even at its widest, each tear contains a piece of the other, a small circle. Some liken the image to a pair of koi carp circling each other.

The design may have its origins in the glaze decoration which potters applied to a plate spinning on a potter's wheel. Examples of such swirls date back to around 2600 BCE. An old Chinese origin myth says that the world was created by two gods, a man and a woman, both half-man and half-snake; and an ancient manuscript contains a version of the yin-yang symbol in the form of two snakes.

The earliest known example of the symbol we know today was carved on some oracle bones in the fourth century CE. Bones have been used for divination in China since at least 1000 BCE, so the symbol may well be even older. The oldest evidence for the yin-yang 'fish' in print comes much later, in 1000 CE.

When the first Chinese dictionary was published, in about 100 CE, yin was defined as 'darkness and the south bank of a river and the north side of a mountain', while yang was described as 'brightness and the south side of a mountain.' Yin and yang often appear as elements in place names.

Metaphysically the meanings of yin and yang can be extended by implication. Brightness, yang, can be associated with height, above shade, and therefore yin can mean a valley and shadow. There can be no shadow without light, a simple example of the complementary nature of yin and yang. Things that happen in shadows might not happen in the light, so yin may represent evil and yang good. The dark north face of the mountain is colder than the south-facing side, so yin and yang maybe cold and warm, illness and health, weakness and strength – and thus submission and domination, female and male.

Taoism believes in a balance of all aspects of yin and yang and accepts the presence of one within the other. Taoists simply try to find a way through it all, rather like the line between yin and yang in the symbol, guided by the Three Treasures – compassion, frugality and humility. There are worse ways to live one's life.

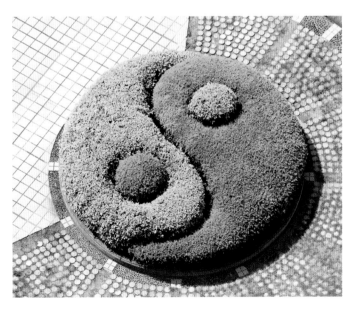

Crescent and Star – Islam

(339 BCE)

The symbol of a crescent moon combined with a star has been associated with Islam since the sixteenth century. Its origin relates to a city long fought over for religious control, and where the Muslim faith endured.

Celestial bodies – the sun, the moon and the stars – have been the object of spiritual fascination since mankind first took note of the sky above. Their significance in marking the passage of time and governing the seasons were early man's first inklings of a power far greater than anything on earth. They became objects of worship in their own right, and then symbols of personified gods. Hecate, for example, was the Greek goddess of the night and therefore associated with the moon.

During a war between the Macedonians and the Greeks in 339 BCE, Phillip II of Macedonia besieged the ancient city of Byzantium (modern-day Istanbul). On a cloudy night early in the new moon, Phillip decided to take advantage of the darkness to launch a decisive attack on Byzantium. Just as his forces were in position for the assault, the clouds parted and a brilliantly bright crescent moon revealed their position to Byzantine look-outs, who were further alerted by barking dogs. Since it was believed that only dogs could see Hecate, the moment was seen as divine intervention by the goddess. With her helpful warning, Byzantium was able to repel the Macedonian army, and in gratitude the city adopted the crescent moon as its symbol.

Centuries passed and Byzantium became Constantinople in 330 CE, the new capital of the Roman Empire named after the Roman emperor Constantine. After the collapse of that regime the city became the centre of its own Byzantine Empire, and then the centre of a Christian Crusade state. Throughout the ages it retained the crescent moon. And then in 1543 the city fell to the advancing Ottoman Empire.

Such was the scale of this victory that the Ottomans made Constantinople their new capital and adopted the city's crescent moon as its own. Because the Ottoman Empire was Muslim by religion, the crescent moon was a decorative feature on mosques built throughout the empire from then on.

A five-pointed star was added to Ottoman flags in the eighteenth century, allegedly to represent the five pillars of Islam – the profession of faith, prayer, alms-giving, fasting and pilgrimage. But there is no particular mention of either star or crescent as a religious symbol in the Koran. Some flags of Islamic countries have a six-pointed star. And many do not include even the crescent, on the grounds that any image of their faith is as blasphemous as a representation of the prophet Mohammed.

The seventeenth and eighteenth centuries also saw a wave of adventurous western travellers, especially from Britain, undertaking the so-called Grand Tour of central Europe. These mind-broadening journeys by the wealthy classes were intended to open their eyes to the cultural treasures that lay beyond their own doorstep. Their trip often took them as far as Constantinople, and to the eyes of European travellers making the Grand Tour, the crescent and star were inseparable from the Islamic faith.

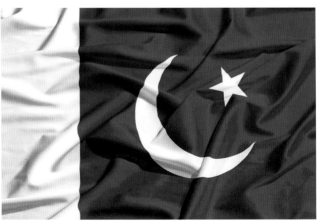

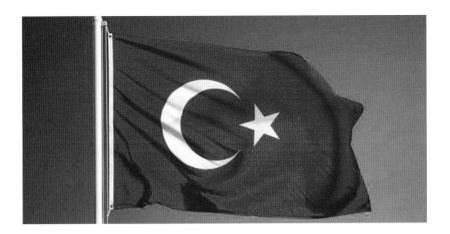

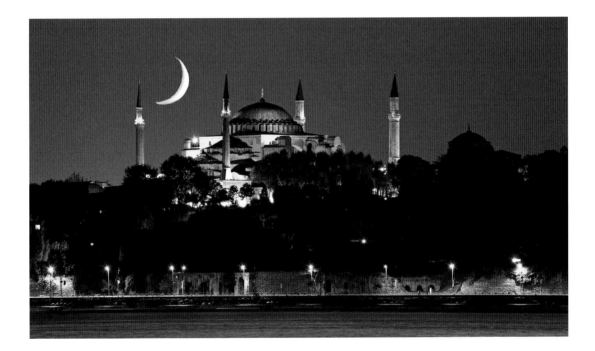

TOP: *The flag of modern Turkey with its crescent and star.*
ABOVE: *A crescent moon shining over the Hagia Sophia in Istanbul.*
OPPOSITE: *Pakistan's national flag, which was adopted in 1947.*

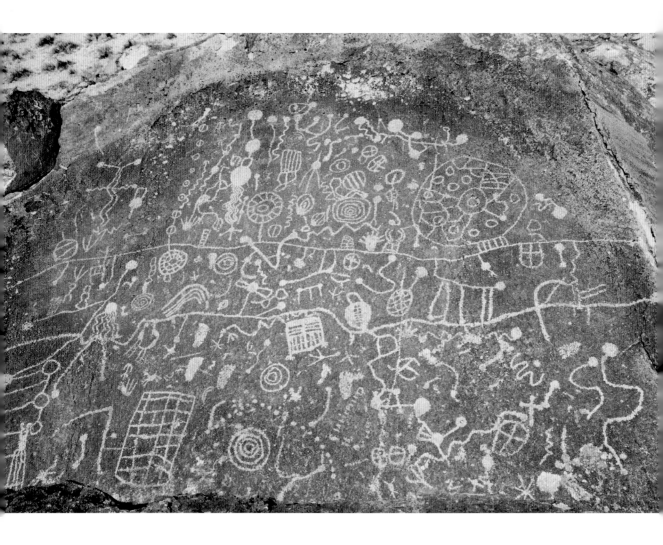

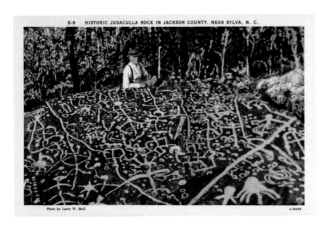

ABOVE: *An American Indian petroglyph carved onto volcanic tuff rock.*
LEFT: *A postcard of the Judaculla rock in North Carolina from the 1930s.*
OPPOSITE: *Exposed in the open, the details of the Judaculla rock have eroded away.*

American Indian petroglyphs
(c.200 BCE)

While Mayan hieroglyphs are considered the earliest form of writing in the Americas, the symbols carved on rock by native Americans of the southeastern United States may predate Maya by millennia. They bear intriguing similarities with Bronze Age rock art in Europe and Scandinavia.

Petroglyphs – markings etched on natural rock outcrops – occur throughout the United States. Those in the west are well documented; but there are hundreds of sites in the southern Appalachian mountains of Georgia and the Carolinas. Often attributed generically to the Cherokee people, some were carved over three thousand years ago, before the Cherokee settled in the area. Others are known to be the work of Creek Indians.

There are thousands of individual carvings on these rocks, to which those who made them returned generation after generation. They consist of astronomical signs, stick figures, animal tracks and more. They may tell stories of history or legend; or they may be maps of the local landscape, indicating hunting grounds and alignments. A collection of rocks at Track Rock Gap in Georgia, an area originally inhabited by the Creek people, was carved between three and ten thousand years ago. Some archaeologists have suggested that the rocks were simply a popular resting place for tired hunters, who idly scored pictures of human and animal footprints. One Cherokee tale, however, says that this is the place where the animals came ashore again from a canoe after a great flood – with echoes of the Old Testament story of Noah's Ark.

The best known of these southeastern rock art sites is Judaculla Rock in North Carolina. Like the Track Rocks, this is an outcrop of soapstone which was easily carved and often quarried by early humans to make bowls. Judaculla Rock bears the scars of such quarrying; the subsequent engraving of more than fifteen hundred separate symbols all over the face of the huge rock (240 sq ft/22 m²) were mostly made over a period of sixteen hundred years, from 200 BCE to 1400 CE. Judaculla is a legendary Cherokee giant whose huge footprints are said to be visible below the rock.

The great age of all these marks, whether as maps or as stories, gives potential insight into the otherwise unrecorded history of American Indians. Their interpretation is open to speculation; and one observer has noted curious comparisons between some Georgian petroglyphs and contemporary Bronze Age carvings in Ireland and Scandinavia. Near-identical symbols for the sun and images of a longboat with many oars have been found on both sides of the Atlantic, raising the possibility that Vikings or their predecessors may have been even more widely travelled than previously suspected.

There is evidence for such a journey in the DNA of native American Uchee descendants in Georgia, and in their origin myths of arrival across the ocean from the home of the sun (the east). Uchee means 'the water people' and may be related to the Irish word for water, *uisce* (from which we also get the word 'whiskey'). Vikings were also, coincidentally, enthusiastic carvers of soapstone bowls.

It's an entertaining but as yet unexplored theory. Because many southeastern petroglyphs may already have been destroyed by the advance of settlers, and many more remain unexplored because they lie in private land, there is still much evidence to be examined. The greater the pool of evidence and knowledge, the greater the understanding of these ancient and enigmatic signs, with exciting implications for the history of the earliest human occupation of North America.

Alchemy symbols

(c.100 BCE)

Alchemy was dangerous work: at a time when religion dominated society and when alchemists were in a race to turn base metals into something far more valuable, alchemical symbols were one way of keeping one's experiments secret.

The word 'alchemy' comes from the Arabic *al-kimia*, itself a combination of the Arabic word for 'the' and the Greek word *khemeia*. It gives a clue to the origins of alchemy in Egypt at a time when it was under Greek influence two millennia ago. *Khemeia* refers to a process of transmutation, a recreation from earthly materials of the divine substance of which, philosophers believed, the world was originally made. It's the same word from which we get the term 'chemistry'.

From Egypt the concept spread to Greece, then Rome; from there to Rome's Islamic successor, the Ottoman Empire, and thence to Western Europe. There were separate alchemical traditions in China, where it was based on Taoist teachings; and in India where, for example, the ayurvedic principles of Rasayana sought to perfect the human body and extend its longevity towards immortality.

European alchemy found itself at odds with the Christian church, which believed that all matter came from God and that no mere mortal should attempt to create things which were only in God's gift. Alchemists also found themselves under pressure from more worldly authorities to deliver those God-ordained things which they sought: eternal life, and a way of transmuting base metals into gold, the rare and divine substance which was held to be the most godlike physical material. Some alchemists believed that the way to achieve both these goals was to discover the Philosopher's Stone, a mythical material which had the power to transform.

Medieval alchemists, under attack from the Church and eager to uncover the secrets of life and wealth ahead of their rivals, were understandably secretive about their experiments. Just as Leonardo da Vinci, in a different context, hid his experimental notes in mirror writing, so alchemists adopted secret symbols to refer to the various materials which they were attempting to combine.

The symbols represented several categories of chemicals. Four of them indicated the four fundamental elements of which alchemists believed the world was made – Earth, Air, Fire and Water. There were three Primes – quicksilver, sulphur and salt – which alchemists saw as the sources of all ailments of the body.

Seven common metals were associated with the seven heavenly bodies visible to the naked eye. They were indicated with the ancient astronomical symbols of those planets, whose characteristics the metals were thought to share. Lead was matched with Saturn, tin with Jupiter, iron with Mars, gold with the Sun, copper with Venus, quicksilver with Mercury, and silver with the Moon. Other elements – compounds such as arsenic and bismuth, which were favourites of alchemists – were given new symbols of their own, and because these proto-scientists worked in isolation, each one might have a different symbol for the same substance.

Alchemy and its symbols persisted until the seventeenth century. As science gradually became more rational and detached itself from philosophy, religion and superstition, they fell into disuse or into the realms of magic and witchcraft, where they remain today. The distinction was made between alchemy and chemistry; and the English scientist Robert Boyle (1627–1691), an experimental alchemist, is also considered the first modern chemist.

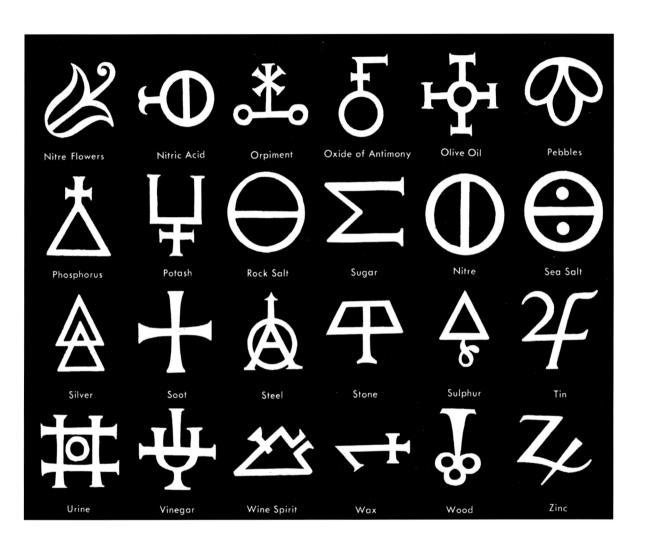

Nitre Flowers	Nitric Acid	Orpiment	Oxide of Antimony	Olive Oil	Pebbles
Phosphorus	Potash	Rock Salt	Sugar	Nitre	Sea Salt
Silver	Soot	Steel	Stone	Sulphur	Tin
Urine	Vinegar	Wine Spirit	Wax	Wood	Zinc

ABOVE: *A set of common alchemy symbols. While notations like this were mostly standardized, the style and sometimes the entire symbol varied between alchemists.*

ABOVE LEFT: *A simple stone tau cross in Donegal.*

ABOVE RIGHT: *Photographed in the depths of winter, a Latin cross blasted by ice and snow.*

OPPOSITE: *A cross from the 8th Station of the Via Dolorosa (Latin for 'Sorrowful Way') a processional route in the Old City of Jerusalem. It represents the path that Jesus would have been forced to take, carrying his cross, on the way to his crucifixion.*

Christian Cross/Latin Cross

(33 CE)

The cross, the symbol of Jesus Christ's suffering and crucifixion, is the best-known representation of Christianity. It exists in many forms, but only became closely associated with that religion some three centuries after Christ's death.

The mark of a cross is a primal decorative element, frequently found scratched on prehistoric building stones; for example in the 5,000-year-old structures currently being excavated on Orkney. Pre-Christian civilizations in Egypt, Asia, Mexico and elsewhere accessorized with cross-shaped jewellery. At least two Greek gods, Diana and Bacchus, were depicted with crosses; and in Christianity, the apostle Saint Andrew is also indicated with a cross because he was tortured to death on one.

Early Christians were reluctant to adopt the cross as a symbol because it represented the death of the son of their god. Some are thought to have made the mark of a cross on their forehead as a secret sign to other Christians during times of persecution. Others used it to protect themselves from evil, opening themselves to a charge of being 'adorers of the gibbet'.

Second-century Greek New Testament manuscripts use a staurogram – a T with a loop above the intersection – as an abbreviation for the cross. At the start of the third century, theologian Clement of Alexandria described the cross as the Lord's Sign. As Christianity became more widespread and Christians were able to publicly acknowledge their god, the use of the cross as a symbol of Christian faith gradually became standard.

The role of the cross in Christian worship was cemented by the supposed discovery of the original cross on which Jesus suffered, by Helena of Constantinople, during a trip to the Holy Land in 324. Helena, the mother of Constantine the Great, erected a church in Constantinople in which she placed pieces of the holy relic and established the festival of the Exaltation of the Cross.

The Christian cross comes in many forms. The tau cross, among the earliest Christian examples, is a simple T shape. The Greek cross has arms of equal length, and the Latin cross an extended lower limb. Not all churches accept the cross as an icon. Today's Jehovah's Witnesses reject the sign of the cross as a form of idolatry. Although the word crucifixion means death in the form of a cross, Jehovah's Witnesses believe, because of a lack of evidence in the Bible for a cruciform crucifixion, that Jesus was killed on a simple stake.

A development of the plain cross is the crucifix, which depicts not only the cross but the body of Christ hung on it. Not all Christians embrace such a graphic illustration of suffering, but for those who do, it is ubiquitous, whether large and suspended above altars, small on pendants for personal protection and comfort, or in wayside shrines for the benefit of travellers far from home or church. There are isolated early examples: the oldest, a small gemstone showing a naked bearded man on a tau cross, was made in the second century. But the use of the crucifix did not become widespread until the sixth century.

Today the cross, especially the Latin cross, is inseparably associated with Christianity. It has been a symbol of aggression on the shields of the Crusaders of the Middle Ages and in the fiery crosses of the Ku Klux Klan; a target for persecution at the hands of other religions or conflict between opposing Christian sects; but above all a symbol of hope of life beyond worldly existence for millions of Christians around the world.

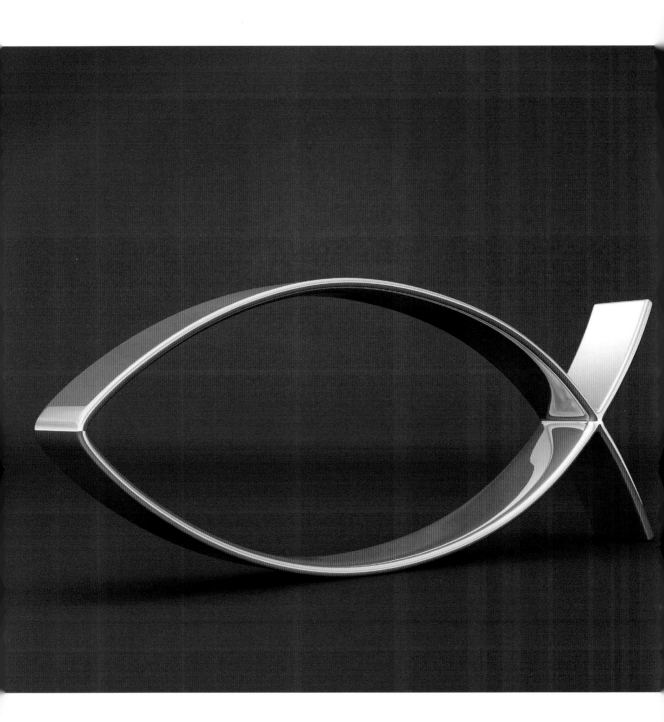

Christian Ichthys

(c.54 CE)

The stylized symbol of a fish is one of the earliest representations of Christian faith, from a time when the sign of a cross was a painful reminder of the death of Jesus. In the decades after his crucifixion, Christians in the Roman Empire were persecuted and needed a secret way of identifying each other.

The earliest examples of the Christian use of the Ichthys – the Greek word for 'fish' – were carved in stone in Ephesus, an ancient Greek city on the coast of modern-day Turkey, during the first century CE. The apostle Paul, who was central to the early spread of Christianity, lived in Ephesus for three years, 52–54 CE, only twenty years after Christ's death.

The choice of a fish to represent the founder of Christianity may seem an odd one. But in a world where the Greek language was widely spoken, it was a visual representation of an acrostic – a phrase alluded to by the initials of the words which make it up. In Greek script the word *ichthys* is spelled with five letters: I (iota, the equivalent of i), X (chi, sounded as ch), Θ (theta, th), Y (upsilon, u) and Σ (sigma, s). The letters are also the initials of the Greek words Iesous, Khristos, Theou, Uios and Soter – 'Jesus Christ, God's Son, Saviour'.

Early Christians wishing to gather together to worship needed a way of recognizing each other without announcing their faith in a world in which being Christian might result in death. Ichthys was a word which could easily be dropped into conversation to test its reception. And the simple drawing of a fish by making two arcs in the dust could be reciprocated by a fellow believer, or ignored as an idle doodle by someone who didn't recognize its significance.

It was probably a happy accident that fish also appear frequently in the books of the New Testament as metaphors or as elements in Christ's life. Most apt, for his followers, was his promise to the fishermen Simon and Andrew, whom he recruited as disciples, that he would make them 'fishers of men' – in other words, that they would catch and convert souls for Christianity. The symbol of the Ichthys was for early Christians entirely appropriate.

Under the rule of Emperor Constantine I (306–337), the Roman Empire officially adopted Christianity, and Christians no longer needed to keep their religion a secret. The use of the Ichthys died out. Fast forward to 1,600 years later, and Christianity – now a firmly established world religion – was facing a new challenge. In the 1960s attendance in churches was dwindling and aging as young people looked to more exotic belief systems for their spiritual connection. To the anti-establishment younger generation, Christianity was part of the establishment.

While hardly the persecuted minority of the Roman Empire, late-twentieth-century Christians felt beleaguered and invoked the Ichthys to make themselves visible to each other and to the public. As a counter to the hedonistic Woodstock festival of 1969, the Ichthus Music Festival was launched in 1970 in Kentucky and became an annual event. Similar musical celebrations of Christianity followed. The Ichthys became a popular motif in jewellery, and is now a common sight on the bumpers of cars owned by Christians. What was once a secret sign has now become a very public declaration of Christian faith.

OPPOSITE: *A highly stylized version of the Ichthys, today a sign of belonging not persecution.*

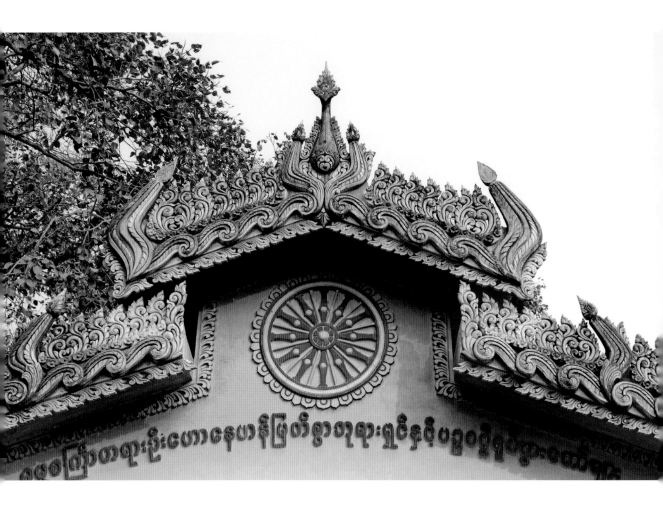

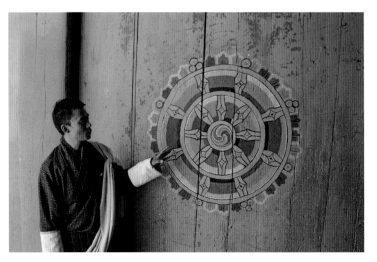

ABOVE: *A wheel of life painted on the ornate gateway to Bodh Gaya, a buddhist place of pilgrimage in the Gaya district of the Indian state of Bihar. It is where Gautama Buddha is said to have attained Enlightenment under what became known as the Bodhi Tree.*

LEFT: *A tour guide describes a wheel of life painted on a door at the Jakar Dzong fortress in the Bumthang District of Bhutan.*

Wheel of Life

(c.200 CE)

A second-century Asian tale of social etiquette in the highest circles resulted in the creation of the Wheel of Life, a symbol which encapsulates all the fundamental elements of Buddhist teaching. In the twenty-first century the idea of life as a spinning wheel of fortune still captures the imagination.

In the *Divyāvadāna*, a collection of Buddhist writings from the second century CE, it is said that when King Rudrayana gave King Bimbisara a jewel-encrusted robe, Bimbisara could think of nothing suitable to give in return. He consulted the Buddha, who drew a diagram in the form of a circle, which was nothing less than a description of the process of life. This was the Wheel of Life. When Bimbisara presented the picture to Rudrayana, Rudrayana immediately converted to Buddhism.

The wheel is a powerful metaphor. It goes round and round, an unbroken circle, returning to the same position after every turn. To the Buddha it was the perfect illustration of the Buddhist concept of *samsara* – the cycle of birth, life, death and rebirth in the temporal world, which everyone must experience and repeat until they are ready to leave samsara and enter nirvana.

In the Buddha's diagram, all the parts of the wheel are significant. At the centre, the hub is filled with depictions of the Three Poisons, the weaknesses to be overcome before leaving samsara. They are Desire, represented by a rooster; Hatred or Jealousy, in the guise of a snake; and Ignorance, shown as a boar. A ring around the hub, called the bardo, illustrates Karma – the ascension of those who have resisted the Poisons, and the descent of those who have fallen prey to them.

From the hub, the radiating spokes divide the circle into six areas representing the six realms of rebirth: the worlds of Gods, Titans, Humans, Animals, Hungry Spirits and Hell. Mortal men and women can only see two of the realms – Humans and Animals. In the Wheel of Life the upper three, of Gods, Titans and Humans, are realms where there is more happiness than suffering;

the opposite is true of the lower three. Depending on how each human behaves in their present life, it is to one of these six realms that they will return in their next life.

The rim is divided into twelve sections, each illustrated with an aspect of another important Buddhist teaching – that everything is dependent on everything else. If one thing exists, it causes another to exist. If it ceases to exist, then so does the other. And finally, the whole Wheel of Life is held by a fearsome monster, Yama, the god of death for both Hindus and Buddhists. Life, the diagram shows, is literally in the hands of death. Nothing, including life itself, is permanent.

The Wheel of Fortune has been a fairground attraction for centuries and embodies some of the same ideas as the Wheel of Life, albeit offering less control over the outcome of its spin. In readings of the esoteric Tarot, the card of the Wheel of Fortune is interpreted as a sign of impermanence, and often of destruction. Traditionally it depicts the wheel used in medieval torture chambers to break the human body, and the card can also be understood to imply the liberation of the spirit.

As young people sought spiritual guidance from beyond European traditions in the 1960s, at least one rock band drew inspiration from the Wheel of Life. New York band Blood, Sweat and Tears had a #2 hit with their song 'Spinning Wheel', which begins:

What goes up must come down;
Spinnin' wheel got to go round.

As the song's composer David Clayton-Thomas remarked, 'It was my way of saying, "Don't get too caught up, because everything comes full circle."' The Buddha would certainly have agreed.

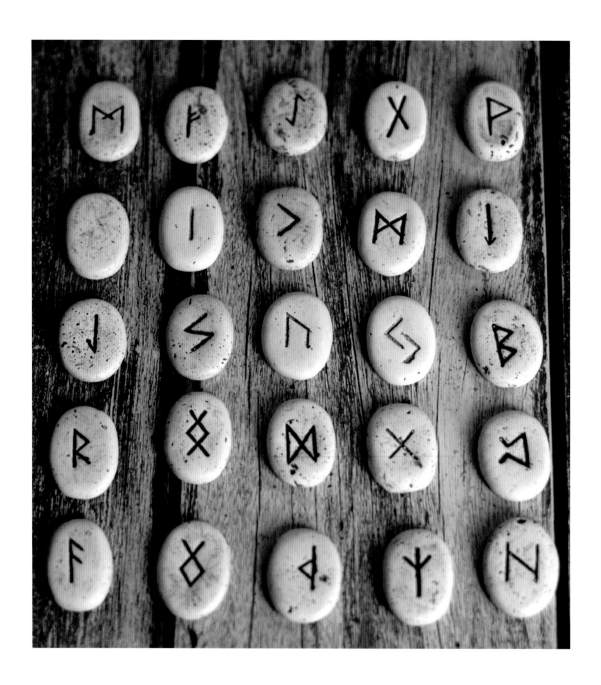

ABOVE: The 'axe friendly' runic alphabet has found
an unexpected twenty-first-century use.

Runes

(c.200 CE)

The runic inscriptions of northern Europe and Scandinavia look to modern eyes like a private code of impenetrable little lines. And that's what they are: the word 'rune' has German and Danish roots meaning 'secret conversation' and the runic alphabet has its origins in divination and sorcery.

If runic letters remind you of anything, it is probably the Bluetooth logo, which is a combination of the runes for H and B. They are the initials of Harald Bluetooth, a Danish king who brought the Danish people together under a single crown in the same way that Bluetooth's inventors hoped Bluetooth would bring people together.

The earliest runes were carved in the middle of the second century CE. Runic writing was itself displaced by Latin letters as a result of the Christianization of northern Europe in the course of the first millennium.

Runes look the way they do because they were carved with a knife or an axe on wood, stone or metal. Short straight lines are much easier to make than curves. There are no horizontal lines because, running along the grain, they would be more likely to split a wooden board or bowl.

It must have seemed rather magical that the meaning of a word could be encapsulated in a few strokes. The first use of runes was in charms and curses engraved on objects of private property or wealth – a sword, a staff, a drinking cup, for example. The oldest known runes are on a bone comb marked with the owner's name, Harja. There are references in several Norse sagas to the use of tokens carved with runes being used for divination, although no such items have ever been found. The phrase 'reading the runes' in English means paying attention to signs which might indicate the likely outcome of one's plans.

If the use of runes was originally confined to an elite, it inevitably spread to the wider population and by the fifth century CE a complete runic alphabet had evolved from which any word could be spelled. Just as the word 'alphabet' is formed of the first two letters of the Greek alphabet (alpha beta), the runic alphabet is called Futhark, after the sounds of its first six letters: F, U, Th, A, R and K.

Although the Latin alphabet replaced the runic in common use, runes persisted until at least the fifteenth century. A huge find of inscriptions on wood and bone in Bergen, Norway, in the mid-twentieth century included Latin texts written in Futhark, Christian prayers, mundane messages, exercises in writing the Futhark alphabet, and explicit sexual graffiti. One item concealed a secret runic plea to switch sides in a conflict, hidden beneath a wax layer on which a more innocent message had been written. 'Leave your party,' it begs. 'Surely you are less stubborn than the Earl.'

The Vikings exported Futhark wherever they settled overseas. The largest collection of runes outside Scandinavia is in the Neolithic chambered tomb of Maes Howe in Orkney, the archipelago north of the British mainland. Vikings looted the valuable burial goods in the tomb in the twelfth century, and left its stone walls covered in runic messages, many of a bragging nature. 'It is surely true what I say that treasure was taken away. Treasure was carried off in three nights before those,' reads one. Another boasts, 'These runes were carved by the man most skilled in runes in the western ocean.' 'Arnfithr Matr carved these runes,' wrote a certain Arnfithr, 'with this axe owned by Gauk Trandilsson in the South land.' One, beside a crude picture of a dribbling dog, claims that 'Ingigerth is the most beautiful of all women.' We will never know whether it was Thorni or Helgi who felt the need to write, 'Thorni ****ed. Helgi carved.'

Pictish symbols

(c.550 CE)

The Picts flourished in northern and eastern Scotland for seven hundred years from 200 to 900 CE, halting the Roman Empire's advance in Britain before defeat by the Vikings and assimilation into the Gaelic culture spreading from Ireland.

With no written records, all that remains of the Pictish people today is their enigmatic symbols, carved on boundary stones, monuments and graves. *Pictus* is simply the Latin word for a painted man, and it's believed that they were either heavily tattooed or wore woad in battle. All that we know about the Picts comes from the historians of other societies – Roman soldiers, Irish missionaries – whose perspective was coloured by the passage of time and the bias of politics or religion. The Roman image of them persists: warlike savages who threatened the peace of the Empire's northernmost border.

Elements of Pictish language, Celtic but closer to Brittonic than Gaelic, survive in place names. Without written records, however, the only source of Pictish history is through archaeology. Several of their forts have been identified, often on defendable coastal promontories. The most detailed and tantalizing glimpses of Pictish culture are to be found in elaborate symbols carved on standing stones.

Around fifty recurring motifs appear on hundreds of monoliths sited from St Andrews in the south to the northern archipelago of the Orkney Isles. Some represent animals, real or mythical; others show tools; and a third group combine geometric shapes and angles in a variety of ensembles which so far defy interpretation.

Some of the animals are simple but graceful representations of common Scottish species: a stag, a wolf, a salmon. One, of a bull, is unique to the Pictish coastal fortress at modern day Burghead in Aberdeenshire; and others may represent other areas defined by tribe or administrative district. One strange-looking animal resists identification. Sometimes referred

to as a dolphin or elephant, it is more often called the Pictish Beast (the most common animal in the Pictish lexicon with fifty-three appearances). The carvings of tools are a useful indication of the level of technology that the Picts enjoyed. A pair of tongs suggests they understood metalwork, for example, and an arch shows either a cave or some architectural ability.

The most remarkable symbols are the abstract ones, known to researchers by names such as 'crescent and V-rod' (the most frequently occurring symbol with eighty-seven instances) and 'double-disc and Z-rod'. These frequently appear in pairs, and some historians suggest that they are the combination of two syllables to produce a word, or the demonstration of alliances between families or tribes. Some pairings occur in clusters and may have defined territories. An alternative school of thought identifies them as astronomical symbols. The double disc might illustrate one complete cycle of the moon, for example; the rods could be lightning; the two edges of the crescent the arcs of the sun in summer and winter. It has been suggested that the Pictish Beast is an interpretation of the Gemini constellation.

The Picts converted to Christianity in the eighth century, and later stones often bear Christian iconography on one side with traditional Pictish symbols on the other. These later decorations often consist of a series of frames showing figures and scenes from some significant event. Without any written history it is hard to know what – but Sueno's Stone at Forres in Moray, at 6.5m high the tallest standing stone in Scotland, seems to depict a late ninth-century battle, from the assembly of the combatants to the beheading of the vanquished. The Picts were not savages, but theirs were violent times.

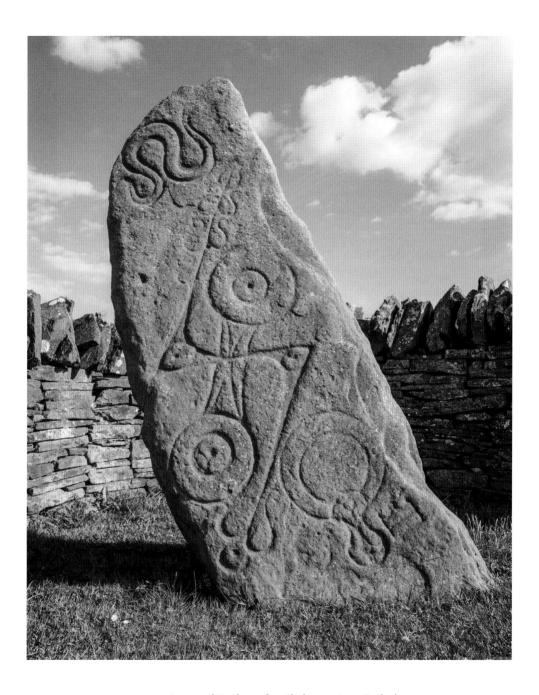

ABOVE: *An engraved Pictish stone from Aberlemno in Angus, Scotland.*

OPPOSITE: *Sueno's Stone is carved from sandstone but has suffered considerable weathering in places. In the early 1990s the stone was encased in armoured glass to prevent further erosion.*

Fleur de Lys

(c.800 CE)

The symbol of the fleur-de-lys, a stylized lily flower, has long been inseparable from France. Its association with that country is explained in several colourful legends, although examples of it from Central Europe and the Middle East predate its French connection.

The fleur-de-lys was a badge of French royalty. It was Louis VI in the twelfth century who first started to use the fleur-de-lys as a royal symbol, and marriages between the French crown and other noble families of Europe ensured its appearance in coats of arms right across the continent.

The heraldic connection between the symbol and the French kings is often attributed to a (probably retrospective) legend about Clovis, a Frankish king who ruled in the late fifth and early sixth centuries. He is credited with uniting all the Frankish tribes under one crown and thereby laying the foundation of modern France. As a reward for converting to Catholicism, God is said to have sent an angel to him carrying a blue banner emblazoned with gold fleurs-de-lys, thereby endorsing his kingship.

However the fleur-de-lys had appeared earlier on coins of Roman Gaul in the first century CE, and at about the same time on coins of ancient India's Kshatrapa Dynasty. Some historians have identified even earlier examples from the 2,500-year-old Scythian culture of the Eurasian steppe. The Franks originally came from an area of modern-day Germany and may have had contact with these influences from further east.

Another legend claims that Clovis adopted the fleur-de-lys after he safely crossed a river lined with lilies and won a subsequent battle. It is certain that the Franks came to France by crossing a river, and the River Lys flows through northeastern France and southwestern Belgium. Many heraldic experts believe that the fleur-de-lys is not the 'flower of the lily' but the 'flower of the River Lys'. The River Lys is lined not with lilies but with yellow flag iris, and it is true that the symbolic fleur-de-lys looks more like an iris than a lily. The German word for the yellow iris is *lieschblume*, which could be directly translated into French as fleur de liesch or lys.

Others claim that the fleur-de-lys symbol is derived not from a flower but a bee, a symbol used by Clovis's father Childeric, who ruled part of northern Gaul with Roman approval. Yet another explanation is that the symbol is based on the angon, a type of Frankish throwing spear.

Whatever its origins, the fleur-de-lys acquired religious symbolism thanks to the story of God's gift to Clovis. It represented perfection, as achieved by Clovis when he converted to Catholicism. This association was cemented in the year 800 CE when Pope Leo III crowned Charlemagne as Holy Roman Emperor, the anointed successor to the rulers of the collapsed Roman Empire. Charlemagne was a latter-day Clovis, a Frankish king who united much of western and central Europe; and Leo gave Charlemagne another blue banner embroidered with golden fleurs-de-lys.

As with so much Christian iconography, the fleur-de-lys became a diagram for explaining Christian concepts. Its three petals were said to represent the holy trinity of God the Father, God the Son and God the Holy Spirit, and the band binding the three petals together was the Virgin Mary. A line from the Hebrew Bible's Song of Solomon describes 'a lily amongst thorns', often taken to be a reference to Mary, whose virginity places her in a state of perpetual perfection and purity. Mary was often depicted with lilies, and later with fleurs-de-lys. The church of Notre Dame de Paris, for example, issued coins in 1146 stamped with her image and a fleur-de-lys. By the end of the century the women of English noble families had also adopted the symbol as a sign of their purity and piety.

France disposed of its monarchy after the French Revolution of 1789. But the fleur-de-lys has survived that purge to become a symbol of the whole nation and not only its kings.

LEFT: *Etymologists believe that the fleur (flower) of the River Lys is more likely to be an iris than the commonly assumed lily.*

BELOW: *The symbol of French monarchs on a wall panel of the Francis I Gallery in the Château de Fontainebleau, Seine-et-Marne, France.*

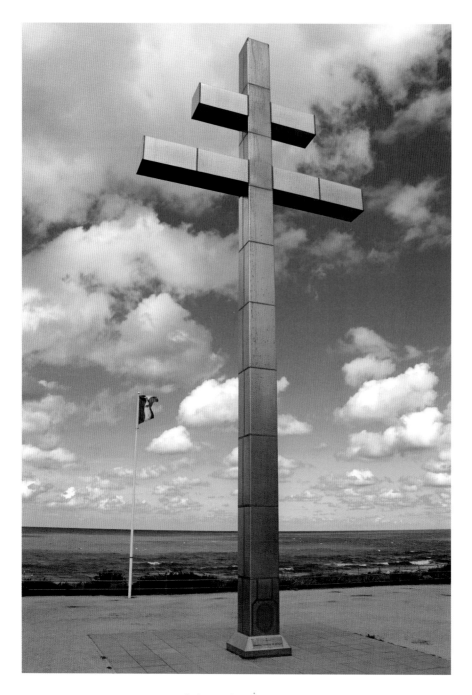

ABOVE: *An 18-metre-high Cross of Lorraine at Courseulles-sur-Mer, built to commemorate General de Gaulle's return to French soil on 14 June 1944, eight days after Canadian troops had cleared Juno beach.*
OPPOSITE: *The tomb of King Béla III and Anne de Châtillon in Budapest, decorated at the foot with a Cross of Lorraine.*

Cross of Lorraine

(c.850 CE)

Closely identified with the French Resistance during World War II, the Cross of Lorraine has been a badge of opposition to power for many centuries. Early Christians used it in the first millennium and it was a symbol of authority in Samaria before Christ was born.

The Cross of Lorraine, sometimes called the Cross of Anjou, consists of a vertical line crossed by two others, the upper one shorter than the lower. It is descended from the Patriarchal Cross, a symbol in which the two horizontal lines are of equal length.

The Patriarchal Cross was used by early Christians in the Middle East and Asia as a sign of their faith. They believed that it was the correct shape of the cross on which Jesus was crucified. But there is evidence that this 'double cross' was recognized in the region of Samaria – modern-day central Israel – by Samaritans good and bad as a symbol of kingship. So the cross held extra symbolism for those first Christians, who spoke of Jesus as the king of their souls. Crusaders bore it on their shields.

The symbol was taken up by the rulers of the largely Christian Byzantine Empire. It was to the Byzantine capital Constantinople that Prince Béla of Hungary fled when his brother was proclaimed King Stephen III of Hungary in 1162. The Empire supported Béla's claim and invaded Hungarian lands. When as Béla III he reclaimed the Hungarian crown in 1172 he adopted the Byzantine cross in the country's coat of arms as a sign of peace between Budapest and Constantinople.

The Cross made its way to France through a number of marriages between the Arpad dynasty of Hungary and the French house of Capet who, among other titles, were the counts of Anjou in Lorraine. Count René of Anjou rode into battle with what was now called the Cross of Anjou on his flags at Nancy in 1477. His victory there over the Duke of Burgundy regained Lorraine for Anjou, and the Cross became permanently associated with Lorraine and resistance to Burgundian rule.

Lorraine remained an independent duchy with its capital in Nancy until 1766, when its last Duke died and it was annexed by France. There was some resistance to this: the region straddles the border between France and Germany and was in many ways culturally closer to the latter. Upon the unification of Germany in 1871 it promptly annexed Lorraine and its neighbour Alsace in its efforts to bring all of German-speaking Europe under one imperial flag. France adopted the Cross of Lorraine as a symbol of its campaign to regain the region. Among other uses it was taken up by the 79th Infantry Division of the US Army, which fought in Lorraine during World War I and to this day uses the insignia of a white Cross of Lorraine on a blue shield.

Following Germany's defeat in 1918 Alsace-Lorraine was confiscated and returned to France. The Cross was now a symbol of French patriotism, and an obvious choice for the nation to rally round again when the country was invaded by Nazi Germany in 1940. General de Gaulle promoted its use by Free French Forces as a direct rival to the German swastika, pointing out that it was easier to daub on walls as a sign of resistance.

Today the Cross of Lorraine is a national symbol which marks the graves of those who died for France in combat. A monument in the form of one marks the spot where de Gaulle landed soon after D-Day; another towers over the village of Colombey-les-Deux-Églises where he was born. Another stands on the ground where the Duke of Burgundy died during the Battle of Nancy. The American biscuit manufacturer Nabisco adopted it to represent the purity of its ingredients, and it can still be found on both sides of an Oreo.

Irish harp

(c.1000 CE)

Harp-like instruments are to be found in musical cultures the length and breadth of the world in all manner of shapes and sizes. For one musically rich nation it has become emblematic of its history, its very soul – and its most famous beer.

No one can say for certain how the instrument came to Ireland. Records are few, and illustrations fewer, from which to deduce its journey to the island. Some say that it was introduced from Egypt by Phoenician traders, who certainly brought other goods to the southern shores of England and Ireland. Others suggest that the harp was carried to Ireland from Scandinavia by the Vikings, and an eighth-century Pictish stone carving of a harpist (in Scotland, which lies between Norway and Ireland) may be evidence of this.

Brian Boru, the king who united all Ireland by defeating the Norsemen at the battle of Clontarf in 1014, was said to be a competent harpist. The harp ascribed to him and preserved in the library of Trinity College, Dublin, is the oldest surviving harp in Ireland, but some three hundred years younger than Boru.

It was a tradition in the princely courts of the country to retain a singer, a poet (or reciter of sagas) and a harpist. This patronage elevated the status of these artists and explains the relative importance of music in Irish culture to this day. In the twelfth century an observer, Gerald of Wales, considered that harp music was the only redeeming feature of the otherwise savage Irish race.

It is certainly true that Irish harpists and their instruments were widely admired throughout Europe. When Henry VIII of England conquered Ireland in 1531, he chose the harp as the heraldic device to represent his new dominion in coats of arms, although – to make

it clear who ruled – the harp was portrayed surmounted by an English crown. The symbolism was not lost on the subjugated Irish people, for whom harp music became a form of protest at English rule until it was outlawed in the seventeenth century.

The Irish harp influenced English court music thereafter, and the symbol was adopted by the Protestant Ascendancy – the new English-sponsored owners of lands in Ireland confiscated from the old Irish aristocracy. Without that aristocracy the harp tradition in Ireland suffered from neglect and was almost lost until efforts were begun to revive it in the eighteenth and nineteenth centuries.

At the same time there was growing opposition to British rule, and the harp once again became a symbol of the old Ireland which adherents wished to see reborn. The seal of the republican Society of United Irishmen, formed in the wake of the French revolution to bring about similar change in Ireland, bore the word 'Equality' above an Irish harp (without a crown), and below it the legend 'It is new strung and shall be heard'.

The image of the harp on a flag of green was one of the most common symbols of the Easter Rising of 1916, which ultimately led to Ireland's independence from Great Britain. Today the harp represents not only Irish culture but the country itself, and appears on official items including coins and passports. Since 1862 it has also appeared on bottles of Ireland's unofficial national alcoholic drink, the dark stout beer made in Dublin by Guinness.

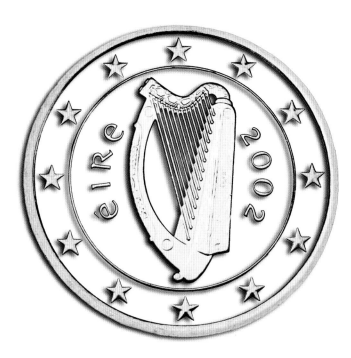

ABOVE: *The harp-shaped Samuel Beckett Bridge over the River Liffey in the centre of Dublin.*
LEFT: *Ireland's contribution to the national design of the euro coins.*
OPPOSITE: *The country's favourite drink wouldn't be the same without a harp on the side of the glass.*

ABOVE: *The Star of David is the centrepiece of the Israeli flag flying above this Old City street in Jerusalem.*

Star of David

(1008 CE)

Given the constant political tensions in the Middle East, it is ironic that the symbol so closely associated with the Jewish faith should have its roots in one which emerged from Islamic literature. The Star of David is derived from the Seal of Solomon.

Intended as a badge of shame by the Nazis, worn as a badge of honour by soldiers fighting to liberate the concentration camps, the connection of the Star of David to Judaism was made well known by the horrors of World War II, and proclaimed by the newly formed state of Israel on its flag in 1948. But its formal link to Zionism was forged only fifty years earlier.

The six-pointed star constructed from two equilateral triangles is a geometrically satisfying shape, creating a ring of six smaller equilateral triangles around a hexagon. It is identified as Solomon's Seal in one of the tales of the *Arabian Nights*, a collection of stories compiled during the golden age of Islamic literature, where Sinbad presents a drinking cup on the base of which it appears. The name the Star (sometimes Shield) of David also dates from this time. The Jews are the people of David, and the phrase has existed since at least the eleventh century, independent of the symbol.

Being composed of straight lines it is easy to carve onto wood and stone and has appeared as a decorative element on religious buildings of many faiths from Jewish synagogues to Christian cathedrals. Its earliest use in a Jewish context is in the Leningrad Codex, the oldest known complete version of the Hebrew Bible, which was produced in 1008 CE. Appearing as a full-page illumination it is not clear if the symbol had a particular relevance or was simply an attractive motif.

King Charles IV of Bohemia may claim credit for aligning the Star of David more closely with the Jews when, in 1354, he granted the Jewish community in Prague a flag of red bearing the Star. From then on Jews began to adopt the symbol as an emblem of their faith in the Jewish quarters of Prague and cities in neighbouring Austria-Hungary and southern Germany.

The association remained an informal one however, until Theodor Hertzl, an Austro-Hungarian political activist, convened the First Zionist Congress in Basle in 1897. Hertzl, the founder of the modern Zionist movement, felt the need for a symbol under which Zionists could rally, comparable to the Christian cross. Over the Basle Congress Hall for the duration of the conference he flew a white flag with a blue Star of David.

When the state of Israel was at last proclaimed in 1948, this was the flag on which it based its own. The Israeli air force insignia is a solid blue Star of David; and the Israeli equivalent of the Red Cross medical service is the Magen David Adom, the 'Red Shield of David', represented by the outlines in red of the Star of David, rather than by a red cross, which is deemed too Christian in symbolism. For the same reason, similar organizations in Islamic countries are represented by a red crescent.

ABOVE: The Star of David hanging in the thirteenth-century Old-New synagogue in Prague.

Heraldic symbols

(1066)

The complex visual language of British heraldry may seem irrelevant to many. It has long outlived its practical origins and survives thanks to the world's love affair with Britain's pageantry. But to those who understand it, a coat of arms speaks volumes about status and heritage.

Human beings are tribal by nature, whether it's as fans of a particular kind of music, supporters of the same football club or believers in the same political cause. Whatever the tribe, people like to identify themselves as being part of it. A recognizable symbol of membership is a welcome to one's fellows and a warning to one's foes.

The greatest loyalty is usually family loyalty, or in more feudal societies to the family which rules their lives. In illiterate societies a symbol would be more widely recognized than a family name spelled out. Early symbols might take the form of a reference to the family name or occupation, its piety, its ferocity in combat, its wealth or its generosity.

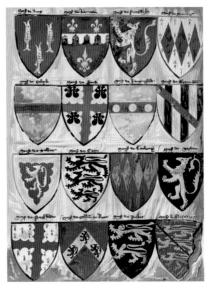

The use of these signs was informal and unregulated at first. Anyone could adopt a picture of a lion as their emblem, for example. National life, however, was transformed by the Norman Conquest of Britain in 1066. The country's Norman overlords were quick to stamp their authority on their conquered province and brought a new efficiency to government. Every state document had to be sealed as a mark of its authenticity, and seals included the name and emblem of the signatory. Heraldry was now an official stamp.

Within a hundred years of the Conquest, the use of heraldic devices had become formalized and widespread. Their adoption was further promoted by the succession of Christian crusades to the Middle East from 1096 onwards. British knights fighting the Muslim occupiers of the Holy Lands wanted their piety to be visible. They wore coats which bore the same symbols as their shields, giving rise to the phrase 'coat of arms'.

With the profusion of coats of arms came the need for administrative control. Heralds, messengers of the ruling classes, were given the job of identifying and recording the designs and regulating their use by the various social ranks of class for which Britain is still famous. Thus the whole system of symbols and styles became known as heraldry.

Disputes sometimes arose over the adoption of the same coat of arms by two families; and so many families wanted the social status of having them that in 1419 King Henry V forbade the adoption of new arms by anyone who hadn't fought at the Battle of Agincourt. This had the effect of cementing the higher status of families whose armorial bearings predated Agincourt, contributing further to Britain's class distinctions. The intermarriage of upper class families was reflected by a merging (called 'marshalling') of their arms, each family now occupying half of the new shield. At a national level this can be seen in the arms of the United Kingdom, which consists of a marshalling of the arms of England, Scotland, Wales and Northern Ireland.

As firearms replaced swords, the need for armour and shields disappeared. But by then the use of coats of arms had already shifted from military to social. Their place in the colourful pageantry of British social and stately events has ensured their survival in the twenty-first century. Like the Royal Family, their use is largely ceremonial, but cherished as a symbol of the country's long history.

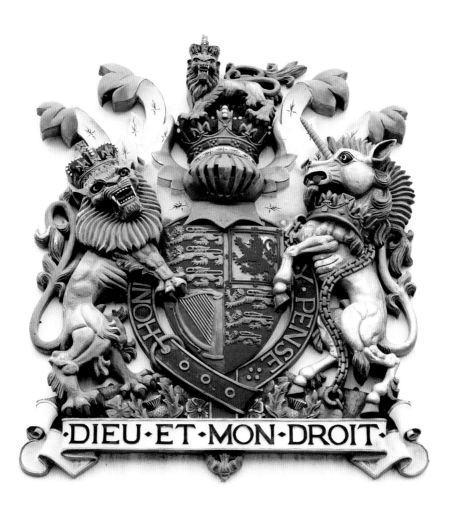

ABOVE: The royal coat of arms divided between symbols of the four nations, England, Scotland, Wales and Northern Ireland.

LEFT: The coat of arms for the Scottish town of Oban.

OPPOSITE: A collection of the shields of English knights and barons, believed to have been painted during the reign of Edward III.

Playing card suits

(c.1150)

The suits of the standard deck of playing cards – Hearts, Diamonds, Clubs and Spades – are four of the most recognized symbols in the world. Yet the suits and their names are far from universal, and different traditions have evolved even within the small continent of Europe.

While it's hard to be certain, most historians place the origin of playing cards in China. Games of dice or dominoes there involved suits as early as the ninth century CE, and by the twelfth century there were cards whose suits reflected the Chinese monetary system: Coins, Strings (of Coins), Myriads (of Strings) and Tens (of Myriads).

These cards and games spread westwards with traders along the Silk Route and were naturally adapted by the cultures along the way which adopted them. The suit of Tens was renamed Swords by Muslims, probably because the Chinese symbol for Ten is a cross, which could be mistaken for a blade and its pommel. Similarly the sign for Myriad looks like an upturned goblet, and that suit became known as Cups. Chinese coins had holes and were regularly strung together to make larger denominations; and in a crude picture a string of coins could be perceived as a baton or club.

As Cups, Coins, Clubs and Swords, the four suits made their way to northern Italy in the hands of merchants like Marco Polo who travelled the Silk Route. In the south of the Italian peninsula, playing cards arrived from Egypt and Moorish Spain and these two so-called Latin card suits developed side by side. Northern clubs are straight like rods, while Spanish ones look more like cudgels. Northern swords are curved like an Ottoman scimitar, but southern ones are straighter and broader, more like a dagger.

From Italy playing cards spread northwards into the German-speaking countries, where the suits were again reinvented for their new users. In Switzerland, the four divisions were Roses, Bells, Acorns and Shields; in Germany they became Hearts, Bells, Acorns and Leaves; and by 1480 they had reached France as Hearts, Tiles, Clovers and Pikes. By different names these are the suits most familiar around the world. French tiles were Diamond-shaped; English players still refer to Clover cards by their earlier name, Clubs; and while Germany's Leaves reminded the French of the heads of pikes, they looked to English eyes more like shovels or Spades.

Tarot decks began to appear in Italy in the early fifteenth century. The name is derived from the Italian word for trumps, *tarocchi*. The cards use the Latin suits, with four face cards instead of three, and with the addition of twenty-one numbered trump cards which are not assigned any of the four suits. Tarot games are still played throughout Europe, although not in Britain. By the middle of the fifteenth century they were already being condemned as the Devil's Instrument; but it wasn't until the late eighteenth century that they took on their role as tools of divination and prophecy. Ordinary playing cards had by then been used in that respect for centuries. In divinatory use the suits are Cups, Pentacles or Coins, Wands and Swords.

LEFT AND OPPOSITE: Like so many innovations, it was almost certainly the Chinese who devised playing cards. Something Las Vegas casinos will be eternally grateful for.

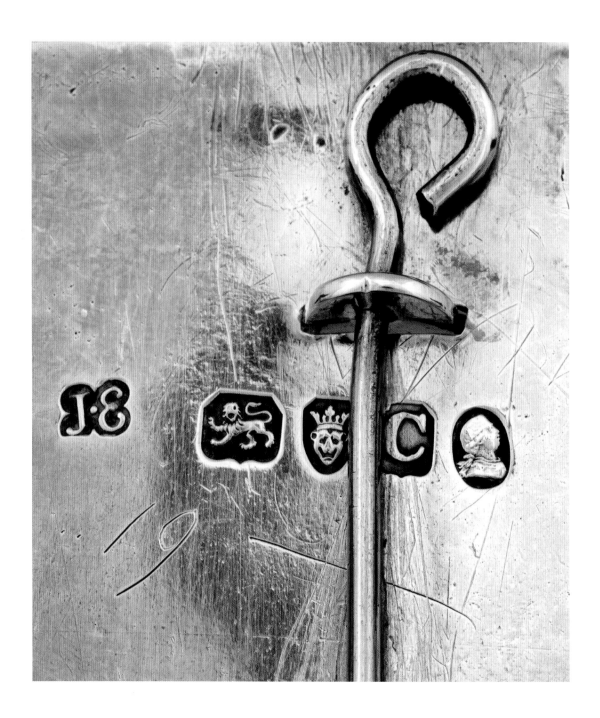

Silver and gold hallmarks

(1275)

For anything which can be made and sold, a section of society will find a way to adulterate it to reduce its costs and increase its profits. In the case of precious metals, hallmarks are the oldest form of consumer protection against debased alloys.

Gold and silver can easily be alloyed with less precious metals such as copper. Sometimes this is desirable – pure silver is quite soft and easily scratched or bent, so silver household objects are made of a silver-copper alloy for added strength. But in ancient times, if someone was paying you in pure gold coin, you wanted to be sure that it was worth its weight in gold.

States have a responsibility to ensure the purity of precious metals bought and sold on their watch. They often benefit from taxing such metals, and the public must have confidence in their quality and true value. In the mid-fourth century CE the Roman Empire was placing official marks on bars of silver, and a system of five stamps was applied to Byzantine silver of the same period.

The present system of hallmarking was introduced in Europe in the fourteenth century, when craft guilds were powerful economic bodies. It was the master craftsman's responsibility to ensure the quality of his workshop's product, a quality confirmed by official marks. France was the first country to guarantee the purity of silver with a set of special symbols punched into the metal, in 1275. The standard set for silver was relatively low at 75–81% silver versus 19–25% other metals. Gold was added to the scheme in 1313.

England followed in 1300 with a silver standard of 92.5%, which is now in common international use. Edward III sanctioned the creation of the English goldsmiths' guild, the Worshipful Company of Goldsmiths, in 1327, with its headquarters in Goldsmiths Hall in London, from which we get the term 'hallmark'.

France and England both began to include maker's marks later in the same century, a mark which can now be applied by either the maker, the trader or the distributor of an item and is known as the sponsor's

mark. After an Assay Office (from *essaye*, the French word for 'test') was installed in the Goldsmiths Hall, a third mark was introduced in 1478 which identified the Assay Master. This mark changes annually on 19 May, the feast day of St Dunstan, the patron saint of silver- and goldsmiths; and so the mark is also a record of the year of production.

A fourth mark, a lion, was added in 1544 to confirm that the item was English. With the establishment of Assay Offices in other parts of the country, each got their own mark – an anchor for Birmingham, a rose for Sheffield and in Scotland, a castle for Edinburgh. At times when silverware was taxed, a fifth stamp indicated that the tax had been paid. Items produced in certain years of special royal significance – for example the silver, gold and diamond jubilees of Queen Elizabeth II – may receive a further stamp.

Although hallmarks are used in the US, there is still no official system of marking precious metals that has been adopted. Other countries developed their own systems of hallmarking, and an attempt was made to standardize them across Europe in 1972. It is common now to see a three-figure number stamp which is the measure of purity – commonly 925 on silver – in parts per thousand. In a rare act of modernization, hallmarks can now be applied by laser instead of hammer which can distort delicate objects.

Testing is also a more modern process these days, but one traditional method remains surprisingly reliable. A touchstone, often a piece of slate, is rubbed with the object in question; then acids are applied and the colour of the stone, compared to charts, reveals the purity of the metal. From this we get the metaphors of a touchstone, something we can rely on to tell us the truth; and of an acid test, which will provide the proof of quality.

Red flags

(c.1290)

Red flags invariably spell danger, in whatever context they are used. From the signal that a motor race is too dangerous to continue to the warning that live firing is underway on a shooting range, red – the colour of blood – is a sign that our wellbeing may be at risk.

Ships fly a red flag – the letter B for Bravo in the internationally recognized maritime flag alphabet – when carrying or taking on munitions. In the age of global heating, red flags are increasingly used in areas where there is a high risk of wildfires. Red means 'Stop!' in any language, whether it's in the universally used No Entry traffic sign, or in the classic children's novel *The Railway Children* by E. Nesbit, in which central characters Bobbie and Phyllis use their red underwear to alert an engine driver to a dangerous landslide.

Red is one of the colours of flags used by beach lifeguards to advise swimmers of sea conditions. It tells them not to swim, because of dangerous currents, heavy surf or another threat such as a shark in the water. Some beaches now use a purple flag to warn of a lesser threat, often the presence of stinging jellyfish or sea snakes. A yellow flag, flown when currents are weaker but still a danger to inexperienced swimmers, advises them to swim near a lifeguard. Some countries also use a black flag, a notice that a storm is coming, while orange means that the wind is blowing offshore and might carry inflatable lilos, boats, bathing rings and their users out to sea. A pair of chequered flags like the one used in motor racing defines a stretch of the coastline where non-motorized craft such as paddleboards and kayaks may use the beach, which swimmers should avoid.

The red flag's best known use is as a symbol of communism and socialism. The songs 'Le Drapeau Rouge' and 'La Bandiera Rossa' are left-wing anthems whose title translates as 'The Red Flag' – which is also the title of the anthem of the left-of-centre British Labour Party.

Communist organizations in Peru and Venezuela are both named the Red Flag Party.

A great many left-wing periodicals and newspapers have been published over the centuries under the title Red Flag, including *Hongqi* by the Chinese Communist Party (1958–1988); *Shimbun Akahata* by its Japanese equivalent, founded in 1928 and still published daily; *Bandera Roja* in Bolivia (in the 1920s); *Die Rote Fahne* in Germany (established in 1918); and *The Red Flag*, an Australian Trotskyist newspaper launched in 2013. The flags of China, Vietnam and the Soviet Union are, of course, red.

The red flag is inseparable from revolutionary politics, a connection which was first established by the French Revolution of 1789, when revolting peasants carried red banners and wore red Phrygian caps. But they in turn were echoing an earlier unsuccessful French uprising, in 1358, in which the participants wore red caps. The Jacquerie, as it was called by the French nobles because Jacques was a common peasant name, became a by-word for all subsequent working class revolts in France.

The red flag has, however, an even earlier antecedent. In the thirteenth century it was used during military engagements, especially at sea, to indicate that the battle was to be a fight to the death, with no quarter given or asked. This usage has persisted, and was employed most famously at the battle of the Alamo in 1836, when the Mexican general Santa Anna warned Texan opponent Davy Crockett and his men that he would spare none of them, by hoisting a red flag. He was as good as his word.

ABOVE: *Pentagrams that are contained within circles are known as pentacles and popular with those practising pagan rites.*

LEFT: *In the past, the pentacle has been used to ward off evil spirits. However, today it is firmly associated with the occult.*

Paganism (pentacle)

(1354)

Low-budget horror films have made the five-pointed star a symbol of absurd devil worship. But the symbol is at least 7,000 years old and has associations with health, the fabric of the universe and Christianity.

There is much debate about the difference between a pentagram and a pentacle or pentangle. For the purposes of this article a pentagram is taken to be a five-pointed star drawn with one continuous line which, when completed, contains a pentagon (a five-sided figure) in its centre. It is a symbol with an ancient history.

Pentagram decoration has been found on Sumerian pottery made in around 5500 BCE. Much more recently, in the seventh century BCE, the pentagram represented good health to followers of the Pythagorean school of philosophy, who used it as a form of greeting among themselves. They may have been the first to see the five points as referring to the five senses – taste, touch, sight, sound and smell.

Five was a popular number for many attributes. For Taoists the pentagram represents the five materials of which the universe is made – wood, water, fire, earth and metal. Christians in the Middle Ages noted the five god-given senses, and the five joys, five sorrows and five glories of the Virgin Mary, which they used the pentagram to list. In addition, the five sides of the pentagon in the middle were the five wounds which Jesus Christ suffered. In the fourteenth century English poem *Sir Gawain and the Green Knight*, Sir Gawain bears a pentagram on his shield as evidence of his healthy senses, the strength he derives from Mary and the faith he places in Jesus.

A pentacle, by contrast, is a star (not always a five-pointed one) enclosed in a circle. In the esoteric Tarot, one of the suits, sometimes known as Pentacles, is illustrated by circular coins with a star on them. The fourteenth century witnessed one of the earliest uses of the pentacle in connection with magic. A book called *The Key of Solomon* appeared in 1354, which purported to be the work of King Solomon, the Old Testament King of Israel. It was a fake, in the form of a catalogue of magic spells called 'experiments', which Solomon was supposed

to have written for his son Rehoboam; and among its many symbols and diagrams were several pentacles. *The Key of Solomon*, itself a forgery, inspired many others, all widely translated in the following centuries. In the same period the pentacle was a popular charm worn to ward off evil spirits.

Perhaps it was this superstitious association with the devil which drew French former priest Eliphas Levi to the pentacle. A practising occult magician, he published his book *The Doctrine and Ritual of Transcendental Magic* in 1855, which contained pentacles. Levi was the first to suggest different meanings of good and evil depending on whether the pentagram points up or down. His writings were influential among those interested in the occult, including the Hermetic Order of the Golden Dawn and the notorious occultist Aleister Crowley.

By the middle of the twentieth century the pentacle was firmly associated with satanic ritual, a connection only encouraged by the prolific British budget horror movie studios of Hammer Pictures. Simultaneously, however, it was being used by the emerging pagan religion of Wicca, a belief system which blends many strands of esoteric practice from both east and west. It is a diverse church, whose many different strands often contradict each other's views on atheism, monotheism and duotheism.

The pentagram and the pentacle are central to Wiccan practice, and as important to them as the cross is to Christianity. The highest point represents Spirit, and the other four the cardinal elements of air, earth, fire and water. Today, Wicca has largely outrun the tabloid sensationalism which focussed on its use of sex magic, and it has survived periodic scandals linking the satanic rituals of other cults to child abuse. Wiccans are understandably eager to clarify that their pentacle points upwards while that of Satanists points down.

Freemasonry

(c.1390)

Freemasonry boasts one of the densest concentrations of symbols of any organization. One online dictionary of masonic terms and signs has 305 entries. They are reminders of the sometimes secretive organization's origins as a craft fellowship and of its profoundly Christian outlook.

The beginnings of freemasonry require some explanation. In medieval times there were two sorts of stonemason. Rough masons were simple stone cutters who knocked out the basic building blocks from the uneven boulders which the quarry delivered. Free masons on the other hand did the finer work of dressed or decorated stone. It was more skilled, and free masons banded together to protect their craft and support each other.

The earliest evidence of freemasonry is a 64-page-long poem from around 1390 known as the Regius Manuscript, now held in the British Museum, which sets out in 794 verses the moral and professional obligations of a mason. It covers good manners and church attendance as well as more obvious trade duties such as having a good grasp of geometry – an essential skill for the accurate shaping of stone in arches, fan vaults, rose windows and the other intricate elements of medieval stonework.

Two of the most familiar masonic symbols are reminders of that geometric skill – the combination of a set-square and a pair of compasses. The square ensures that a mason's angles are right, not just right-angled but correct; and the compasses measure size accurately, making for a good fit and perfect arcs. Freemasons aren't only thinking of stonework here: they believe that their Christian god is the supreme mason, maker of all things, and perpetually checking that we are doing things right. The diamond shape made by the square and compasses often encloses a capital G. Some say it stands for God, others for Geometry, and others again for Gnosis, a Greek term for spiritual knowledge.

The imagery of another masonic symbol, the all-seeing eye, also captures God and geometry. It's most familiar to us on the back of a one-dollar bill, pictured above an unfinished pyramid, a historically challenging masonic endeavour. The eye and pyramid are on the Great Seal of the United States, which was designed fourteen years before they first appeared in a masonic context. Boston man Thomas Smith Webb, Grand Commander of the Grand Commandery of Knights Templar and the Appendant Orders of Massachusetts and Rhode Island, published details of them and much more in his book *The Freemason's Monitor or Illustrations of Masonry*.

The eye is the eye of God watching every mason's deeds, usually shown radiating God's light and often framed in a triangle. Three, the number of the Holy Trinity of God – father, son and holy spirit – is significant in masonic ritual. The G in the square and compasses is sometimes explained as being the third letter of the Greek alphabet.

The triangle appears in another symbol, an illustration of Pythagoras' Theorem (that the square on the hypotenuse equals the sum of the squares on the other two sides, known to freemasons as the 47th Problem of Euclid), one of the common mathematical calculations used in geometry. During certain rituals, freemasons wear a threefold cord (a rope with three strands) called a cable tow. This is based on a verse in the Bible, Ecclesiastes 4:12, which says that 'a threefold cord is not easily broken', and the length of the cord reflects the length to which a freemason is able to go to help his fellow mason. Masons who have achieved a higher degree of freemasonry may wear a longer cord, which also represents his bond of commitment to his fellows.

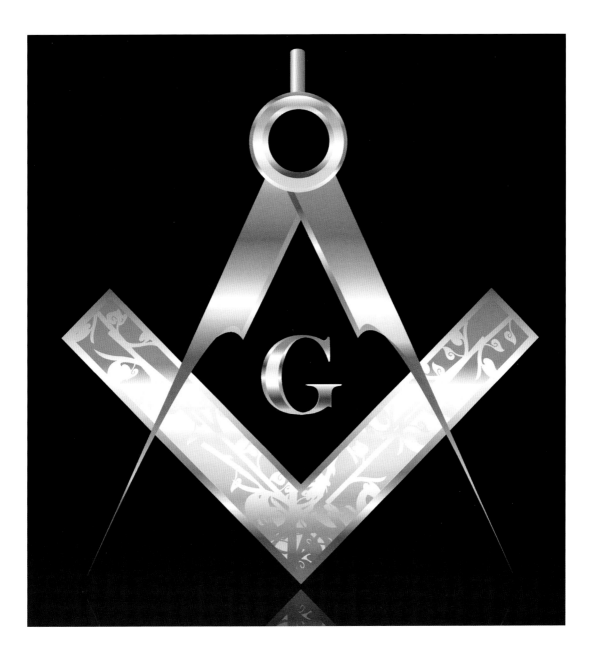

ABOVE: *The set-square superimposed on the pair of compasses is the core symbol representing freemasonry.*

OPPOSITE: *An image of the all-seeing eye, representing the god that watches over freemasons.*

Square root

(1525)

It is said that the dimensions and proportions of the great pyramids reveal the ancient Egyptians' fascination with numbers. Papyrus manuscripts over 3,500 years old contain some 120 equations, some containing the earliest evidence of the concept of the square root.

The square root of a number is another number which, when multiplied by itself, produces the first number: 3 is the square root of 9, for example, and 3.5 is the square root of 12.25. Egyptian builders had clay tablets with tables of the square roots of common numbers to which they could refer. The square root, which they called the *kenbet*, was indicated by a symbol, a right-angle with arms of equal length. In geometry, they reasoned, the right-angle was indeed the root or starting point of any square.

This may well be the origin of the angular sign which is used today, technically called the radical symbol, from the Latin word for a root, *radix*. But in the thirteenth century European mathematicians were still using an ornamental R or double R to indicate the radix or root. For example, Leonardo Fibonacci of Pisa, who gave us Fibonacci numbers, adopted an R with a line through it. Some say that our modern square root symbol is an abstract version of this R.

Fibonacci, whose father was an Italian trader based in northern Africa, did a great deal to popularize Arabic numerals (1, 2, 3 etc) in Europe, at a time when most were still working with the cumbersome Roman system of combining the letters I, V, X, L, C, D and M to represent totals. The Arabic world has always been strong on commerce and the mathematics that a good business mind requires. The word algebra is derived from the Arabic word *al-jabr*; and many mathematical historians see in the initial letter of *jabr*, the modern square root sign.

The modern symbol first appeared in print in 1525, when the Silesian mathematician Christoph Rudolff published the first German textbook about the mysteries of algebra. It was called *Behend und hübsch Rechnung durch die kunstreichen regeln Algebre so gemeinicklich die Coss genent werden* (Nimble and beautiful calculation via the artful rules of algebra, commonly called Coss). Almost all German words beginning with C are borrowed from other languages, and 'coss' is a corruption of an Italian phrase meaning 'things unknown'.

Rudolff used his symbol without the vinculum, the horizontal line extending from it above the numbers whose square root it refers to. That was added for the sake of clarity in 1637 by the French philosopher René Descartes, who was the first man to unite the two previously separate disciplines of geometry and algebra. In so doing he connected the two great mathematical traditions of the Egyptian and Arabic worlds, an event which shaped the science of modern mathematics.

BELOW: Builders of the Great Pyramids would have had detailed knowledge of square roots.

1. $14.\textit{ze}. \;+\; .15.q \;=\; 71.q.$

2. $20.\textit{ze}. \;-\; .18.q \;=\; .102.q.$

3. $26.\textit{z} \;+\; 10\textit{ze} \;=\; 9.\textit{z} \;-\; 10\textit{ze} \;+\; 213.q.$

4. $19.\textit{ze} \;+\; 192.q \;=\; 10\textit{z} \;+\; 108q \;-\; 19\textit{ze}$

5. $18.\textit{ze} \;+\; 24.q. \;=\; 8.\textit{z}. \;+\; 2.\textit{ze}.$

6. $34\textit{z} \;-\; 12\textit{ze} \;=\; 40\textit{ze} \;+\; 480q \;-\; 9.\textit{z}$

1. **In the firſte there appeareth. 2. nombers, that is** $14.\textit{ze}.$

The whetſtone of witte,
whiche is the ſeconde parte of
Arithmetike: containyng thextrac-
tion of Rootes: The Coſſike practiſe,
with the rule of *Equation*: and
the woorkes of *Surde*
Nombers.

Though many ſtones doe beare greate price,
The whetſtone is for exerſice
As needefull, and in woorke as ſtraunge:
Dulle thinges and harde it will ſo chaunge,
And make them ſharpe, to right good vſe:
All arteſmen knowe, thei can not chuſe,
But vſe his helpe: yet as men ſee,
Noe ſharpeneſſe ſemeth in it to bee.
The grounde of artes did brede this ſtone:
His vſe is greate, and moare then one.
Here if you liſt your wittes to whette,
Moche ſharpeneſſe therby ſhall you gette.
Dulle wittes hereby doe greatly mende,
Sharpe wittes are fined to their fulle ende.
Now proue, and praiſe, as you doe finde,
And to your ſelf be not vnkinde.

These Bookes are to bee ſolde, at
the Weſte doore of Poules,
by Jhon Kyngſtone.
1557.

ABOVE: Some of the calculations in Robert Recorde's book, with the extended equals sign.
LEFT: Recorde's book of 1557 was the first in English to use the plus and minus signs as well as introducing the equals.

Equals sign

(1557)

Symbols are not merely abbreviations, they are visual representations of ideas. When Welsh polymath Robert Recorde invented the 'equals' sign, he changed forever the way in which the brain perceives mathematical equations.

Robert Recorde (1512–1558) was born in medieval Tenby, Pembrokeshire, a walled coastal town then at the height of its fortunes thanks to its trade connections with France, Portugal and Spain. It was probably the town's commercial activity which sharpened Recorde's arithmetical acumen. At the age of thirteen he went to Oxford University, and subsequently became a maths tutor.

In 1545 he returned to study, this time at Cambridge University, from which he emerged with a degree in medicine. The fruits of his medical experience he published in *The Urinal of Physick* (1548), a study of all that could be learned of a person's health by examining their urine.

He was a prolific author. His made his debut with *The Grounde of Artes* (1543), the first algebra text book written in the English language. He followed that with *The Pathway to Knowledge* (1551) on the subject of geometry; and *The Castle of Knowledge* (1556), a summary of Ptolemaic and Copernican astronomy. Several anonymous books have also been attributed to him, including works on clockmaking and geography.

Recorde's writing style was usually in the form of a platonic dialogue between a master and his pupil, a word-heavy style which to modern readers can seem quite unsuited to mathematical treatises. Recorde began to feel the same way, and during the writing of *The Whetstone of Witte* (1557), an algebraic sequel to *The Grounde of Artes*, he introduced the plus and minus symbols to the general English reader. They were by then in common use in Germany, where they were replacing the previous words and abbreviations *plus* or *p* and *minus* or *m*. The plus symbol was an abstraction of the Latin word for 'and' (as is the ampersand); the minus was a line called a tilde, originally written above the m to indicate that it was being used as a symbol and not just a letter.

In the same work, Robert Recorde made his greatest contribution to mathematics. As he wrote in an explanation to his readers, 'to avoid the tedious repetition of these words, "is equal to", I will set a pair of parallels.' His two lines were longer than ours today, but as he succinctly and algebraically explained, no two things can be more equal than two lines of equal length, width and angle to the horizontal.

The difference between
two plus two is equal to four
and
$2 + 2 = 4$
is obvious.

Recorde's innovation made it visually possible for the human brain to understand maths more clearly. As maths historian Joseph Mazur has noted, the only mathematical symbols which existed before the 'equals' sign were the plus, the minus and the square root symbol. In Recorde's wake came all the others – multiplication, division, proportion, summation, differential and a hundred others, not to mention the many new areas of pure and applied mathematics which the brain has devised since Recorde's equals.

Tragically Robert Recorde was not as clever in other areas of life. He foolishly accused a high-ranking enemy, Sir William Herbert, the future Earl of Pembroke, of defamation. Sir William sued him back and won thanks to his higher status. Recorde, unable to pay his and Herbert's costs, died in a debtors' prison only a year after the publication of *The Whetstone of Witte*. Robert and Sir William were not, it turns out, equals.

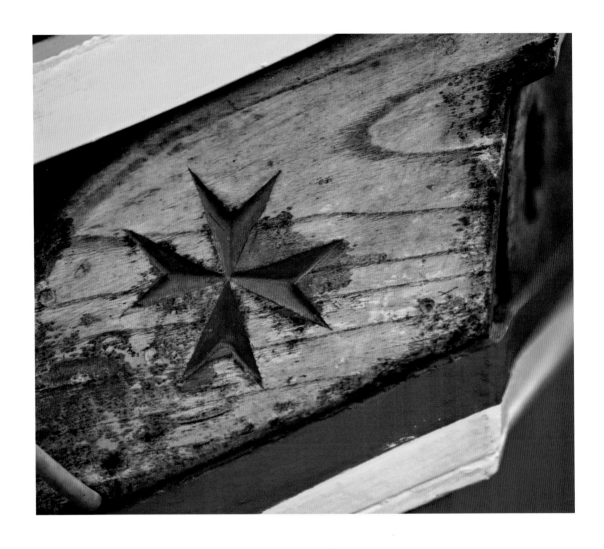

ABOVE: A Maltese Cross painted on the bow of an old fishing boat in Valetta harbour.
ABOVE: The cross continues to have a high profile, adorning uniforms and vehicles of Britain's volunteer first aid organization.

Maltese Cross

(1567)

The Maltese Cross is the least cross-like of the many 'cross' symbols, more like a star or a flower than a cross. Its four arms do not in fact cross at all, but converge like arrows on a bullseye. Its origins may lie elsewhere, but its connection to the island of Malta is historic and unbreakable.

Merchants from Amalfi in Italy were given permission to build a hospital in Jerusalem in 1023, on the site of a ruined monastery dedicated to Saint John the Baptist. At the end of the First Crusade in 1099 a group of knights dedicated themselves to supporting the work of the hospital, which cared for Christian pilgrims to the Holy Land. They became the Order of Knights of the Hospital of Saint John of Jerusalem, or more simply the Knights Hospitaller, and their work expanded from caring for sick pilgrims to providing armed escorts for them.

During the Crusades, the Knights identified themselves with a simple cross, but as Knights Hospitalier they gradually adopted a form known as the 'cross moline', in which the ends of the arms were split, creating eight tips instead of four. This version of the cross had appeared on Amalfitan coins as far back as the eleventh century.

When Islamic forces reconquered the Holy Land, the Knights retreated, first to Rhodes, and in the sixteenth century to Malta, which they were granted in perpetuity by Pope Clement VII in return for an annual gift of a Maltese falcon (a deal which became the basis of the plot of the Dashiell Hammett novel and classic film noir *The Maltese Falcon*). In Malta, in 1567, the first fully formed example of a Maltese Cross as we know it today was stamped on a coin issued by Grand Master Jean Parisot de Valette.

The Knights were by then a powerful organization with extensive trade and military networks throughout Europe. As individual knights returned to their homelands across the continent, they wore the Maltese Cross to demonstrate their connection to the Order, and the Cross can now be found in the insignia of many European families, military orders and decorations, and even countries. Although the Order eventually became fragmented by the emergence of Protestantism, its name and aims survive internationally in organizations such as the St John Ambulance.

The Maltese Cross evolved as a simple badge of the Knights' relationship with the Amalfitan hospital in Jerusalem, but several meanings have been retrospectively ascribed to its eight sharp points. They are said to represent the eight regions of Europe from which the knights originally came: Provence, Aragon, Auvergne, Castille, Portugal, Italy, Germany and England.

Alternatively, some claim, they point to the eight Beatitudes enumerated by Jesus. In the light of the Beatitudes, others suggest that they are the eight values by which a Knight Hospitaller should be guided: to live in truth, to have faith, to repent of one's sins, to be humble, to be just, to be merciful, to be sincere, and to endure persecution.

The flag of the town and commune of Amalfi today is a white Maltese – or perhaps Amalfitan – cross, on a blue background.

Yellow ribbon

(c.1600, or 1979)

When Americans awaiting the release of US hostages in Iran began to hang yellow ribbons from their trees and porches in 1979, they were reviving a symbol of hope whose history stretches back some four hundred years.

Iranian students stormed the US Embassy building in Tehran in November 1979, taking fifty-two diplomats and civilian personnel hostage in revenge for US support of the overthrown Shah of Iran earlier that year. A group of women in Kentucky were the first to make a show of support for the hostages by tying yellow ribbons around public trees. The idea received national attention when in the weeks before Christmas, Penelope Laingen, whose husband Bruce was the most senior of the diplomats being held, hung one on her lawn and encouraged others to do likewise rather than engage in violent confrontation with Iran. 'Do something constructive,' she urged, 'because we need a great deal of patience. Just tie a yellow ribbon around the old oak tree.'

The reference was to the popular 1973 hit song 'Tie a Yellow Ribbon Round the Old Oak Tree', which told the story of a released prisoner asking for a sign from his family that he would be welcomed home despite his crime. The song was itself based on similar traditional stories dating back to at least the early twentieth century, in which the ribbons are sometimes replaced by a yellow handkerchief.

There are many earlier versions of the song. The theme is always that of a woman whose love or fidelity is being tested by the absence of her husband for one reason or another. She must demonstrate her steadfastness by wearing the yellow ribbon in her hair or round her neck, a symbol which the returning husband will see with relief.

The song seems to have originated with the Puritans of England, who fought alongside Cromwell against the King during the English Civil War of the mid-seventeenth century. On battlefields where Englishman fought against Englishman, the Cromwellian forces identified themselves with a yellow sash. The same issues which precipitated the war also persuaded some Puritans to leave England altogether and seek a new life in the New World; thus, alongside their beliefs, Puritans brought the song 'She Wore a Yellow Ribbon' to America.

Since the end of the 444-day diplomatic tussle in 1981, yellow ribbons have become a familiar sign of hope for families of soldiers in any overseas conflict. In many countries a yellow ribbon has also been used to raise awareness of suicide prevention campaigns.

They have also been adopted for specific causes: in Catalonia, for example, they were demonstrations of opposition to the imprisonment of two political leaders of the region's secessionist aspirations. In Korea, a statue of a so-called 'comfort woman' provocatively placed outside the Japanese Embassy in Seoul has been decorated with defiant yellow ribbons to draw attention to the Korean women forced to work in Japanese brothels during World War II.

OPPOSITE TOP: A yellow ribbon in Verona Beach, New Jersey, for Staff Sergeant Justin Nielsen, who was serving in Kabul, Afghanistan.
OPPOSITE BOTTOM: Yellow ribbons hanging at Quincy Center, Massachusetts in 2010 for American military personnel serving abroad in Iraq and Afghanistan.

The Jolly Roger

(1625)

Pirates are still a danger in some of the world's seas and oceans, but gone are the days when they announced their intention to attack by hoisting the Jolly Roger. The traditional sign of the pirate is now most closely associated with Hollywood franchises and anarchic political groups.

The skull, with or without crossed bones, has been a recorded symbol of death since at least the sixth century when it began to appear on grave markers. It was a *memento mori*, a reminder that death – the Great Leveller – comes to us all, rich or poor, weak or powerful.

The practice became less common after the fourteenth century. It has been claimed that the wealthy medieval organization the Knights Templar, who ran a vast trading network all over Europe from their headquarters in Jerusalem, carried the symbol into battles of the Crusades. A retrospective legend says that the bones represented were those of the order's last Grand Master, Jacques de Maloy, who was burned at the stake when Pope Clement V outlawed the wealthy Knights in 1312 – but that was some sixty years after the Crusaders lost their last battles.

As members of the Knights Templar disappeared from public life and re-emerged in different guises, some former knights turned to crime to sustain the wealth and power to which they had become accustomed. The trading Templars had maintained a large fleet of ships, and if some of them were repurposed for piracy it would explain how the skull and crossbones found its way into that profession.

The first recorded use of the flag is by pirate ships on the notorious Barbary Coast of northern Africa. These ships were involved in the early slave trade, raiding ports not only in that continent but around Europe. A version of the skull and crossbones on a green flag was seen during a slave raid on the southwestern English county of Cornwall in 1625.

Many pirate captains had their own versions of the flag. Blackbeard, for example, depicted a full-length skeleton stabbing a heart with a spear on his signature flag. Englishman Black Sam Bellamy, the richest pirate of his day, flew the classic skull and crossed femurs. Bellamy drowned in a storm in 1717 and his ship, the *Whydah Gally* (a former slave ship) was rediscovered off Massachusetts in 1984.

The origin of the flag's name, the Jolly Roger, is unclear. Pirates used the term even for flags with no bones on them, and before the skull and crossbones, many of them flew a plain red flag, representing the blood which they threatened to spill. It has been suggested that this was known ironically as the Jolie Rouge, the 'pretty red [flag]' in French. A pirate captain would hoist the Jolly Roger when he was preparing to attack, knowing that the mere sight of it was usually enough to persuade his opponents to abandon ship or surrender.

The golden age of piracy was the first quarter of the eighteenth century and by the start of the nineteenth the threat had more or less been eradicated from Atlantic waters, leaving fiction authors a clear field in which to tell elaborately embellished tales of terror on the high seas in which the Jolly Roger was a convenient shorthand. There was no denying the persistent implication of death which the skull and crossbones embodied, and in 1829 New York State was the first regime to adopt it as a label for poisonous substances. Today the internationally recognized pictogram for toxic substances which are a high risk to health is a skull and crossbones inside a red or yellow diamond.

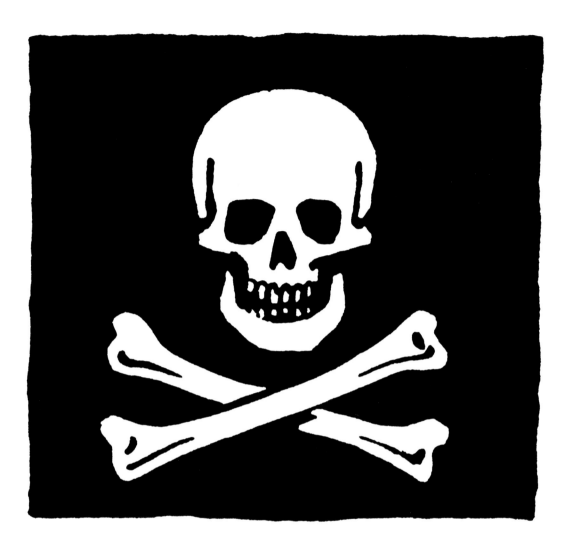

ABOVE: *The flag of the once-marooned pirate Edward England, who was said to be one of the more humane pirates in 'The Golden Age of Piracy'.*
LEFT: *Exhibition staff at the National Museum of the Royal Navy, help hang a flag captured from pirates off the North African coast in 1790.*
OPPOSITE: *The skull and crossbones is put to good use in warning of potential hazards.*

ABOVE: *The Vegvísir, the Vikings' magic compass surrounded by runes and dragons.*
OPPOSITE: *The Ægishjálmur, or 'The Helm of Awe/Helm of Terror' is*
an object mentioned in the Norse sagas. It became an Icelandic magical stave,
and was used in Christian ceremonies.

Viking staves

(c.1650)

Sigils – magical symbols supposed to invoke protective angels or demonic curses – have been used since Neolithic times. They were believed to ward off evil, put curses on others or ensure the desired outcome in a given situation. They are rooted in mankind's earliest belief systems.

What we call magic today can be considered a mere deception, willingly accepted by its audience as entertainment. But it can also be seen as an attempt to reproduce, by trickery, unexplained events of appearance and disappearance – the sort of events which convinced a more ignorant, primitive population of the existence of gods and spirits.

Different gods or demons were assigned the responsibility for different kinds of event, just as saints are in the Christian church today. The word 'sigil' comes from the Latin word for a seal or sign. In magical terms, sigils were supposed to invoke the demons which they represented: summoning a spirit suggested that one had power over it and could command it to do one's bidding.

Although today we regard such magical signs as arcane and superstitious, in a sense many of the world's religions still have sigils which summon their gods. The Vikings' heaven, Valhalla, was populated by gods such as Odin and Thor; and Vikings had their own system of sigils, called staves. Although Vikings gradually converted to Christianity from the ninth century onwards, the use of staves persisted. Examples are found in Icelandic and Swedish *grimoires* – books of alleged magic spells – from the seventeenth to the nineteenth centuries.

Some were general charms against evil – *Stafur gegn galdri* literally translates as 'staves against witches'. *Djófastafur* [thyofa-stafur], found in a seventeenth-century Icelandic medical text, summoned protection from thieves. As might be expected of a warrior people, many were intended to ensure victory: *Brýnslustafir* were drawn on whetstones to guarantee their effectiveness in sharpening swords, while *Skelkunarstafur* and *Ægishjálmur* (also known as the Helm of Terror) aimed to instil fear in one's enemies in battle.

The seafaring Vikings had fears of their own, and a sailor might carve a *Vatnahlífir* to prevent drowning. Boats would be decorated with *Veiðistafur* [veythi-stafur] to guarantee a good catch of fish; and one of the best-known staves today is the *Vegvísir*, the so-called Viking Compass which promised to guide its wearer through bad weather. It's often used as a design motif in jewellery. Many of the staves, including the Compass and the Helm of Terror, took the form of an eight-pointed diagram, as if ensuring protection from whatever direction evil might appear.

Like every civilization before or since, the Vikings also had more personal concerns; and one stave, *Að unni* [ath unni], is translated simply as 'to get a girl'.

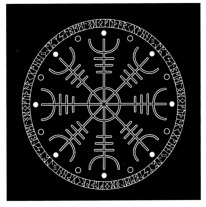

British Pound sign

(1661)

Why is the British currency, the Pound, symbolized by the letter L and not P? The answer lies in Latin, the language of the Romans. Rome conquered England in 43 CE, bringing new roads, buildings and administration to a tribal landscape. And the Romans had a word for everything.

The impact of Latin on the English language cannot be overstated. Not only did it transform the native language directly through 400 years of Roman rule, it was the basis of the *lingua franca* of medieval Europe, the composite language understood throughout the continent.

England continued to adopt words from other European languages including French, another Latin offspring. Latin was the official language of English courts and lawmakers and scientific texts, reinforcing the idea that English language and civilization owe everything to the Romans. There is some truth in the notion; and Latin certainly gave the English several words for money.

For a start, money comes from the Latin word *moneta*, a coin. Cash is derived via French and Italian from *capsa*, a box in which, presumably, the Romans kept their cash. (Alternatively cash is named after the small denomination coins of old China.) The scripted L which represents the British currency stands for *libra pondo*, a Roman unit of weight from which we also get the word 'pound'. Roman soldiers were sometimes paid at least partly in kind, with rations weighed out. Libra, as astrologers know, is the Latin for the scales on which rations were measured. An important part of those rations was a regular allowance of salt. The Latin word for salt is *salis*, from which we get the word 'salary', a regular payment.

Despite the impressively long influence of Latin on English financial life, the use of L as an abbreviation is relatively recent. The earliest example in the archives of the Bank of England is on a cheque written in 1661. That example also included the distinctive horizontal line across the letter; but the use of a simple L in upper or lower case persisted into the mid-nineteenth century. There is no distinction between the pound symbol with one line across it or two: the Bank of England itself has switched between the two in the printing of bank notes, and sometimes dropped the symbol altogether. The two-barred L was also the symbol for the Italian Lira (which is also a corruption of *libra*).

Before Britain switched to a decimal currency in 1971 (in which £1 = 100 pennies), the pound was divided into twenty shillings, and each shilling was worth twelve pennies and so £1 used to equal 240 pennies. This currency was known informally as L.s.d., the letters which headed the accounting columns of the pounds, shillings and pence. L stood for *librae*; S stood not for shillings but for *solidi*; and D, obviously not for pennies but for *denarii*. Solidi and denarii were gold and silver coins respectively of the Roman Empire, and the divisions of currency using their names was ordered by King Offa of Mercia in the eighth century, some four hundred years after the last Roman troops left British shores.

Offa's pounds, with their 240 pennies, had the great advantage of being divisible by 2, 3, 4, 5, 6, 8 and 10. This made it easier to calculate the price of fractional quantities of an item in trade, but harder to work out the exchange rate with decimal currencies. Luckily, much of Europe, including France, Germany, Italy and parts of Spain, also used an L.s.d. system, which only disappeared with gradual decimalization in the eighteenth and nineteenth centuries. Britain, Roman to the end, was the last to convert, in the late twentieth century.

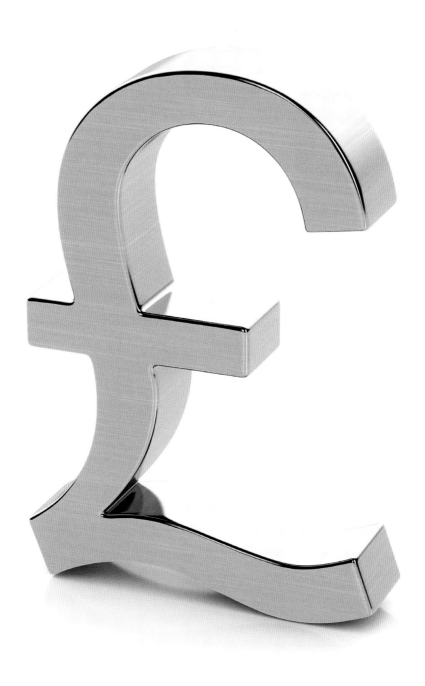

ABOVE: *Britain's unit of currency started out as the* Libra pondo, *hence the letter L*

Naval flag symbols

(1689)

There have been battles at sea ever since there were ships to fight them. There might be a plan of attack, but how can that plan be put into action? And how can a change of tactics be ordered? Until the invention of radio, the way for seafarers to communicate was by flags.

Smoke signals are vulnerable to the wind. Light is binary, either off or on; and before the signal lamp was invented in 1867 to transmit Morse Code, light was little more than a naked flame and hard to spot in the fog of cannon fire.

The Roman Empire had sophisticated signalling systems on land and sea; but it was the French Navy which, in the late seventeenth century, began to explore the possibilities of communication by flag. The Comte de Tourville published a series of books on the subject beginning with his 1689 treatise *Signaux Generaux pour les Vaisseaux de l'Armée Navale Du Roy* (General Signals for Ships of the King's Naval Army).

De Tourville died a national hero in 1701, having ensured the French navy's domination of the waters of Europe. After the French Revolution of 1789, however, a series of coalitions fought wars with France in the hope of restoring its monarchy. A British admiral, Sir Home Popham, devised a signalling system to rival de Tourville's, which was adopted by the British Royal Navy in 1803. Two years later at the Battle of Trafalgar it communicated Nelson's famous injunction, that 'England expects that every man will do his duty', and helped him to coordinate his fleet's tactics against the superior numbers of France. Although France remained dominant on the European continent, England took decisive control of the seas.

This dominance meant that it was a British proposal in 1857 which formed the basis of the International Code of Signals (ICS) now used across all the world's oceans. A review in 1920 sought to standardize the shapes of the flags and introduced the phonetic alphabet – Alpha, Bravo, Charlie, Delta and so on.

Today, flags representing letters are all square, with the exception of B Bravo – an all-red swallowtail flag still used as in the past to indicate that a vessel is carrying or taking on dangerous goods such as fuel or munitions. Numbers are shown by pennants – long triangles – while short triangles called fanions are used to indicate repeated letters.

Flags are distinguished by their unique combinations and divisions of colour – stripes arranged horizontally, diagonally or vertically; crosses at right angles or on the diagonal; squares within squares or arranged as a checkerboard, and so on. The ICS allows only three colours (red, dark blue and yellow) along with black and white. Green is too close to yellow and blue for a system in which the contrast between parts of a flag is vital to its understanding. Q Quebec is the only flag with only one colour – yellow. Although every letter now has its own flag, spelling out a lengthy sentence takes too much time and space. Flags were originally devised as shorthand codes for situations of which other ships needed to be informed. For example V Victor, flown on its own, means 'I require assistance'. Certain letter flags, when flown in conjunction with number flags, also indicate what the numbers refer to: for example, S Sierra means the numbers which follow are the ship's speed in knots. Other combinations expand the range of phrases available to the signaller: D Delta followed by X-ray, for example, means 'I am sinking'.

One of the most familiar flags, at least for British audiences, is P Papa, a large blue square with a small white one at its centre known as the Blue Peter. It was originally a summons, a sign when in port that all personnel should return at once to their ship since it was about to depart. Since 1958 it has also been the name of a BBC TV show, now the world's longest running children's television programme.

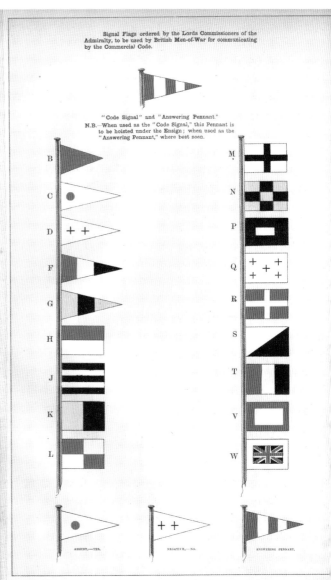

Signal Flags ordered by the Lords Commissioners of the Admiralty, to be used by British Men-of-War for communicating by the Commercial Code.

ABOVE LEFT: *Admiral Nelson's* HMS Victory, *ended its days in Portsmouth Harbour as a floating signal school. It was finally decommissioned in 1904.*
ABOVE RIGHT: *British Naval flag signals from 1873.*

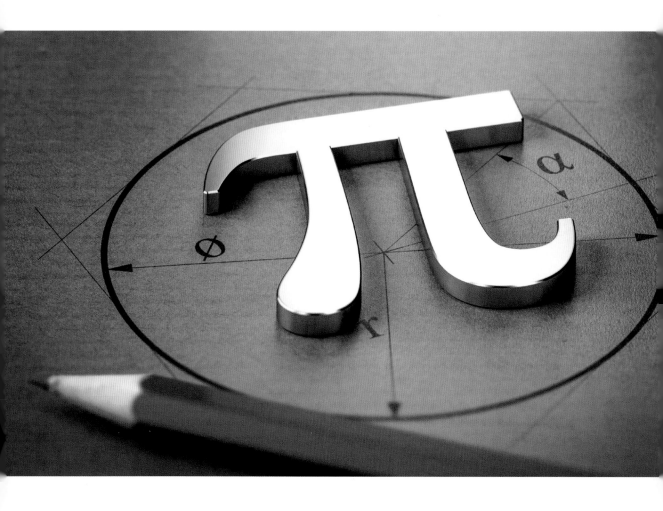

ABOVE: *The great mathematicians of history have tried their hand at calculating pi, including Archimedes, Vitruvius, Zhang Heng, Ptolemy, Fibonacci, and Newton. Euler suggested that the number might be transcendental.*

OPPOSITE: *A selection of suitable desserts for March 14th.*

Pi

(1706)

How do you write down a number that cannot be expressed? Although the concept of pi was known to Babylonian geometrists in the second millennium BCE, it wasn't until the eighteenth century that the widely used but unexpressable constant was given its own one-letter symbol.

The relationship between the diameter of a circle and its circumference is a constant: the circumference divided by the diameter is the number we now call pi, regardless of the size of the circle. Pi can never be calculated precisely – mathematicians call it an irrational number. Computers can now work it out to trillions of decimal places, but for almost everyone else, two is enough: pi is approximately 3.14, or (as Archimedes put it) somewhere between 223/71 and 22/7.

The number was known in the Middle Ages as *quantitas in quam cum multiflicetur diameter, proveniet circumferencia* ('the quantity which, when the diameter is multiplied by it, yields the circumference'), which mercifully gave way to the altogether snappier Archimedes' Constant. But if you're a mathematician writing out equations and calculations, eventually you tire of spelling out Archimedes' Constant when everything else on the page is a single character long.

The first recorded use of π (pronounced 'pie', the Greek letter p) in mathematics was by an English clergyman and mathematician, William Oughtred, whom we must also thank for inventing the sliderule, the multiplication sign (x) and the abbreviations for sine and cosine (sin and cos). In Oughtred's hands, however, π was shorthand not for Archimedes' Constant but for periphery or perimeter – the circumference of a circle. He used δ (delta, the Greek d) for the diameter, and thus the constant was, in Oughtred's terms, π/δ.

After Oughtred's death his papers were bought by another mathematician, John Collins, and some years after Collins' death they found their way to a Welshman, William Jones. Jones had honed his mathematical skills at sea with the British Navy, where he applied them to navigation. He was present at a number of sea battles against the Spanish fleet and while his fellow sailors grabbed the spoils of war in the form of gold and silver, Jones sought out rare books on the mathematical arts.

Jones retired from the sea in 1702 and in 1706 he published *Synopsis Palmariorum Matheseos,* a beginners' introduction to mathematics in which he used π not for the perimeter but for Archimedes' Constant, the first time this had been done.

The great Swiss mathematician Leonhard Euler, who is often credited with the innovation, did not start to use π until 1727. Even then, because he preferred to define π as the circumference divided by the radius (which is half the length of the diameter), he gave π a value of about 6.28. Nevertheless, Euler's fame during his lifetime ensured the widespread adoption of the symbol. By 1761 the whole world was agreed that π is (approximately) 3.14.

As if they had any need for a special day, mathematicians and other π aficionados celebrate Archimedes' Constant on Pi Day every year. When is that? March 14th, of course – 3/14.

Male/Female

(1751)

In our modern non-binary world the symbols for male and female gender have proved open to adaptation. Their origins can be traced to the prophecies of ancient Greek astrologers whose predictions were preserved and copied in the Byzantine era of the early Middle Ages.

The early sciences of astronomy and astrology overlapped. The astronomer/astrologer would be employed both to observe the movements of planets in the night sky and to make predictions for his employer – usually the local ruler – based on those observations. Among the stars were five planets visible to the naked eye: Mercury, Venus, Mars, Jupiter and Saturn; and to identify them in crowded star charts astrologers used symbols instead of words.

In second-century-CE documents, Saturn, the god of agriculture, was shown by a sickle; Jupiter, king of the gods, by the staff of authority; Mars, god of war, by a spear; Venus, the goddess of love, by two linked necklaces. Mercury, nearest to the sun and appearing therefore to move fastest across the sky, was associated with Hermes, god of business and thievery, and assigned the caduceus – two slippery snakes wrapped around a winged stave.

Over the following millennium these symbols evolved into ones we know today. Among them the spear of masculine Mars became a shield and raised spear, and the necklaces of feminine Venus evolved into a circle above a cross, which can be seen as either a necklace with a pendant or a handheld looking glass.

Five centuries later the great natural historian Carl Linnaeus, father of the modern classification system of plants and animals, published his *Philosophia Botanica* (1751), a definitive edition of his system. Looking for convenient symbols to indicate the perceived sex of plants in the reproduction of species, he settled on those already associated with masculine and feminine attributes – Mars and Venus. This is the first known example of the planetary symbols being used specifically to indicate gender. Linnaeus represented hermaphrodites (animals with both sexes of reproductive organs) with the symbol for Mercury.

Mercury and hermaphroditism are more usually depicted with a simple cross nowadays. The planetary

symbols have proved flexible in dealing with the twenty-first century acknowledgement that gender is less straightforward than being either male or female. Adaptations of them can now indicate transsexuality, male and female homosexuality and even asexuality.

Other indications of sex exist. Genealogists write male ancestors in a square and female ones in a circle when drawing up pedigrees. This convention was first used in 1845 by Dr Pliny Earle, a US physician who studied the occurrence of the inherited characteristic of colour blindness in his family tree.

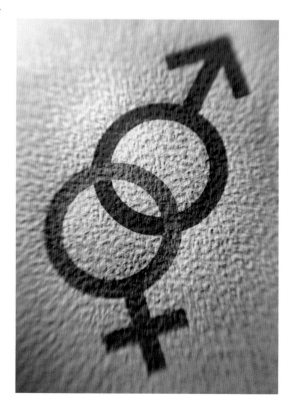

ABOVE: *The binary symbols of female and male are being rapidly reassessed in the twenty-first century with an acknowledgement that gender is far more complex.*

OPPOSITE: *A simple symbol tale of boy meets girl.*

US Dollar sign

(1778)

There have been many theories on the origins of the dollar sign, but the strongest weight of evidence is behind a lack of coinage, trade with the Spanish colonies, and clerks shortcutting the sign for the Spanish-American peso.

The United States of America formally adopted the dollar in 1792, sixteen years after the American Revolution threw off British rule. Before 1776 the official currency was the British pound with its divisions of shillings (twenty in a pound) and pennies (twelve in a shilling). In addition, some states issued their own pounds, shillings and pence, which varied in value against each other and against the official British coinage.

Coins were in short supply and for everyday practical purposes early Americans found other ways to trade – either through barter or with the coins of other colonial powers. The most common was the Spanish-American peso, which was called the Spanish dollar. The name was coined by Dutch and Bohemian settlers whose words *daaler* and *thaler* originally referred to coins minted in Sankt Joachimsthal, a silver-mining town in present-day Czech Republic.

Some historians suggest that the dollar symbol is derived from the Pillars of Hercules, which appear encircled by S-shaped banners in the Spanish coat of arms and sometimes on peso coins. Others claim that it has its origins on the Bohemian thaler coin, which portrayed a snake wrapped around a cross. Both explanations are plausible but neither is widely accepted.

The abbreviation for pesos was PS; and with frequent writing the P and the S gradually began to overlap each other. Over time only the vertical line remained of the P, over which the S was superimposed, and the dollar sign evolved. There is documentary evidence for this evolution in the correspondence of an Irish immigrant, Oliver Pollock, who built a successful trade network between Havana, then Spanish, and New Orleans, then French.

When New Orleans fell to the Spanish at the end of the Seven Years' War, Pollock's friend Alessandro O'Reilly, the Governor-General of Cuba, was made Governor of Louisiana. Pollock took advantage of his friendship with O'Reilly to become the largest trader in the American city. It is from Pollock's correspondence over the years that we can see the progress from PS to $, which first appeared in its final form in his letters in 1778.

The first typeface to include the dollar sign was cast in 1797 in Philadelphia by a Scottish immigrant, Archibald Binny. Binny, a passionate American, had been a printer in Edinburgh and he established the Philadelphia Type Foundry, America's first, to reduce the States' reliance on imported type from Britain.

LEFT: A dollar sign with a single downward stroke is a historically more accurate representation of the currency than a double stroke.

The Democratic donkey and the Republican elephant

(1828 and 1874)

Neither a donkey nor an elephant is a flattering self-image to adopt. It was the critics, not the supporters of the US Democrats and Republicans who chose those symbols of the two parties. One artist's persistent use of the animals as metaphors ushered in the modern age of the political cartoon.

Democrat Andrew Jackson was running for President in 1828. The election, a re-match of the 1824 contest, was notable for the level of character assassination attempted by both his party and that of his rival John Quincy Adams. In what could be seen as a predecessor of the attack adverts of the modern political era, his opponents started to call him Jackass instead of Jackson.

They hoped that the ridicule would belittle him in the eyes of the electorate, but Jackson took their jackass and ran with it. He incorporated it into his campaign literature and won by a landslide, becoming the Democrats' first incumbent of the White House. During his time in office the jackass was used as a metaphor for his stubbornness; and afterwards, a cartoon of a donkey refusing to follow Jackson was a symbol of the Democrats' reluctance to continue to be led by him.

During the Civil War the expression 'seeing the elephant' meant confronting the enemy and, by extension, thus gaining an advantage in battle. When the Republican candidate Abraham Lincoln was campaigning in 1864, his posters depicted an elephant waving Unionist victory banners.

The elephant turned up occasionally in cartoons thereafter, but was not yet indelibly linked to Republicanism. That connection was first cemented by Thomas Nast, a staff illustrator at *Harper's Weekly* magazine who was a German by birth and a Republican by nature. Nast was a frequent commentator

on the corruption among Democrats in Tammany Hall, and a supporter of rights for African Americans and American Indians.

The artist was a stern critic of the Democrats. Nast thought they showed little respect after the death in 1872 of the Republican Secretary of State for War, and drew a cartoon of a 'live jackass kicking a dead lion'. Two years later he depicted an elephant labelled 'Republican vote' trembling on the edge of an abyss of chaos because of the scaremongering of a lion, which was really a donkey in a lionskin (labelled as the pro-Democrat *New York Herald*).

This was the first explicit use of the donkey and elephant symbols together in the context of American politics. Nast repeated the combination in further cartoons and the animals became a shorthand eventually adopted by other cartoonists and political commentators of the day. Although neither is particularly complementary – the stubborn, stupid jackass and the nervous, slow-moving jumbo – both parties have accepted with good humour their zoological depictions and exploited them as best they can. Another Nast cartoon, from 1877, shows a solid elephant standing firm in favour of the Union.

At the Democratic Convention in Denver in 2008, where Barack Obama accepted his nomination as presidential candidate, the party even produced a real donkey, called Mordecai, on stage, as its official 'asscot'. To date the Republican Party has not reciprocated the gesture with a live elephant.

RIGHT: *Although introduced to poke fun at the Democrats and Republicans, their respective animals are now worn as badges of pride.*

OPPOSITE: *The adoption of the cartoon jackass and elephant as political symbols was a boon to American humour magazines, such as Puck.*

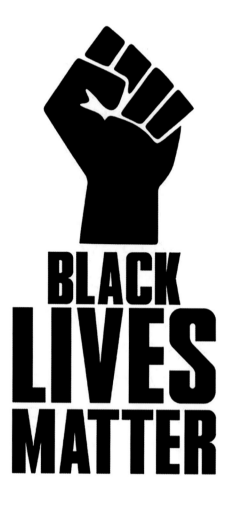

ABOVE: The Black Lives Matter campaign has re-introduced the symbol of protest that was core to protests by the Black Panther Party of the 1960s.
LEFT: Founded in 1924, the Red Front Fighters' League was a left-wing paramilitary organization associated with the Communist Party of Germany.
OPPOSITE: Honoré Daumier's seminal painting The Uprising.

Clenched fist

(1848)

A clenched fist is an inherently aggressive gesture. It is not a handshake or a wave. It suggests a punch, and it has been adopted by anti-authoritarian groups as a gesture of defiance since at least the mid-nineteenth century. The Black Lives Matter movement is its latest incarnation.

A contemporary painting of the French coup d'état of 1848 shows a man in an advancing crowd, his fist punched upwards against an oppressor bearing down. Honoré Daumier's painting *The Uprising* may be the first recorded example of a symbolic clenched fist. In the early twentieth century a Hungarian poster called workers to strike by showing a muscular forearm and clenched fist rising from a crowd of men to threaten the country's parliament. At the same time, in America, union organizer Big Bill Haywood was using the metaphor of a powerful fist compared to a weak individual finger to urge collective action in a strike at a silk mill in Paterson, New Jersey.

In the wake of World War I the clenched fist was taken up by several anti-fascist groups as a formal salute or greeting. The Red Front Group, or Roter Frontkämpferbund (opponents of the Nazi Party), did so in Germany, prompting the Nazis to adopt the familiar open-handed out-stretched arm used by the Roman Empire. The fist was used by the Republicans during the Spanish Civil War in the late 1930s, and from there it spread to Mexico, where a revolutionary print shop began to use the gesture in its poster designs.

From Mexico, posters found their way into the US, where the salute was taken up by radical student organizations and eventually by members of the militant Black Panther Party, representing that most oppressed of groups, America's black community. Its use by black athletes on the victory podium in both the 1968 and 1972 Olympic Games shocked onlookers but very effectively drew the world's attention to their fight for equality.

Since then the fist has been used by many and diverse groups of citizens who see themselves as suppressed by another sector of society. It has featured on posters for everyone from feminists to librarians, and by those with aspirations at both ends of the political spectrum. In Northern Ireland, for example, it has been used by both the Protestant and the Catholic factions. While most associated with Black Power, a fist depicted in white instead of black has been a rallying symbol for extreme white supremacists too.

It was urgently reclaimed by black Americans in 2020, following the horrifying death of George Floyd under the knee of a white police officer in Minneapolis. It seemed to a watching world as if no progress had been made in the matter of racial equality in America since the 1960s, and that a black man's life meant less than a white's in the eyes of the law. George Floyd's last words, 'I can't breathe', were shouted in violent confrontations with police forces throughout America, where protesters once again raised the clenched fist of resistance. The slogan 'Black Lives Matter', accompanied by a clenched black fist of solidarity, quickly spread across the US and beyond into the rest of the world. Time will tell whether, sixty years after the symbol's first use in the fight against racial discrimination, Black Lives Matter's black fist will bring about meaningful change.

The Confederate Battle Flag

(1861)

The aptly named battle flag of the Confederate State of America has itself been a battleground for much of its history. It has meant different things to different groups of people, from its invention in the American Civil War to its presence during the storming of the Capitol.

At the first Battle of Manassas in July 1861, the opposing American armies carried their own flags – which were unfortunately very similar. Both the Stars and Stripes of the Union forces and the Stars and Bars of the Confederacy consisted of a main field of red and white horizontal stripes, and both had a canton (a box in the corner) with gold stars in it. From a distance it was hard for commanders and tacticians to distinguish between them as they observed the ebb and flow of the fight. (For the record the Confederates won, despite the further confusion of many Confederate regiments carrying their own local flags as well as the national one. Plus the fact that their uniforms had yet to be fully differentiated between the blue and the grey.)

Rather than abandon the Stars and Bars, which had been adopted only two months before the battle, Confederate General P. G. T. Beauregard made the argument for designing a second flag, to be used only on the battlefield. The design on which Beauregard settled came from no particular tradition among the southern states but was very effectively different from the Stars and Stripes. The blue diagonal St Andrew's Cross could not be mistaken for any set of parallel red lines; nor could the disposition of the stars along the diagonals (thirteen, one for each secessionist state) be confused with a canton in a corner.

It was an altogether bolder flag, especially when used in the form of a square rather than a rectangle – a decision originally made to save money on cloth. When it was presented to Confederate troops of General Robert E. Lee's Army of North Virginia in November 1861, it was met with enthusiasm. Nicknamed the Southern Cross, it led Confederate soldiers into battle for the remainder of the four-year-long war. A rectangular version with a slightly lighter shade of blue was adopted by the Confederate Navy in 1863.

At the conclusion of the Civil War the Confederacy was dissolved and, by and large, efforts were made to leave the nation's divisions behind. The Battle Flag, never officially adopted by the Confederate Congress, nor even by any of its soldiers' Veterans Associations, became a relic of the past. Then, in 1948, it found a new public role in the hands of a political party called the Dixiecrats, a southern states breakaway group of segregationist Democrats opposed to equal rights for African Americans.

Although the Dixiecrats soon disappeared, the association of the flag with the attitudes of the Civil War South had been renewed. As the Civil Rights movement grew in momentum during the 1950s and 1960s, so too did the use of the Battle Flag by those who resisted it, including a resurgent Ku Klux Klan.

Despite the long-standing success of the Civil Rights movement, this old rip in the fabric of the nation has been re-opened. The flag has become a strong symbol of what some call the heritage of the Southern States and others call racism. It represents an unwelcome division in the country which neither side can heal through compromise. In 2020, Mississippi became the last state to drop the Southern Cross from its flag, where it had been a canton since 1894. In the same year, the US Navy and the Marine Corps banned its use.

It's no coincidence that America's first Black president, Barack Obama, was succeeded by the anti-immigrant Donald Trump. The identification of the flag with so-called white supremacy has seen its use spread beyond the USA to right-wing groups in central and eastern Europe; and closer to home Confederate Battle Flags were among the banners carried by the insurrectionists who stormed the Capitol in Washington DC on 6 January 2021, in the hope of overturning Trump's defeat after one term.

ABOVE: *The Southern Cross was designed to be a Confederate symbol on the battlefield, but today it is used to encourage division and create new battlefields.*

LEFT: *General Pierre Gustave Toutant-Beauregard led the attack on Fort Sumter in Charleston Harbor that sparked the Civil War, and was responsible for commissioning the Southern Cross.*

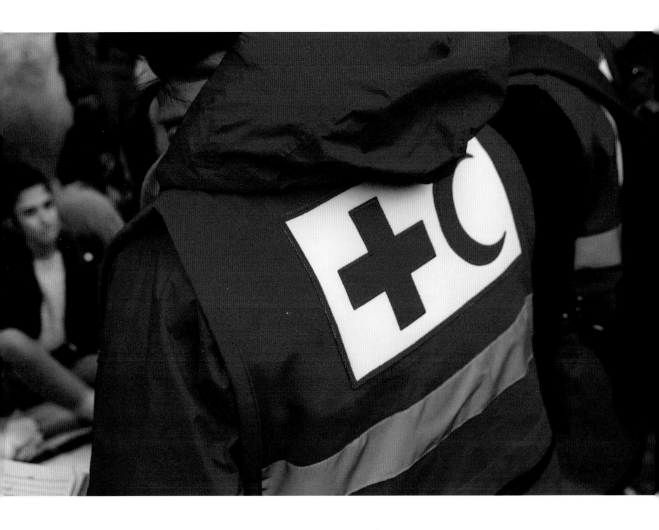

ABOVE: *Red Cross/Red Crescent workers carrying the dual symbol in Sofia, Bulgaria.*
LEFT: *Flags flying outside the International Red Cross and Red Crescent Museum, Geneva, Switzerland.*

Red Cross and Red Crescent

(1863 / 1876)

The bloody Battle of Solferino in 1859 was significant for many reasons. It resulted in the expulsion of the Austrian Empire from the Italian peninsula and the eventual unification of the many Italian kingdoms into one country, Italy. It also led directly to the foundation of the International Red Cross.

The Battle of Solferino was fought between Austria and the combined forces of France and the Kingdom of Sardinia as part of the Second War of Italian Unification. It was the last battle in history to be conducted under the personal supervision of the monarchs of the countries in question: France's emperor Napoleon III, Sardinia's king Victor Emmanuel II and Austria's emperor Franz Josef I.

Elsewhere in the world a Swiss businessman, Henri Dunant, was trying to get a corn-trading scheme off the ground in the French colony of Algeria. Encountering a lack of cooperation from the colonial authorities, he decided to appeal directly to their boss, Napoleon III. War or no war, he travelled to meet the French emperor at Solferino, arriving on the evening after the battle had been concluded.

By such coincidences the world changes. The following day he visited the battlefield and was horrified by the 40,000 dead and injured of both sides who had simply been abandoned where they fell. He took it on himself to rally the women of Solferino to their aid, personally paying for medical supplies and helping to erect a field hospital, in which they tended the injured regardless of nationality. Dunant negotiated the release of Austrian medical personnel being held prisoner by the French to help with the humanitarian effort.

Back in Geneva, Dunant wrote a book of his experiences in Solferino, in which he called for every country to establish a voluntary service to treat the wounded of future wars. Such volunteers, and their patients, should be protected from danger on the battlefield. Five men formed a committee in 1863 to consider Dunant's ideas and proposed a single internationally recognizable symbol by which first aid volunteers could be recognized. Switzerland's neutrality in wars was by then well established and its flag, a white cross on a red background, was a starting point

for discussions. By simply reversing the colours the committee also incorporated the accepted convention of the white flag of truce. Thus the Red Cross was born.

Dunant's achievement goes further. At a conference in Geneva the Red Cross and the protection afforded its volunteers were written into international treaties. This marked the beginning of modern humanitarian law, and the Geneva Convention still guarantees the safety and fair treatment of prisoners of war and the injured.

The Convention was put to the test during war between Russia and the Ottoman Empire in the 1870s. Although the Red Cross is a non-religious organization, its roots as a symbol on the Swiss flag are undoubtedly Christian; and the Muslim troops of the Ottoman Empire took exception to it. While continuing to guarantee the safety of Russia's Red Cross, the Ottoman equivalent flew a red crescent instead, borrowed from the crescent and star of the Ottoman flag. Today, more than twenty national first aid organizations around the world use the crescent.

Matters were further complicated when Persia, a rival in the region of both Russia and the Ottomans, rejected both the cross and the crescent in favour of the emblem of its own flag, a red lion and sun. Although Persia was admitted to the International Red Cross and Red Crescent Movement in 1923 with the lion and sun, it was agreed that, for the sake of clarity in the fog of war, no further new symbols would be allowed; and when the Shah of Iran was overthrown in 1979, it dropped the lion and sun in favour of the crescent.

The Movement still longed for a single unifying symbol for its work, and in 2005 it launched the Red Crystal, a diamond-shaped outline in which a cross, or a crescent, or a cross *and* a crescent, or no symbol at all, may be displayed. To date it is not clear whether this will end confusion or increase it by adding a third, unfamiliar symbol to the list of humanitarian signs to be protected in time of war.

Anarchy

(c.1865)

A is for Anarchy in many languages. Although the concept of anarchy is often misunderstood, there's no mistaking the simple symbol of an A in a circle, as adopted by nihilists, punks, students and anarchists all around the world.

Anarchism is a nineteenth-century phenomenon, which took shape with the industrial age and the resentment of the working man for the exploitative conditions of his employment. One way or another, the working classes sought ways to influence the society and government under which they lived.

Often confused with mere chaos, anarchism advocates the abolition of the state in favour of everyone acting individually for the common good. Its natural enemy is capitalism, but it also opposes communism because of that ideology's belief in state control. Its earliest proponents were the French socialist Pierre-Joseph Proudhon, who gave the world the phrase 'property is theft' – and Mikhail Bakunin, a radical Russian who declared that 'the urge for destruction is also a creative urge'. Bakunin favoured the violent overthrow of state, Proudhon a more peaceful means to that end.

Because all governments at the time were more or less conservative and capitalist, their opponents – all more or less left-wing – tended to gather under the same banner, a red flag. As differences between socialists and anarchists became apparent, the latter adopted a black flag, the first true symbol of anarchism and an explicit negation of the colours and patterns of state.

The earliest example of the circle-A symbol in an anarchist context was a design for the Federal Council of Spain of the International Workers Association (pictured right), whose name was incorporated in the elements of the letter A and the ring around it in the 1860s. There is photographic evidence of the circle-A on a soldier's helmet during the Spanish Civil War of the 1930s.

In the 1960s the symbol was adopted by Jeunesse Libertaire, a French anarchist group, and by Circolo Sacco e Vanzetti, an anarchist cell in Milan named after two Italian immigrant anarchists who were sentenced to death in Massachusetts in 1921. (The pair were also honoured, curiously, in the name of a state-sponsored fountain pen brand in communist Russia.)

The circle remained relatively unknown until the late 1970s, when it was adopted by the punk music movement, whose iconoclastic attitude to the pop music industry was distinctly anarchic. It's no accident that the Sex Pistols' first release was the song 'Anarchy in the UK'. Other groups espoused the political ideology; for example the band Crass, founded by singer Steve Ignorant, who first saw the circle-A symbol while on tour in France. Crass's brand of anarchy was all-encompassing, and included anti-fascism, animal rights, feminism and direct action in its aims.

Retaining full control of their recordings and promotion, Crass promoted anarchy by genuine example. But as punk music spread around the globe, the circle-A and anarchism itself became confused with a nihilistic rejection of everything, without necessarily considering alternative arrangements for human co-existence.

Real political anarchism remains a minority pursuit. Some see the circle-A symbol as an A in an O, a reference to Anarchy and Order in Pierre-Joseph Proudhon's definition of anarchism. In his 1840 book *What Is Property?* he wrote that 'as man seeks justice in equality, so society seeks order in anarchy.'

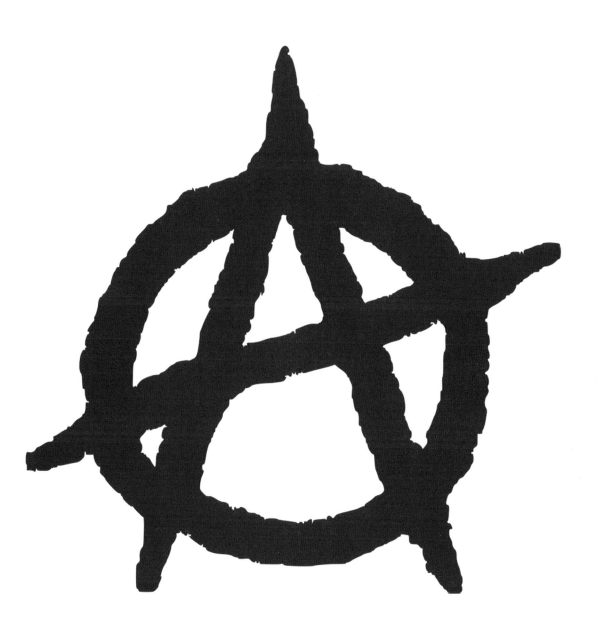

ABOVE: A punk version of the circle-A symbol. The poster slogan for anarchists has long been 'no gods, no masters' and reliance on self-rule, although it is regularly used in the context of absolute chaos and no rule.

Motor racing flags

(1865)

Men have been racing in motor cars ever since they invented them. The history of motor racing is very much a balance between the thrill of speed and the need for safety. Waving a warning flag is one way of catching a speeding driver's eye.

Flags have been used as symbols representing and identifying strongholds, armed forces and nations for thousands of years. Their fluttering shape is more effective in drawing attention than a static signpost; and their visibility has often been exploited for the purposes of communication over long distances. Flag signals were a well-established means of messaging at sea, when the first motor race was run between Ashton-under-Lyne and Manchester in the north of England.

That race was run, paradoxically, without the use of a red flag, which was already a legal requirement. Since 1865, cars, already recognized as dangerously fast, had been required by British law to drive behind a pedestrian marshal waving a red flag to warn others of their approach. The law was designed for railway locomotives, and the two cars which raced along that northern English road were, like locos, powered by solid-fuel steam engines.

By the time of the first formal racing contest, from Paris to Rouen in 1894, most cars were powered by internal combustion. The winner's steam-driven machine was disqualified for requiring the services of a stoker, and the team champions, Peugeot and Panhard, were assessed on safety and handling as well as on speed.

These early races were run on public roads, in a time before the plethora of road traffic safety signs we see today. When competitions moved onto private circuits – either horse-racing tracks or purpose-built motor rings, organizers were free to devise their own safety systems. Flags, so effective at sea, were seen as an efficient signalling system.

Today there is still no universally recognized flag code, and different umbrella organizations have their own small variations. But some flags are universally understood: a red flag, always the colour of danger, means Stop! because a driving session (race or practice) is suspended. Green, perceived as the opposite of red, means Go!, either at the start of a race or, in the case of Formula 1, after a previous warning has been lifted.

There are a variety of warning flags. One yellow flag alerts drivers to a hazard on or near the course; two tell drivers the hazard could be blocking the road ahead. A blue flag asks drivers to allow a faster vehicle behind them to pass. For motorcycle events, a white flag indicates that a race has been declared officially wet, and that riders may therefore switch to bikes with more appropriate tyres. In NASCAR and IndyCar races, however, a white flag announces the last lap.

Black, traditionally the most threatening of colours, tells a driver they must return to the pits, either for a mechanical fault or because of disqualification. A chequered black and white flag, however, as even those with no interest in motorsports know, is the flag a driver longs to be the first to see – it means the end of the race, waved as the winning vehicle crosses the finish line.

Today's racing drivers and riders have signal lights among their controls and radio communications from their teams. Coloured lights and digital signs are replacing flags as their source of information around the track. But flags remain important in races on smaller circuits, where the comprehensive safety infrastructure of a dedicated circuit is not available; and during any event spectators still rely on flags to give them information and drama.

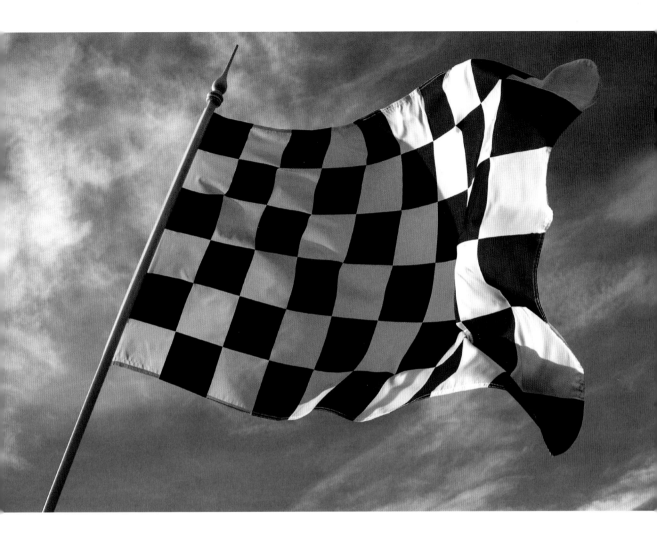

ABOVE: *The chequered flag signalling the finish of a motor race has been adopted as an 'end' symbol in other spheres – particularly SatNavs.*

LEFT: *A selection of warning flags at a race marshal's post. Two yellow flags are needed to give the signal 'double-waved yellows' which means, 'slow down; be prepared to stop'.*

Japanese Yen/Chinese Yuan

(1871 / 1889)

The peso, the so-called Spanish dollar, exerted its economic power on the countries of the western Pacific coast as much as on the Americas. Both the Chinese Yuan and the Japanese Yen were devised in the nineteenth century in imitation of the peso's popularity.

The Spanish dollar, also known as a piece of eight because it was worth eight silver reales, circulated widely in the Pacific region from the seventeenth century onwards thanks to the Spanish Empire's influence in the Philippines and Guam. Its general use there and in North and South America made it the first truly international currency.

As South American countries began to win their independence from Spain, they minted their own 'Spanish' dollars. Mexican pesos, minted from silver mined in Bolivia and Peru, gradually replaced the Spanish coins; and Hong Kong was the first Asian region to start producing its own silver dollars in imitation of Mexico's. It abandoned production, however, when the large Chinese economy rejected it in favour of the more familiar Mexican version.

Japan promptly bought up Hong Kong's minting machinery and in 1871 the country's new Meiji regime launched a new currency, the yen, as part of its efforts to modernize Japan's economy. Before that point every Japanese feudal fief had its own currency which bore no relation to its neighbours' or to other countries' money – a chaotic system which severely limited internal and export trade. The word *yen* means 'round': the new yen coins were all circular, some (as above) with round holes in them, while earlier Japanese coins had square holes, and some were oval in shape.

China, meanwhile, had managed a reasonably unified currency since the second century BCE. It was the first

country to introduce paper money, in the tenth century CE. It also used round coins with square holes, called cash, which were threaded together on strings to make larger units of currency. China launched its new currency, the yuan, in 1889 with coins produced at the newly built Canton Mint. Each yuan was worth ten jiao; each jiao ten fen; and each fen ten cash. So you would have had to string together a thousand cash to make a yuan.

Yuan is etymologically the same word as the Japanese yen and the Korean currency, the won. These countries have their own scripts, and their own characters to denote their currencies, generally unreadable in countries which use Latin or Cyrillic alphabets. Both the yuan and the yen became among the top ten traded currencies in the world, and a more widely recognized Latin symbol was required for the international money market.

In Japan the word is actually pronounced 'en'. But Europeans have said 'yen' for so long now that when it came to designing a Latin symbol for the currency, China and Japan settled on ¥, in acceptance of Europe's mispronunciation and in imitation of the USA's $ and the UK's £. Like those symbols, the use of one line or two across the Y of ¥ is at the discretion of the user or font designer. The Korean won, introduced in 1902, now exists as two separate currencies for the North and South of the country. Both have a similar Latin symbol, ₩.

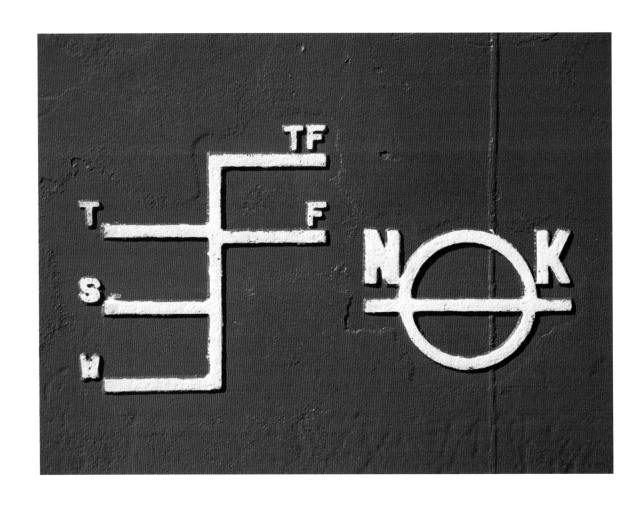

Plimsoll Line

(1876)

By international agreement all ships now carry the International Load Line painted at water level on either side of their hulls. It is still known in many countries as the Plimsoll Line, but few people outside the maritime community know the origins of its contribution to safety at sea.

Several maritime nations in the Middle Ages adopted the practice of a safe loading line on ships, including the Venetian Republic and the Hanseatic League. In the nineteenth century, however, unscrupulous ship owners habitually overloaded their vessels to dangerous levels in order to maximize the profits from each voyage. Such ships, known as coffin ships, were often lost at sea with their crews; but, anticipating such an event, owners often over-insured their ships so that they profited even from tragedy.

In Britain, attempts to legislate against the practice were at first scuppered by the fact that many of those unscrupulous owners were also powerful members of the British Parliament. It took some very unparliamentary behaviour from a campaigner with no connection to the sea to shame the government of the day into changing the law and saving thousands of sailors' lives.

Samuel Plimsoll (1824–1898) was born in the port of Bristol but spent his early adulthood as a brewery manager in Sheffield, about as far from the sea as you can get in England. He saw an opportunity to become a coal merchant in London, but the move was unsuccessful and for a time he was destitute. He saw poverty from within and became determined to improve the lot of the poor when his own fortunes improved. Many of those with whom he shared lodgings were sailors down on their luck, who spoke of the coffin ships.

Plimsoll was elected a Member of Parliament in 1867. It was a time when industrialization and the expansion of international trade were accompanied by an increase in the number of ships sinking under the weight of too many exports. Plimsoll immediately introduced a Bill to regulate the condition and capacity of merchant ships but was defeated by the maritime interests of his fellow MPs. Several ship owners took him to court in attempts to neutralize his threat to their livelihood; but he became known as the Sailors' Friend.

Undaunted, he wrote a book about the working conditions of British sailors, *Our Seamen*, which became a best seller. With attention thus drawn to the industry, he persuaded Parliament to investigate it through a Royal Commission and, in 1873, to introduce a government Bill. When the Prime Minister Benjamin Disraeli announced his intention not to proceed with the Bill, Plimsoll was so enraged that he shook his fist in the Speaker's face and described some of the ship-owning MPs as villains.

This behaviour broke parliamentary convention and Plimsoll was forced to apologize publicly. Thanks to his book he had public sympathy on his side and in 1876 the government was forced to reintroduce and pass the legislation which eventually became the Merchant Shipping Act. Its most visible result, a diagram of safe loading levels to be calculated for each ship and painted at the water line on both sides of the ship's hull, became quickly known by grateful sailors as Plimsoll's Line.

There are, in fact, several lines in the symbol, reflecting the varying buoyancy of different waters – saltwater, freshwater, tropical oceans compared to temperate ones, winter seas compared to summer ones. A line through a circle was included to show whether the ship was evenly loaded fore and aft.

The highly visible Plimsoll Line meant that anyone could see at a glance if a ship was overladen. It became compulsory on British ships from 1894, and on foreign ships entering British ports in 1906. At a convention in 1930 fifty-four nations adopted the mark.

After he left Parliament, Plimsoll was made the honorary president of the sailors' trade union and turned his attention to the appallingly overcrowded conditions of cattle ships. In the early twentieth century a type of rubber and canvas shoe also known as a sand shoe or deck shoe was nicknamed the plimsoll – because it was only watertight up to a certain level.

Football club badges

(1888)

Nowhere does the human instinct for tribalism find its expression more strongly than as a supporter of a football club. The most popular English clubs attract fans from around the globe who will never visit the team's home town. But a club's badge can tell even the most remote follower something of its history.

Manchester United Football Club (MUFC) has fans about as far away from the northern English city of Manchester as it is possible to be. Like many English clubs its badge is derived from the coat of arms of the city, which depicts a sailing ship above three diagonal yellow lines on a red background. In the 1960s, United acknowledged its nickname, the Red Devils, by replacing the lower half of the crest with a scarlet demon. Local rivals Manchester City FC also retain the city's sailing ship, above the red rose which represents the county of Lancashire of which Manchester was once a part.

Lancashire's historic enemy, its neighbour Yorkshire, displayed a white rose, and the long-running conflicts between the two were known as the Wars of the Roses. Today the badge of Sheffield United FC, in the heart of Yorkshire, is a white rose above a pair of crossed swords, a reference to Sheffield's traditional skill at making blades for weapons and cutlery; the club's nickname is the Blades. Arsenal, another club represented by weaponry, was originally formed by workers at the Royal Arsenal in Woolwich, London, where they made cannons for the British Army. A cannon has featured on the club's crest since 1888, and it's no surprise that this club's nickname is the Gunners. Another London club, West Ham United, known as the Hammers, also displays the tools of its trade on its badge. They are rivet hammers, a reference not to the club's name but to the employment of its founding players at the Thames Ironworks, which built the world's first all-iron warship, HMS *Warrior*, in 1860.

Liverpool FC, Manchester United's frequent rivals for many of football's highest honours, are one of many English clubs to portray a bird in their badge. In Liverpool's case it is the liver bird, a mythological creature whose history encapsulates that of the city of Liverpool. It began life as an eagle on the city's seal in the thirteenth century but gradually changed shape until it more closely resembled a cormorant. Liverpool's local rivals Everton were actually the first club to use the liver bird, but since the 1930s their badge has shown a local landmark, the Everton Lock-Up, which served as a holding cell for drunks, thieves and perhaps football fans in the eighteenth century.

Norwich FC's bird is a canary – the club is nicknamed the Canaries, a name also reflected in its bright yellow home strip. But the name actually derives from the locally popular hobby of keeping caged canaries, at a time when the strip was blue and white. Much humour was derived from a 1907 fixture between Norwich and West Bromwich Albion (WBA), both of whom sported a bird badge. In WBA's case it is a throstle, a song thrush. The pub where the WBA players used to drink in the early days of the club's history used to keep a caged thrush in the bar, and for many years WBA played with a caged thrush on the touchline during matches. It was said that the football-loving bird only sang when its club was winning.

These days a footballer's most frequent celebration after scoring is to grab the badge on his shirt and kiss it. So in 2021 when Puma redesigned the club shirts of Fenerbahçe, Manchester City, AC Milan, Borussia Dortmund, Marseille, Valencia and PSV Eindhoven, the club crest had been moved from its usual position and used instead as a repeating pattern along the jersey. In the first matches in the kit, the footballers who scored, pulled their shirts forwards but then couldn't find anywhere to kiss...

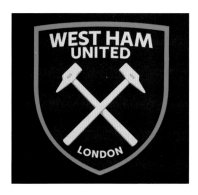

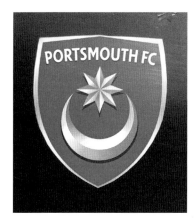
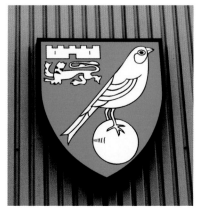

TOP: Two church icons from the Ordnance Survey, on the left with a spire,
on the right with a tower.
ABOVE: Despite the introduction of mapping on mobile phones, paper maps are still a
reassuring guide for walkers … and their batteries never run out.

Cartography symbols on OS maps – the church

(1892)

Maps, two-dimensional representations of the world present the greatest concentration of symbols in everyday use. The detailed maps of Great Britain and Ireland, first surveyed 275 years ago, have developed a rich vocabulary of signs for the natural and man-made landscape.

Many nations now have similar comprehensive mapping of their lands, but few can rival the UK's Ordnance Survey (OS) series of maps for accuracy and detail. In the digital age, OS enters around 20,000 updates every day, and in addition to permanent features it now includes a wealth of information about leisure activities.

Like most maps, the OS series was originally produced for military purposes. 'Every prince should have a draught of his country and dominions,' wrote Thomas Burnet in his 1684 work *The Sacred Theory of the Earth*. 'Such a map or survey would be useful in time of war or peace, and a good many observations might be made by it.' In the case of the Board of Ordnance, responsible in the eighteenth century for Britain's defence, the original survey was prompted by the need to control rebellious Scotsmen after the defeat of their hero Bonnie Prince Charlie at the Battle of Culloden in 1745. Focus soon switched to England's south coast, however, which faced the very real possibility of a French invasion.

Only in 1972 did the OS become a wholly civilian operation, and it is now fairly independent of government, required to cover its own costs and pay a proportion of its profits to the UK Treasury. Its symbols, as well as its status, have changed over the centuries. In its lifetime it has seen the invention of railways and airfields, the creation of reservoirs, the loss and reclamation of coastal land and a constantly expanding urban landscape. Of all the different types of building represented in its maps, most are shown by a general outline with initials indicating any special use: P for Post Office, TH for Town Hall, and so on. Only a very few have their own symbol, generally those with a distinctive visual or social presence in the landscape: radio masts, windmills, lighthouses, commercial glasshouses, bus and train stations – and churches.

Churches have always been designed to stand out. In the nineteenth century, when Christian worship in Great Britain was at its height, many old village churches were rebuilt as acts of piety, and many new churches were built to serve new urban communities. In addition, the rapid spread of different doctrines of Christianity – Baptists, Methodists and other non-conformist denominations – meant mapping more places of worship per head of population than ever before.

Churches were indicated by a simple cross in the first generally available OS series, which mapped the country at a scale of one inch to the mile. Known as the One-Inch maps, they proved extremely popular with the new breed of ramblers – people who walked long distances simply for the pleasure of walking. And so for the first revision of the One-Inch series, completed between 1892 and 1908, the OS introduced two new symbols, for churches with either spires or towers. This was a boon for ramblers walking across a landscape with many villages, because the very visible spires or towers of village churches helped them to navigate towards the right one. Churches with neither feature remained a simple cross on maps. Windmill and lighthouse symbols were added from 1896, and the new series also introduced P for Post Office and T for that modern innovation the Telegraph Office.

Landscapes represent the society that lives and worships in it. In the changing urban landscape of the multicultural twenty-first century, the three church symbols are still in use on OS maps: but they now represent a more general 'place of worship', and what once showed a church with a spire now indicates 'a place of worship with a spire, minaret or dome'.

Hammer and Sickle

(1895)

Inseparable from the ideology of the Soviet Union, the image of the hammer and sickle was chosen in 1917 to represent the unity of industrial and agrarian workers. But the oldest known use of the design was twenty years earlier and on the other side of the world…

In the aftermath of the 1917 Russian Revolution, May 1st became especially significant as a celebration of the power and dignity of labour. Political leader Vladimir Lenin ran a competition to design a motif for May Day 1918. The winner was Yevgeny Kamzolkin, a thirty-three-year-old artist from Moscow.

Kamzolkin's credentials were impeccable: he was descended from serfs, slaves attached to the land on which they worked and whose owners changed whenever the land was sold. He delivered a motif in the style of an imperial coat of arms, subverted to portray the overthrow of the Russian imperial class.

In Kamzolkin's version, a wreath of harvested wheat was bound in ribbons which carried, in six languages, the slogan 'Proletarians of the world, unite!' In the centre of the wreath a globe basked in the rays of the (presumably communist) sun. Imposed across the map of Europe were a crossed hammer and sickle where in a more conventional crest a Christian cross might have been, implying that communism ruled not by divine right of any god but by the will and power of the people. Above this powerful collage of imagery Kamzolkin placed one final icon, the guiding red star of communism.

In the wake of violent revolution, the artist also included a rifle in his design, which Lenin rejected.

Otherwise the design was such a perfect encapsulation of worker power that in 1923 the Central Committee of the Soviet Union adopted it as the symbol of the USSR.

Workers' tools are obvious choices as symbols for any movement rising up against its ruling classes. As the tide of communism spread around the world in the wake of the Soviet Union, many countries adopted Kamzolkin's imagery; and with the collapse of the ideology, many countries have now banned its use.

Surprisingly, the first recorded use of the hammer and sickle combination occurs not in the northern hemisphere but in the most southerly country on Earth – Chile. In the wake of a civil war in 1891 which pitted the nation's navy against its army and its congress against an autocratic president, a more democratic form of government emerged. The president and his wealthy foreign financiers were defeated and in 1895 a new One Peso coin was introduced. It depicted the national bird, the Andean condor, on one side and on the reverse a laurel wreath with a crossed hammer and sickle at its base. The design remained in circulation until 1940.

TOP: The hammer and sickle appeared on the Chilean One Peso coin from 1895.
ABOVE: Yevgeny Kamzolkin's award-winning design.
OPPOSITE: A Russian poster from c.1918.

No. 685,957.

N. TESLA.

Patented Nov. 5, 1901.

APPARATUS FOR THE UTILIZATION OF RADIANT ENERGY.

(Application filed Mar. 21, 1901.)

(No Model.)

Fig.1

Fig.2

Fig.3

Fig.4

Witnesses:

Inventor

Nikola Tesla

by Ker. Page & Cooper Attys.

ABOVE: One of Nikola Tesla's original patent applications from 1901 showing electrical earth as a triangle of ground. OPPOSITE: The symbol for electrical earth that is in use today.

Electrical Earth

(1901)

When the International Electrotechnical Commission (IEC) set about defining the standard symbols to be used in circuit diagrams, it consulted the leading figures in the field. Edison and Marconi both contributed advice and suggestions; and we owe the Earth symbol, among others, to Nikola Tesla.

Nikola Tesla (1856–1943) was born in Croatia, then part of the sprawling Austrian Empire. He became fascinated by electricity thanks to the demonstrations of his teacher at high school, and his father promised to send him to engineering school if he recovered from a dangerous bout of cholera at the age of seventeen.

He studied in Graz, in southern Austria, where he worked so hard that his tutors feared he would die of exhaustion. Tesla dropped out after he became addicted to gambling, but eventually found work in the electrical industry: he was chief electrician at the Budapest Telephone Exchange, and later a lighting engineer for the Continental Edison Company in Paris. He performed so well there that he was offered a job in the Edison Machine Works in Lower Manhattan. There he worked on a street lighting utility, but quit when his design for efficient arc lighting was not put into production.

Now his own boss, he designed generators and motors and developed the use of alternative current (AC), a better means of carrying electricity over long distances, which was gaining ground in Europe. Edison, in contrast, was committed to the very high voltages required by direct current (DC). Tesla won the battle of the currents.

Tesla applied for many patents in his lifetime and the applications were lodged with detailed circuit diagrams. Although there was as yet no standard way of drawing them, Tesla had his own style of notation, derived from the precise technical drawing required of him at engineering school in Graz. He was therefore a person of considerable interest to the IEC when the Commission was researching electrical symbols.

A study of Tesla's surviving diagrams shows the development of his symbols. What began as actual representations of circuit components became more symbolic over time. His Earth symbol is a case in point. A drawing from 1900 titled 'Apparatus for Transmission of Electrical Energy' includes a picture of an electrical terminal embedded in a rectangular cross-section of ground. A year later the picture has been simplified: the terminal is much smaller and the cross-section is triangular. Remove the terminal altogether and Tesla's Earth symbol is identical to the one adopted by the IEC.

The same is true of several of Tesla's notations. From a historical perspective this legacy has the additional benefit of making Tesla's diagrams easy to read and understand today, 120 years after they were drawn.

Tesla died in poverty after the funding failure of an ambitious experimental wireless transmission station on Long Island. In life he had been quite a showman, but in death his work was largely unknown to the public until it was rediscovered in the second half of the twentieth century. The SI unit of magnetic flux density was named the tesla in his honour in 1960, and in the 1980s and 1990s he began to make appearances in science fantasies and graphic novels. David Bowie played him in the 2006 film *The Prestige*, and Ethan Hawke took the role in the eponymous *Tesla* in 2020. The flamboyant inventor's reputation is now anything but down to Earth.

Traffic symbols

(1908)

From military milestones to digital displays, traffic signs have been vital aids to road users for more than two millennia. They are some of our most familiar symbols. But, as anyone who has ever driven abroad will tell you, they are by no means universal in their style or clarity.

Despite international conventions of 1908, 1931, 1949 and 1968, which aimed to standardize signs in the name of road safety, many countries have traffic symbols which confuse the first-time visitor. Road signs, it could be said, are immature symbols, only as old as the motor industry itself and still evolving into universal acceptance.

Roman roads were measured by milestones, perhaps the earliest widely recognized signs for the traveller. The earliest warning signs on roads were put there by club cyclists to alert their fellow pedallers in the 1870s. The Italian Touring Club was the first to do so for motorists, in 1895; and a convention of European driving clubs in 1900 discussed the need to standardize their signs. The British government was the first, in 1903, to introduce standard shapes for different categories of signage – a triangle for warnings, a red circle for prohibitions, a white one for speed limits and a diamond for vehicle-related hazards such as weight limits. The sign's information was contained not within the shape but below it on a separate sign.

It was not an ideal strategy. British drivers had to take in three separate symbols: the geometric one at the top of the pole, a pictogram below it, and often an additional written warning below that. While traffic signs across Europe gradually became standardized, it wasn't until 1964 that the United Kingdom modernized and simplified its signs, adopting the continental convention that triangular signs warn, circles command and rectangles provide information. New pictograms, many designed by graphic artists Jock Kinneir and Margaret Calvert, were now contained within the shapes.

Calvert was particularly proud of the new sign for a school. Britain's first school sign reflected the country's devotion to a classical education. It showed not children but the flaming Torch of Knowledge – something motorists were not likely to encounter in reality. A picture of children was introduced in the 1950s, with archaic details like a school satchel and a uniformed schoolboy complete with cap leading a little girl. Calvert removed all references to school so that the symbol could be used in a wider variety of situations, and made a feminist point of depicting the leading child in the image as a girl.

Detroit was the location of America's first traffic sign, a simple STOP in black lettering on a 24-inch white square background. America remains more reliant on words than Europe. It has different conventions for the shape of a sign and places more emphasis on the colour of a sign's background: orange for traffic movement, in construction zones, for example; green for regular direction of traffic; yellow for general warnings; white for regulations.

America also led the way in animal warnings. There are millions of collisions between deer and vehicles every year, and the Canadian warning sign for deer crossing shows an elegantly prancing stag worthy of Santa Claus. In some parts of the North American continent there is also a need for pictograms of moose and bears. Signs in Norway include a white bear on a black background with a red border, to alert drivers to polar bears. In China the panda warning sign is black and white on yellow with a black border. In Australia kangaroos are a hazard, while in Africa strolling elephants and giraffes can be a problem. Despite the best efforts to standardize road traffic symbols, every continent has its own animal highway dangers. In road signs, as in many other areas of cultural symbolism, there will always be differences.

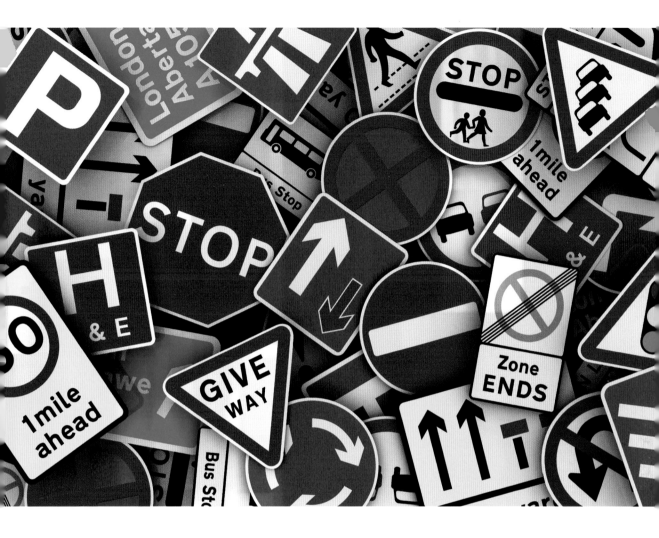

ABOVE: A collage of British road signs.
RIGHT: This polar bear warning sign can be found on the roadside at Svalbard, a group of Norwegian islands in the Arctic Circle.

Electrical symbols for circuit diagrams

(1909)

When the invention of the vacuum tube sparked the beginning of electronics, it became clear that a system of symbols would be required to standardize what was about to become a very complicated field...

Experiments in electricity multiplied following Alessandro Volta's invention of the steady power supply in 1791. Electronics was kick-started by John Ambrose Fleming's invention of the diode vacuum tube in 1904 and Lee de Forest's triode in 1906.

A month-long International Exposition of Electricity had already been mounted in Paris in 1881, demonstrating the advances in the field. A congress held during the Exposition agreed the first international system of electrical and magnetic units and gathered again in Paris in 1900. There the national electrical organizations of many countries, including Britain's Institution of Electrical Engineers and the American Institute of Electrical Engineers foresaw the future complexity of electronic equipment and the need for an international body to standardize all aspects of electrical engineering.

They were wise, because as we now know, electronics underpin every aspect of our daily lives. The International Electrotechnical Commission (IEC) was established in 1906, with the redoubtable Lord Kelvin as its first president. It developed a system of standard units and measurements named after Italian physicist Giovanni Giorgi. From the Giorgi System, today's International System of Units, SI, developed.

Every aspect of electrical engineering fell under the IEC's remit, and in 1909 it began to consider the symbols by which electronic circuits might be represented on paper. The electronic revolution was in full swing and it was essential that scientists in different countries were able to understand each others' contributions.

From the start the IEC was composed of professionals from industry and science and made their choices based on the practices of the leading electricians of the day. Several IEC symbols, including the inductor, capacitor, and American resistor symbols were adopted from the diagrams of Nikola Tesla, who pioneered the use of alternating current (AC). The ever-expanding results are contained in a document, IEC 60617, *Graphical Symbols for Diagrams,* which currently contains around 1,900 circuitry icons and their uses.

Without the work of the IEC, the international design, manufacture and trade of electronic devices would be severely restricted by their incompatibility with each other. The modern world only functions, to all intents and purposes, because computers in Seoul can talk to computers in New York, cellphone calls can be made from Sydney to London, and circuit diagrams drawn in Scandinavia can be understood by circuit board builders in Asia.

The IEC's reach is, however, not complete. Although many countries subscribe to its standards, there are local and national variations in practice. Furthermore, circuit diagrams are not the exclusive province of electronics specialists. For example, the wiring diagrams of electrical engineers and architects have evolved separately.

Eighty-seven countries are full or associate members of the IEC and most others adopt its standards. Another eighty countries have joined an affiliate programme, launched in 2001, which allows developing countries access to some of the IEC's standards and databases. It employs over 10,000 experts, almost all from within the electrical industries, to reach consensus on its standards, which go far beyond symbols, units and measurements. Since 1938 the IEC has developed the International Electrotechnical Vocabulary, a multilingual attempt to unify the terminology of all things electrical. It is now published online as Electropedia.

Olympic rings

(1912)

These days every Olympiad has its own logo, reflecting the host nation's pride and vitality. It's usually the product of an expensive team of advertising executives and a string of focus groups. But the Five Olympic Rings were the design of one man, Pierre de Coubertin.

Pierre Frédy, Baron de Coubertin was a sociologist, historian and educationalist. His vision was the modern Olympic spirit itself. It began with a visit to Britain in 1883, during which he saw the mental and physical benefits of introducing sports to the English school curriculum. De Coubertin determined to introduce them to the French education system.

Although he was largely unsuccessful in this, his classically educated mind had already made the connection with the sporting contests of the ancient Greeks so admired by nineteenth-century thinkers as the source of western civilization. He devoted the rest of his life to the creation of the Modern Olympic Games. He refined his notions of Olympian ideals at a congress of like-minded enthusiasts in 1894, and the first Games were held in Athens two years later.

Following the inaugural Games, Coubertin was elected as president of the International Olympic Committee (IOC). He invented and introduced the Modern Pentathlon at the Stockholm games of 1912. Perhaps the combination of five sports in one event gave him the idea for the five symbolic rings, which he also devised in 1912. The first use of the design was intended for an Olympic Congress in 1914, but world events got in the way and they made their debut at the 1920 Games in Antwerp.

The rings, de Coubertin explained, represented the five inhabited continents of the world from which Olympic competitors came. The colours were chosen because at least one of them was present in the flag of every competing nation. He didn't intend to link any individual continent to any one of the colours, although for a while in the mid-twentieth century the IOC allocated blue to Europe, yellow to Asia, black to Africa, green to Oceania and red to the Americas.

The five rings of the Olympic flag are now one of the most recognizable symbols of the modern world, and one of the most successful in depicting the ideals the flag represents. Five different colours, five different but equal circles all linked together against a background of pure white – the image of people of all colours and creeds joining together on the field of sport could hardly be clearer.

OPPOSITE AND BELOW: The Olympic rings proudly on display at St Pancras International Station for the 2012 London games, and in Paris in advance of the 2024 games.

LEFT: *A magazine cover from 1916 shows a Parisian model with hat boxes in the shape of the French air force roundel.*
BELOW LEFT: *The Balkenkreuz as used by the Luftwaffe in World War II.*
BELOW RIGHT: *An early version of US aircraft identification. After Japan attacked Pearl Harbor, the central red circle was dropped.*

Military aircraft insignia – Luftwaffe, RAF, USAF

(1912)

France was the first country to indicate the nationality of its planes, with a roundel in the blue, white and red colours of the French flag in 1912. Since then the function and design of identification symbols on military aircraft have undergone many changes.

There were some instances of aeroplanes being used for combat prior to World War I, but aerial warfare really took off in 1914. It was immediately important that both ground forces and other pilots could distinguish friend from foe. At first Britain simply painted the Union Jack flag on its planes, but at a distance it could be confused with the Iron Cross of the Imperial German Flying Corps.

The Iron Cross with its flared arms of equal length, technically called a cross pattée, was a symbol used by the Teutonic Knights during the Crusades of the Middle Ages. It became a military award under King Frederick William III of Prussia. On aircraft in the course of World War I it gradually altered in form: the flaring was reduced, and then dropped altogether in favour of a simple black cross with arms of constant thickness.

In World War II it became the Balkenkreuz, a black cross on a broader white cross (for extra visibility) framed by black lines and accompanied by a swastika on the tail fin. While Germany abandoned the swastika at the end of the war, Finland's air force, which had been displaying a swastika on its tailfins since 1918, only removed it from its insignia in 2020. The modern German Air Force has reverted to a version of the cross pattée.

Having abandoned the national flag, Britain's Royal Flying Corps (RFC) copied the French roundel, simply reversing the order of the colours so that red was in the centre. This insignia is still in use today by the RFC's successor, the Royal Air Force (RAF), but there have been many variations to suit circumstances. As camouflage was introduced on military planes, a yellow outer ring was added to make the roundel more visible – but later the white ring was omitted altogether to make it less visible,

especially on night-time missions. In the Pacific arena during World War II, the central red circle was removed to avoid confusion with Japanese aircraft.

The USA joined World War I in 1917. Its planes had until then been identified either by a red star (in the Aviation Section of the US Signal Corps) or a blue anchor (for US Navy aircraft). But to avoid more confusion with the German Iron Cross, and to align itself with the Allied air forces, it adopted a roundel which had originally been used by the Imperial Russian Air Service, of white, red and blue. After the war it chose a red circle inside a white star inside a blue circle, which it retained until 1942.

In the wake of the attack on Pearl Harbor the US, like the UK, dropped the central red circle as it fought the Japanese air force. The now-familiar horizontal bar was added to the insignia to further distinguish it in shape from Japan's red disc. Only in 1947 was the United States Air Force (USAF) officially created, and a red line was added to the bar as an echo of the Stars and Stripes flag. This is still the USAF insignia today.

In modern high-tech aerial warfare, military planes are painted and shaped in such a way as to avoid the most sophisticated early warning systems. The USAF has been using low visibility versions of its insignia in grey or white, or fine black outlines, since the 1980s. The RAF, like other air forces, now uses roundels in shades of grey on its latest aircraft; in the case of the F-35B Lightning II, it is not painted at all but built into the structure of the plane itself.

London Underground

(1915)

At the beginning of the twentieth century the train services of the London Underground were operated by a disparate group of companies. The managing director of one of them was a design visionary whose unified approach branded not only London Transport but London itself.

Frank Pick worked for the Underground Electric Railways Company of London (UERL), whose lines later formed the basis of the Bakerloo, Northern and Piccadilly routes of the London Underground. He wanted to create a joint marketing strategy with the other underground operators, and his first step was to come up with an umbrella name for the network. The word Underground, which we take for granted now, was until then simply a description of where the trains ran; now, in 1908, it became the name of the network, the Underground. A logo emphasized the length of the word (and by implication the extent of the underground network) by printing it with an enlarged first and last letter.

Pick's next challenge was a complaint from passengers that it was hard to find the station name amid the jumble of advertisement of all shapes and sizes which were posted in stations wherever space could be found. Frank Pick devised a simple solution – all stations' names would henceforth be in white on a bar with a blue background, with the addition behind it of a solid red disc, like the bullseye in a target. That would give passengers something distinctive to look for. Pick also standardized the size and positioning of advertising posters so that stations were less visually confusing.

To distinguish the Underground's posters from those of advertisers, Pick commissioned a new typeface in 1915. It was designed by Edward Johnston, a calligrapher, who also took a fresh look at the bullseye. UERL had recently bought out the London General Omnibus Company, whose bus crews wore a cap badge consisting of a wheel with a bar or ribbon across it. Johnston reworked the Underground logo in this mould by heightening the Underground's blue bar and replaced the solid disc with a bold red circle with a white centre.

The effect was to emphasize the station name with an even more target-like roundel. With the typeface, Johnston aimed for quiet simplicity, something distinctive which would, however, not jar with repeated exposure. Typographer Eric Gill worked with Johnston on the new lettering, named Railway, and based his own classic font Gill Sans on Johnston's design.

The resulting typeface and symbol were rolled out across the network from 1916 onwards and with minor adjustments are still in use today, one of the longest examples of continuous use of a corporate symbol in the world. Architects and designers even began to incorporate its shape into the plans of buildings and furnishings of Underground stations.

Pick fully intended it to be an ubiquitous brand; but neither he nor Johnston can have anticipated the extent to which it would become visible throughout London. The roundel now appears on bus-stops, trams and trains above ground as well as in the Tube below; and it has become as much a symbol of London itself as of the transport network which keeps the city moving.

The London Underground was nationalized in 1947, although surprisingly the roundel was only adopted as its formal logo in 1972. A new body, Transport for London, was created in 2000 to oversee all of London's public transport infrastructure from buses to taxis, trains to ferries, trams to transport museums; wisely it retained the roundel, one of the most recognizable symbols in the world.

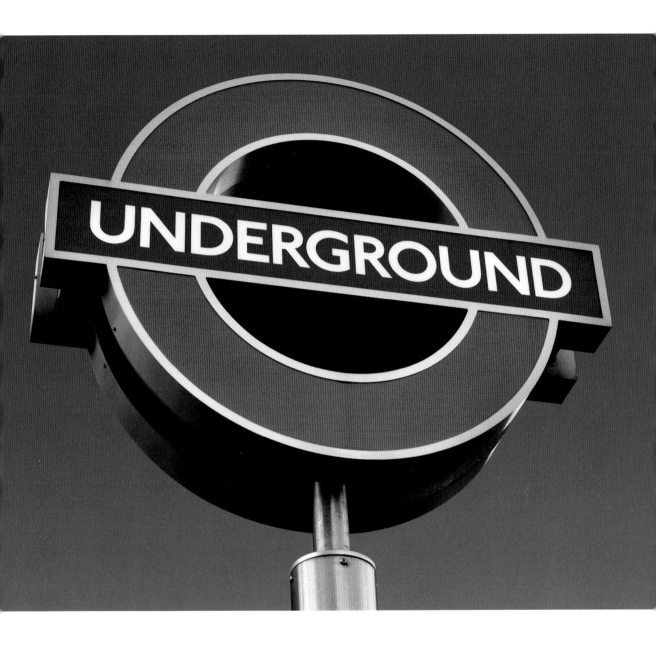

ABOVE: From its origins in 1915, the London Underground sign has become a design classic and is used to adorn a catalogue of souvenir items.

Poppy
(1915)

When Canadian medical officer Lieutenant Colonel John McCrae lost a close friend on the battlefield of Ypres during World War I, he expressed his grief in a few short lines of poetry. The poem, in today's terms, went viral, inspiring a symbol of loss and commemoration.

Canada, as a dominion of the British Empire, was drawn into Britain's war with Germany in 1914. John McCrae was attached to the 1st Brigade, Canadian Field Artillery, whose wounds he treated in a makeshift operating theatre in the form of an 8ft (2.4m) square hole dug in a hurry just behind the trenches of the front line at Ypres.

The fighting in Belgium was intense. Thousands of men died with little or no gain of territory, and the constant bombardment by both sides obliterated every natural feature in debris and mud. Scarcely a tree was left unsplintered. And yet, when the ground was disturbed to dig a new grave for another fallen soldier, wild poppy seeds were among the first to germinate there.

McCrae's friend Lieutenant Alexis Helmer was killed at Ypres on 2 May 1915. McCrae conducted Helmer's burial himself; and as he mourned his colleague's death he wrote down a few lines to express his feelings. They began:

> In Flanders fields the poppies blow
> Between the crosses, row on row
> That mark our place;

And ended:

> To you from failing hands we throw
> The torch; be yours to hold it high.
> If ye break faith with us who die
> We shall not sleep, though poppies grow
> In Flanders fields.

Some months later McCrae submitted it to the British magazine *Punch*, who printed it anonymously under the title 'In Flanders Fields'. It immediately became popular on both sides of the Atlantic and lines from it were used to promote the war effort and the sale of War Bonds.

At the conclusion of the war a professor at the University of Georgia, inspired by McCrae's poem, vowed to wear a poppy every day in remembrance of the war's dead. Professor Moina Michael was in Germany at the outbreak of the war and helped thousands of American tourists with their disrupted passage back to the US. She campaigned for two years to have the poppy adopted as an official symbol of remembrance; and at its 1920 conference the American Legion, formed the previous year to support US war veterans, did just that.

One of the delegates at the conference was a Frenchwoman, Anna Guérin, who saw an opportunity to raise money not only for veterans but for their widows in France. She organized the manufacture of thousands of artificial poppies which she sold to veterans' organizations all round the world. In Britain, the British Legion bought nine million of them and sold them on Remembrance Day, 11 November 1921. They sold out so quickly that the British Legion set up its own factories in England and Scotland to cope with the demand for the following year.

Today in Britain alone, over 40 million red poppies are now bought every year. Many pacifists choose to wear a white one, symbolizing their respect for the dead but also their opposition to war. Some have adopted a black poppy to recognize the sometimes unacknowledged sacrifice of many soldiers from the Asian and African dominions of the British Empire.

John McCrae died of pneumonia at a field hospital in Boulogne-sur-Mer just before the end of the Great War and never got to see the legacy of the poem he wrote.

ABOVE: The standard Remembrance Day poppy on sale in Britain every autumn was inspired by a Canadian medic, promoted by an American professor and launched as a means of raising money by a French woman.

ABOVE: Ceramic poppies cascade from the side of the Imperial War Museum North in Salford Quays, England.

Mercedes tri-pointed star

(1926)

Every company strives to have a distinctive logo, a design which they hope will make them stand out in their chosen marketplace. Very few transcend the confines of their own sphere to become universally recognized.

The Mercedes-Benz car company was formed in 1926 from the amalgamation of Karl Benz's Benz & Cie and the Daimler Motoren-Gesellschaft, then led by Emil Jellinek but founded by Gottlieb Daimler. Benz had already made history by manufacturing the first petrol-powered vehicle in 1886. Daimler had set up shop in 1883.

After the death of Gottlieb Daimler in 1900, his sons recruited Jellinek, an Austrian diplomat with an enthusiasm for the new sport of motor racing. Jellinek commissioned a new racing model from the company and christened it Mercedes after his daughter. The car represented Daimler at races and helped to build its reputation. The names Mercedes and Daimler became interchangeable in the public's mind and in 1902 the company adopted the daughter's name as its own.

The Mercedes logo was originally a simple adaptation of the Daimler one, the name spelt out in a horizontal oval. Mercedes trademarked the now-familiar tri-star mark in 1901, but it had to wait to make its first appearance until 1909, when it was used as a simple star without any surroundings.

There are several stories about how it came into being. It was not, as many assume, the design of the Mercedes steering wheel at the time. Some say that Gottlieb's sons recalled a map on which their father marked the site of the family's new home with a star. He wrote beside it, 'One day this star will loom above the roof of my car factory, symbolizing prosperity.' Another legend suggests that it symbolized the company's ambitions for its engines, with the three arms pointing at their use on land, at sea, and in the air. These days a Mercedes salesman will tell you it stands for the three qualities of reliability, speed (or perhaps safety) and craftsmanship, in all of which the company stands for excellence.

Meanwhile, Karl Benz was having his own success on the race track and decided to add the victor's laurels to his badge, which from 1909 showed golden leaves surrounding the word Benz in blue on a golden dome. When the companies merged in 1926, they combined the Mercedes star and the Benz laurels in a blue and silver design which included the two names above and below. It has remained in essence the company's symbol ever since.

Over time the design was simplified: the names disappeared, and the laurels became a simple circle. Briefly in 2009 and 2010 the shading of the star and circle was abandoned in an attempt to present a more modern, two-dimensional, iconographic version. But reworking a 100-year-old design proved so unpopular that the shading was quickly reintroduced in 2012. You meddle with tradition at your peril.

OPPOSITE: *Two original badges from the Benz and Mercedes companies, alongside two versions of the combined automotive badge. Every motor manufacturer has a logo, but Benz produced the first petrol-driven car in 1886.*

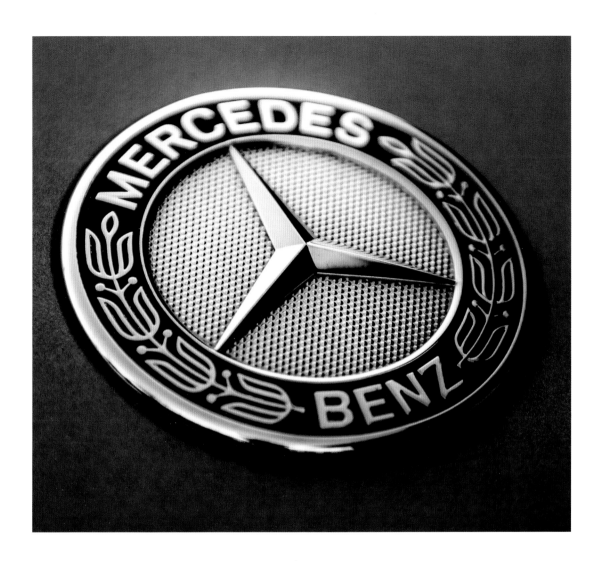

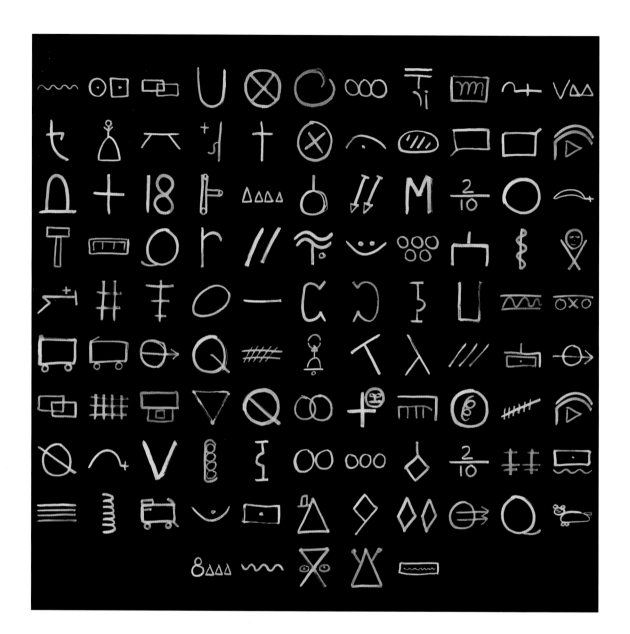

ABOVE: *A lexicon of hobo signs.*
OPPOSITE: *Hobos went looking for casual work across the
United States in the 1930s.*

138_____100 Symbols That Changed the World

Hobo symbols

(1930s)

There have always been migrant workers, men and women who travelled far and wide to do seasonal work. But there was a desperation and poverty about those who were forced into this way of life during the Great Depression of the 1920s and 1930s. These became known as the hobos.

There was a clear distinction between hobos (people who would willingly work), tramps (who would only work if they had to) and bums (who were too lazy to work at all). In the deepest depths of the Depression, it is estimated, there were between three and four million hobos. Unemployed and dispossessed, they were the human face of that economic disaster.

The origin of the label is unclear, first recorded towards the end of the nineteenth century. Since most casual work was likely to be on a farm, the term may have been an abbreviation of 'hoe-boys', referring to the hoe or other agricultural implement which they would have been asked to use. Another suggestion is that it was originally short for 'homeward-bound', or of Houston and Bowery, a location in New York where seasonal workers used to gather to find work.

Since hobos relied on personal approaches to employers and householders for food and work, they tended to walk alone, meeting others only when they found work or when they were hitching a ride on a slow-moving freight train. Jostling together in a box car, they would exchange information about places where they would be well received and others where they would be chased away.

To support this sharing of information, a system of drawn symbols developed which could be written unobtrusively in coal or chalk on a gate, for example, or the back of a signpost. A hobo on his own would then know if the owner of a property was wealthy or likely to threaten him with a gun, whether the dogs would bark or bite, and so on.

Some of the symbols were simple pictograms – a cat symbolized a kindly woman; a steam engine indicated a place where trains slowed down enough to jump on board; a top hat with a triangle represented a gentleman with a pile of money, a wealthy man. A dog was reduced to a horizontal line with four lines for legs and a fifth, the tail, raised up if friendly and pointed down if not. A stylized pair of handcuffs suggested that the local police were hostile to hobos.

Others were more abstract hieroglyphics. A dot in a rectangle meant danger; a danger sign above a ripple therefore meant bad water. An X meant OK; an X in a circle suggested there was a good chance of being given some money; a ripple above an X holding two small circles indicated good water and a safe place to camp.

Although intended as secret signs among hobos, they were reported by authors who romanticized the hobo lifestyle in articles and novels. Although there is no doubt about the authenticity of many hobo symbols, it is probable that fanciful writers embellished the lexicon with invented symbols for extra pathos or comedy. In a sense it hardly matters: all languages are a melting pot of many tongues, and the dictionary of hobo symbols was certainly not the work of any one hobo.

Hobos had all but disappeared by the 1940s when author Jack London was writing about his first-hand experiences of the life. Less tolerant policing, the end of the Depression and the start of US involvement in World War II all played a part in the end of their era. By its very nature, few examples of hobo symbols survive and, like any dead language, we rely on the records of others to know it ever existed.

LGBTQQ – pink triangle
(1933)

What is now a symbol of pride was once intended as a badge of shame. Triangles of various colours were used to label those considered socially deviant under one of the cruellest regimes of modern times. However, the pink triangle has been reclaimed, by the very people it once targeted.

Although male homosexuality had been illegal in Germany since 1871 it was tacitly tolerated until 1933, when Adolf Hitler became the country's Chancellor. His vision of a pure and perfect Aryan race had no room for those so-called degenerates who would never contribute to the expansion of its population. Hitler's government rounded up around 100,000 gay men before and during World War II. Some were imprisoned and as many as 15,000 were sent to concentration camps, of whom it's estimated that 60% may have been killed. Many were tortured.

The notoriously efficient record-keeping of the Nazi regime demanded that its prisoners be categorized and labelled according to their alleged crimes. Being Jewish was one of the worst 'crimes', and Jews were forced to wear a yellow Star of David – two triangles superimposed – as evidence of their outcast status. Other prisoners were similarly marked out by the nature of their supposed offence to Germany. Political inmates wore a red inverted triangle; habitual criminals a green one; foreign workers a blue one; Jehovah's Witnesses were singled out by a purple triangle. Roma were assigned brown, and other undesirable nationalities, Poles and Czechs, had a P or a T (for Tchech) imposed on the triangle of their other 'crime'.

Jews who were guilty of another crime as well as their religion must wear the triangle of the appropriate colour on top of a yellow one, making a two-colour Star of David.

Those regarded as antisocial members of society were given a black triangle. These included ordinary criminals, the homeless, alcoholics, thieves, prostitutes, those engaging in relationships outside marriage or with

Jews and anyone else who didn't fit the Aryan racial stereotype. Lesbians, who were not explicitly outside German law, also fell into this category. Homosexual men were expressly banned by legislation and were regarded as the lowest of the low and identified by a pale pink triangle of cloth sewn onto the front of their prison uniforms.

Homosexuals were treated so badly in the concentration camps that one gay man is said to have swapped badges with a Jew in order to get better conditions. The episode is portrayed in Martin Sherman's stage play *Bent*, based on the memoirs of a gay Jewish survivor of the camps.

The 1970s witnessed a rise in gay liberation activism around the world and the German group Homosexuelle Aktion Westberlin began to use the pink triangle in 1973 to draw attention to the continuing discrimination against gay men. The bisexual transvestite character Frank N Furter in the 1975 film of *The Rocky Horror Show* wore a pink triangle, and the symbol was increasingly adopted as a positive statement of sexuality in the 1980s. Some display the triangle point upwards as a deliberate reversal of the Nazi usage. Pink triangles now grace memorials to holocaust victims in many towns and cities, and San Francisco has a Pink Triangle Park.

Just as the swastika has been reclaimed from its Nazi use and restored to its original Hindu meaning, the pink triangle is now a mainstream symbol of sexuality, widely recognized in and beyond the gay community. Sportswear manufacturer Nike introduced a special collection of shoes for Pride Month 2018 which incorporated pink triangles in their design. Without doubt pink triangles send a more positive message on shoes than on prison uniforms.

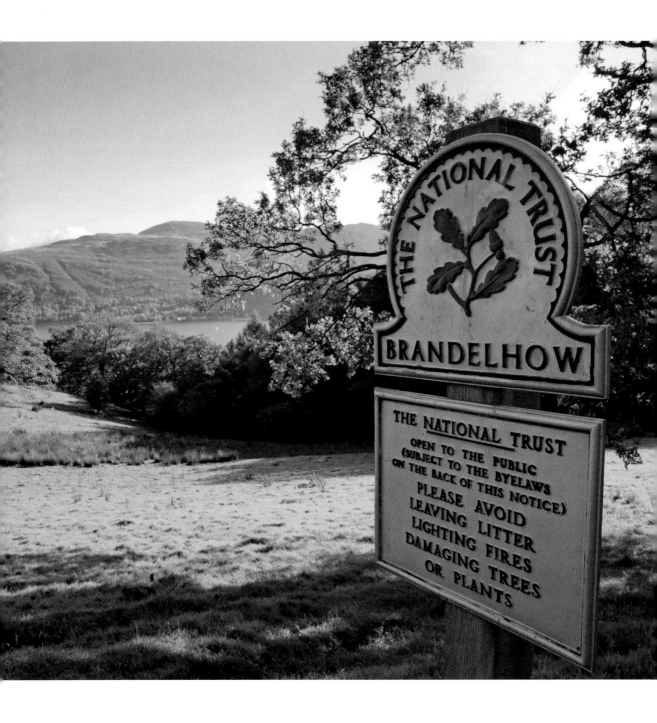

ABOVE: The National Trust's cluster of oak leaves has come to represent exceptional conservation values and a dedication to preserving a wide variety of national heritage sites.

National Trust oak leaf

(1936)

Britain's National Trust organization was established in 1895 with the intention of preserving landscapes and buildings of aesthetic and historic interest for the enjoyment of future generations. The choice of a symbol to represent this diverse portfolio was a hard one.

The Trust owns and manages property in England, Wales and Northern Ireland, representing almost every aspect of Britain's social, industrial and natural heritage. Its holdings include iconic natural features like the Giant's Causeway, industrial landmarks such as the sixteenth-century copper works at Aberdulais, stately mansions such as the imposing nineteenth-century Cliveden House, and more modest buildings like the childhood homes of John Lennon and Paul McCartney. Some of its earliest purchases were parcels of land in the threatened natural habitat of the Cambridge Fens; while the first building it acquired, in 1896, was Alfriston Clergy House, Sussex, a small timber-framed, thatched cottage built in the fourteenth century.

It wasn't until 1935, forty years after its founding, that the National Trust felt the need for a symbol to represent it and its properties. It ran an open competition that year to design a symbol adaptable enough to be used on everything from plaques to letterheads, from paper brochures to cast iron signposts. There were no other requirements for the design, and the competition attracted 109 entries from artists hoping to win the £30 prize.

None of them was considered suitable for the Trust's use, and the disappointed trustees met again in 1936 to reconsider their approach. This time the competition was restricted by invitation to six designers, who were given a more precise brief. The symbol must be based on one of three quintessentially English icons: the garden rose, the heraldic lion or the mighty oak.

The winning design, a sprig of oak leaves and acorns, was submitted by Joseph Armitage (1880–1945), a respected sculptor and wood carver. He studied at Leicester School of Art and taught carving there from 1906 to 1913. During that period he undertook several commissions throughout Britain, including oak leaf carvings very similar to the design which he later entered in the Trust's competition.

The oak has been held in particular esteem in England for millennia. In prehistory, religious druids were said to gather in oak groves; and in the seventeenth century marriages were held in the shade of an oak tree, which represented strength. The oak's wood was felled to make everything from barrels to buildings; its bark was employed in the tanning process; and oak apples – round growths caused by the larva of the gall wasp – were used to make ink.

It earns its position as the English national tree because of its contribution to the country's naval superiority over the centuries. Ships were built of English oak until the advent of iron hulls in the mid-nineteenth century, earning the Royal Navy the sobriquet of 'the wooden walls of Old England'. Since 1660, when the monarchy was restored after England's brief spell as a republic, there have been eight warships named HMS *Royal Oak*, and the official march of the Navy is a tune called 'Heart of Oak'.

The monarch who was restored in 1660 was Charles II, who had escaped the forces of Oliver Cromwell in 1651 by hiding in an oak tree in Boscobel Wood in Shropshire, the original Royal Oak. That tree was destroyed by royalist souvenir hunters who broke pieces off in the seventeenth and eighteenth centuries. A direct descendent, Son of Royal Oak, now some three hundred years old, still stands in Boscobel.

The Woodland Trust, dedicated to preserving and planting native trees in Britain, also uses an oak leaf motif as its logo. And, this being England, the Royal Oak is also the third most popular pub name in the country, after the Red Lion (the heraldic symbol for England) and the Crown.

The National Trust for Scotland is a separate organization, represented by that country's national flower, the thistle.

PW – Polish WWII resistance

(1942)

When Nazi troops massacred 107 civilians in Wawer, a suburb of Warsaw, in December 1939, the Polish slogan for 'We shall avenge Wawer' became a rallying call for disparate groups of Polish resistance fighters.

The phrase 'Pomścimy Wawer' was abbreviated to PW, which could also stand for Polska Walcząca ('Fighting Poland'), and began to appear overnight scrawled on buildings where German troops would see it.

The invasion of Poland by Germany, soon followed by the Soviet Union, marked the start of World War II. Poland's government and armed forces were thrown into disarray, but soon regrouped as the Polish Underground State, based in exile in London. From there they coordinated acts of espionage and sabotage of German activities in the country.

Although PW graffiti quickly become a popular act of defiance, the Underground State ran a competition in 1942 to produce a design for the initials, for use by the Armia Krajowa (AK, 'Home Army'), as the now-organized resistance groups were known. From twenty-seven submissions, the winning design was by an Art History student at the University of Warsaw, twenty-two-year-old Anna Smoleńska. Her combination of the letters in the form of an anchor was considered a strong symbol of hope, recognizable and easy to paint quickly where it would cause most offence to the occupying forces.

The Kotwica (Polish for 'anchor') began to appear everywhere. As well as being incorporated in AK insignia, it was subversively painted on German equipment and stamped on German newspapers and banknotes. All acts of AK sabotage were signed with the Kotwica, and its ubiquity was a form of psychological warfare against the Germans in Poland.

The Warsaw Uprising in 1944, the largest military effort by any country's resistance fighters during World War II, was the Kotwica's high point. PW could also stand for Powstanie Warszawskie ('Warsaw Uprising') and Wojsko Polskie ('Polish Army'). The sign was superimposed on Polish flags and, for two months,

there was a very real possibility of success. Churchill sent airdrops of supplies to sustain the fighters; but the Soviet Union already saw Poland as a useful communist bulwark after the war and offered almost no support. When Germany eventually regained the upper hand, its retribution was swift and brutal. Tens of thousands of Warsaw Poles were executed. After the war was over, the Soviet Union controlled Poland and banned the use of the Kotwica.

By then the symbol was firmly embedded in the hearts of patriotic Poles. Expatriate organizations continued to use it; and when martial law was introduced in 1981 and the Gdansk shipyard trade union Solidarność was banned for opposing the government, an underground resistance sprung up again, called Solidarność Walcząca ('Fighting Solidarity') which incorporated Smoleńska's design in its logo.

Anna Smoleńska and her entire family (apart from one brother) died in the Auschwitz concentration camp in 1943, but her work inspired a nation. It continues to inspire, and to represent the Polish people's love of country and freedom. It has found new military use among the insignia of GROM, the Polish Special Forces formed after the fall of communism in 1990.

In 2014, respect for the Kotwica was enshrined in Polish law, when it became a finable offence to misuse it or abuse the memory for which it stands. The new law was tested in 2016 when the Polish Green Party staged a demonstration in favour of women's rights. They carried a banner bearing the Kotwica with the male and female symbols added to the ends of the W. The Warsaw chief of police began criminal proceedings on the basis that it ridiculed the Anchor. The courts ruled that the association of gender equality with the sign of the Polish resistance could not be offensive to either.

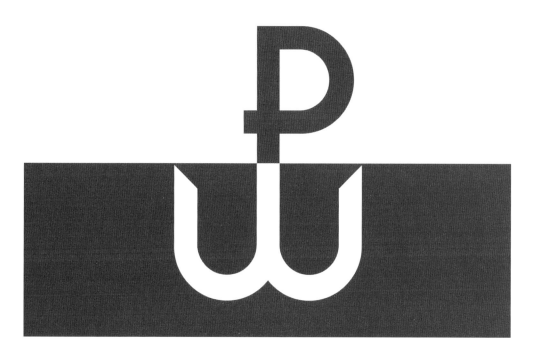

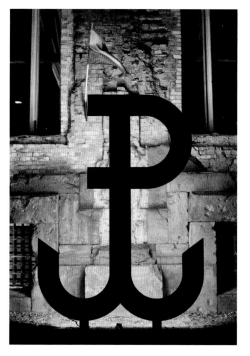

ABOVE: *The Kotwika combined with the flag of Poland.*
LEFT: *The 'Fighting Poland' symbol on the Reduta Bank Polski monument to the Warsaw Uprising.*

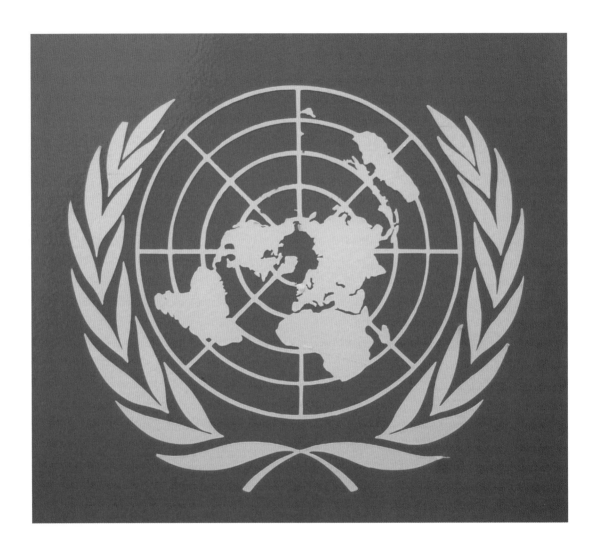

ABOVE: Argentina was missed off the original Donal McLaughlin design of 1945, but was included in the official logo and flag of 1946.

United Nations

(1945)

The now familiar symbol for the United Nations was originally designed as a temporary measure to identify delegates at a conference. The challenge was to produce a simple image which captured the organization's lofty aims of lasting peace among all nations.

The League of Nations was the first attempt by the international community to ensure lasting peace. It was formed in 1920 in the wake of World War I at a time when that conflict was optimistically called 'the War to End All Wars'. At its height it attracted fifty-eight member countries, but the United States never joined even though President Woodrow Wilson was an enthusiastic supporter; and the USSR, which joined late, was thrown out early for invading Finland. When World War II erupted in 1939 it was clear that the League had failed in its mission.

At the end of World War II, fifty nations of the victorious alliance gathered for the United Nations Conference on International Organization in San Francisco, to plan what would become the United Nations (UN). The organizers needed a symbol to fit on a one-inch (2.5cm) pin to be worn by all delegates, and a committee was formed to develop an idea by American architect Donal McLaughlin.

Before the war McLaughlin had built a successful commercial career designing interiors for Kodak Eastman, US Steel and Tiffany's in New York, among other clients. During the conflict he turned his attention to communication, making training films and diagrams that were easy to understand, whether by new recruits or by undercover saboteurs. Afterwards, it was McLaughlin who designed the courtroom for the trials in Nuremberg of Nazi war criminals.

McLaughlin's original design was a simple map of the world framed by olive branches of peace. To make it suitable for a circular pin the committee, headed by another architect, Oliver Lundquist, used a different,

azimuthal projection of the world, viewed from the top. It superimposed three concentric circles as lines of latitude with lines of longitude radiating from the North Pole at the centre. The view was distorted slightly to include countries lying below the equator – Australia was thus visible, but not Argentina which was not expected to join the UN, having incurred the US's wrath by remaining neutral after Pearl Harbor.

Olive branches enclosed the whole thing and were themselves surrounded on the pin by the date, city and name of the conference. McLaughlin's amended design was placed on a sky blue background (ironically similar to the blue of the Argentinian flag) because the colour represented serenity and peace, the very opposite of warlike red.

The original orientation of the map placed Asia, Europe and North America on the central line of longitude and later it was rotated through 100 degrees so that no country was prominent. The scale was also reduced so that Argentina could be included. In this form it was formally adopted by the UN in 1946, both as a logo and as a flag. It has subsequently formed the basis of the symbols of many other international agencies, including UNESCO and the World Health Organization.

The same blue background was adopted by Somalia for its flag, in recognition of the UN's role in the country's achievement of independence. A similar tribute to the UN was proposed in designs for the new flag of Bosnia and Herzegovina after the Bosnian War of 1992–1995, although in the end the country opted for the darker blue of the European Union.

Radioactivity

(1946)

The familiar trefoil radiation warning sign was devised in California in 1946, not long after the detonation of two nuclear bombs ended the war in the Pacific so decisively. Although still in use today, its design has been the object of criticism.

It is very often the case that experts in one field – say, radioactivity – are not experts in another – such as communication. The radioactivity symbol was the product of a small group of American scientists working in the University of California Radiation Laboratory in Berkeley. Aware of the dangers of radioactive material, they wanted to convey the idea of radioactivity emanating from a source, the central dot. They assumed that, after Hiroshima and Nagasaki, everyone knew that radiation was a dangerous thing.

But the three radiating beams could appear to the unscientific eye as the blades of a propeller revolving around a central shaft. It lacks what modern symbol experts call an intuitive interpretation – nothing about it says clearly 'danger – radiation'.

To compound the lack of urgency in the symbol, they opted at first for an exclusive and defiantly low-impact colour scheme: magenta, on a powder-blue background. They reasoned that magenta ink was more expensive and therefore less likely to be used by anyone else; and similarly that blue would be distinctive because it was not found on other hazard warnings. Yellow, they felt, was too common.

In fact blue is a weak colour for signs because it fades in sunlight. In any case it is now considered desirable for all hazard signs to share the same characteristics, so that one is immediately aware that some sort of hazard is present; and in 1948 yellow became the standard background colour. Magenta is still used for the symbol itself in the US; but the rest of the world has adopted a rather more visible black.

In 1961, when nuclear war between Russia and America seemed a distinct possibility, fallout shelters were constructed across the US. The proposal to use the radiation trefoil to identify them was rejected on the grounds that they should be seen as places of safety, not of hazard. Instead, the sign was adapted – slightly – as

three triangles pointing inwards to a central gathering point. But the two symbols remain uncomfortably similar and are often confused.

Although the trefoil is an elegantly simple design, it contains just too many sources of confusion. In 2007 the International Organization for Standardization (ISO) and the International Atomic Energy Agency (IAEA) launched a new radiation sign. Conventionally triangular (like road safety hazard signs), it shows the trefoil with added radioactive rays, raining down onto a skull and crossbones and a fleeing human figure, all in black on a red background. These hieroglyphics clearly convey the message 'Danger – radiation – keep away': not beautiful, but effective.

ABOVE: *A standard radiation warning sign.*
LEFT: *The more recent radiation sign is far more complex and inelegant, but gets the message across.*
OPPOSITE: *The US continues to use magenta as the colour for its trefoil, in this case, backed with an explicit warning.*

ABOVE: *A re-imagining of Pablo Picasso's stylized 'Dove of Peace'. He had created a detailed lithograph of* La Colombe *(the dove) in 1949, but a simpler line drawing of a dove would be used for peace congresses in Wroclaw, Stockholm, Sheffield, Vienna, Rome and Moscow.*
OPPOSITE: *A poster for Hiroshima Day, held each year on the anniversary of the detonation of the first nuclear bomb over the Japanese city in 1945.*

Dove with olive branch

(1949)

Although the dove was only formally adopted as a symbol of peace in the wake of World War II, its meaning of serenity and spirituality has evolved over thousands of years and across many cultures.

The World Congress for Peace in 1949 was part of an ideological campaign by the Soviet Union to seize the initiative after the conclusion of hostilities in 1945. It was a propaganda exercise which contrasted the peace-loving communist bloc of Eastern Europe with the war-mongering West. The event had to be held in two European capitals – Paris and Prague – because the French authorities refused visas to many communist delegates.

Contributions were invited from sympathetic politicians and other public figures. When scientist Albert Einstein refused to alter the text of his message of support, the organizers (the Communist Information Bureau known as Cominform) substituted another one without consulting him. African American singer and Civil Rights activist Paul Robeson gave a speech and sang a song in Prague which would later become the Chinese national anthem: on his return to the US he was blacklisted and his passport was revoked.

In Paris, the Congress considered the adoption of a universal symbol to represent Peace. The artist Pablo Picasso had been a vociferous anti-fascist since the Spanish Civil War, during which he painted his famous anti-war painting *Guernica*. He was a regular attendee at Peace congresses from 1948 to 1951, and the posters for the 1949 gathering used a lithograph by him called *La Colombe* ('The Dove'). The following year the event was held in Sheffield, England; and speaking there Picasso declared, 'I stand for life against death: I stand for peace against war.' The original sitter for the image was a Milanese pigeon, which fellow painter Henri Matisse had given Picasso.

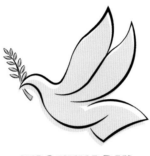

HIROSHIMA DAY
6 AUGUST

Picasso's dove became the official symbol of the World Peace Council established by Congress that year, and became a sign of peace around the world. For many it became synonymous with the dove of Christianity, which itself is a conflation of two biblical doves. In the New Testament the fluttering landing of a white dove represents the Holy Spirit descending into the body of a Christian believer. In the Old Testament the dove which returns to Noah's ark carrying an olive branch is proof that the waters of the Great Flood are receding; so it represents an end to chaos and a return to prosperity.

Noah's flood has a precedent in the ancient Mesopotamian epic poem *Gilgamesh*, which describes a flood covering the whole world, in preparation for which Utnapishtim built an ark. In this story, however, the dove returns with nothing, having failed to find land.

Arguably the ability and willingness to speak to each other is mankind's greatest opportunity for Peace. An Azerbaijani folk tale tells of two kings who were on the verge of going to war. The mother of one king begged him not to put his helmet on because a dove was nesting in it. The obedient king took to the battlefield with a bare head, to the astonishment of his opponent. When the helmetless king explained why he was fighting unprotected, the other king was impressed. While they were about to start a war which would kill thousands of troops and civilians, here was a man who would not even disturb a dove and its chicks. The two kings shook hands and declared peace, and from then on, in Azerbaijani legend, Peace was represented by a dove.

UNICEF

(1953)

A year after the end of World War II, the newly established United Nations set up a temporary fund to support children displaced and deprived by the conflict. Seventy-five years on, the work goes on and the fund's logo has become one of the most recognizable symbols of hope for the future.

UNICEF, originally the United Nations International Children's Emergency Fund, was founded in 1946 as a temporary humanitarian measure. As an arm of the United Nations it was entitled to use the logo of the UN, a map of the world over a stylized globe, embraced by two olive branches of peace.

It became clear, however, that war was not the only threat to the health and security of the young, and in 1953 the UN extended UNICEF's mandate indefinitely. With this permanency UNICEF was granted its own variation of the UN symbol. Since a focus of UNICEF's work at the time was the provision of fresh milk for every child, the symbol's first iteration showed the silhouette of a child drinking from a glass, retaining the globe background and the olive branches.

UNICEF's role was expanding and in 1959 the UN issued a declaration of universal children's rights, not only to nourishment but to schooling, health, shelter and shielding from war and other man-made threats. The UNICEF symbol changed in response, from a child holding up a glass of milk to a mother holding up a child.

This in essence has remained the UNICEF symbol ever since, although in 1986 the child's silhouette was enlarged and the mother's reduced to a more gender-neutral head and shoulders. In recent years UNICEF has campaigned for the rights of LGBT+ parents and their children.

The organization is represented in 191 countries and inevitably there have been cultural clashes over their policies towards children. UNICEF has argued for safer abortion practices and for family planning through contraception. The latter earned it the wrath of the Vatican, which withdrew its financial support from the Fund in 1996. Elsewhere its programs have not always been successful in reducing child mortality, drawing criticism that it focuses too much on idealistic rights and not enough on practical care and support.

UNICEF celebrated its 75th birthday in 2021 with a logo little changed since it was first introduced. Only the typeface for the organization's name has varied in size and style with the fashions. Constant at the centre of the design, as it is at the heart of everything UNICEF does, is the child, a symbol of those who suffer most from the evil that men do in the name of power and hate.

OPPOSITE LEFT: UNICEF's first logo from 1953 featured a child drinking a cup of milk, reflecting the organization's mission, delivering milk to children.
OPPOSITE RIGHT: After the UN Declaration of the Rights of the Child in 1959, the 1960s logo became a woman lifting up a child.
OPPOSITE TOP: The mother and child figure became larger in the circular frame from 1986.

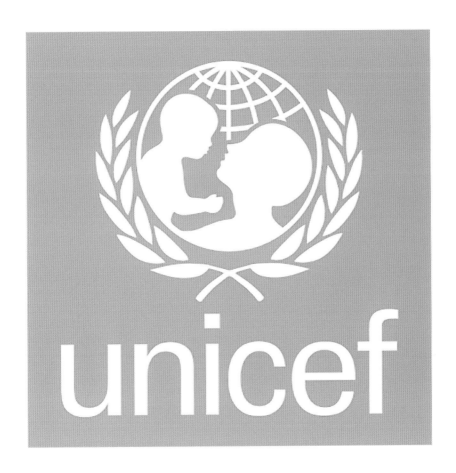

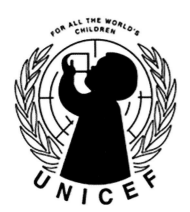

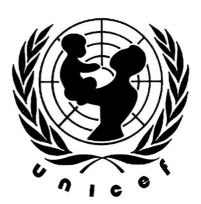

NATO

(1953)

The North Atlantic Treaty Organization (NATO) was formed in the aftermath of World War II at the start of the Cold War, to counter the perceived threat of Soviet influence in Europe. It is a political and military alliance, and that is reflected in the history of the NATO symbol.

As the organization's name suggests, it wasn't only Europe which was concerned about the advance of communist ideology on that continent. At the end of World War II American and Russian troops raced to liberate areas occupied by the Nazis and establish their own ideological footholds in the region. It was the US, not Europe, which instigated the organization and, after the signing of the Treaty in 1951, it was General Eisenhower who posed in front of NATO's first flag.

That flag bore the emblem of the Supreme Headquarters Allied Powers Europe, the NATO military command set up under Eisenhower to oversee Europe's return to civilian life. Against a background of symbols of peace (olive branches and doves' feathers), two swords are raised that are touching at the tips. The whole is surrounded by a ribbon carrying the legend (in Latin), 'Vigilance is the price of peace'. Clearly nobody at NATO was going to be resting on the laurels of victory.

It was felt that NATO should eventually have a distinct symbol, separate from its military operations, and a conceptual brief was given to designers in 1952. The emblem, NATO said, 'needs to be simple and striking in design. It also needs to illustrate the community of traditions and ideals which united the members of the North Atlantic community. Lastly, the emblem has to bring home the peaceful purpose of the North Atlantic Treaty.'

It was a very loose instruction for an organization which initially consisted of fourteen disparate allies. Several artists had already submitted designs before the brief was published, incorporating some of the many symbols of war and defence – a chain, a flaming torch, a shield, a knot, the still waters of the Atlantic, even (on one) an olive branch of peace. One included fourteen stars to represent the fourteen members, but was rejected on the grounds that it would have to be redesigned every time a new state joined the organization.

A NATO emblem was approved in 1953. Abandoning all the military symbolism of earlier submissions, it was a simple, white four-pointed star in a circle, representing the four points of the compass, on a deep blue background representing the Atlantic Ocean. It was certainly 'simple and striking' as requested. Further interpretations of the symbolism, as described by NATO's Secretary General at the time, may seem fanciful and retrospective: the compass, he claimed, 'keeps us on the right road, the path of peace, and a circle represents the unity that binds together the 14 countries of NATO'.

There are now thirty member states in NATO. The admission of West Germany in 1955 prompted the signing of the communist equivalent of the North Atlantic Treaty, the Warsaw Pact. With that event, the two sides of the Cold War were clearly drawn and labelled in each others' and the public's eyes.

OPPOSITE TOP: The NATO logo emblazoned on the side of a jet at the Farnborough airshow. OTAN is the French acronym (L'Organisation du traité de l'Atlantique nord).
OPPOSITE BOTTOM: The chosen logo and accompanying flag lack any kind of aggressive military symbolism.

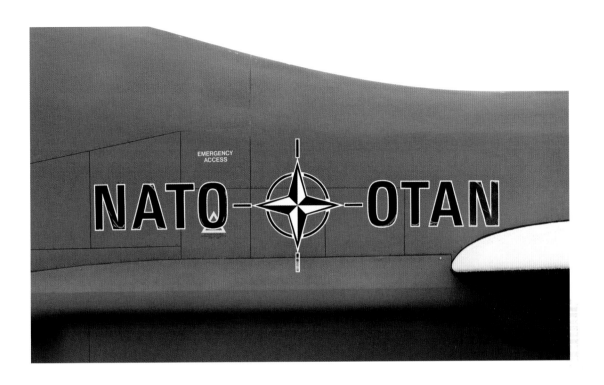

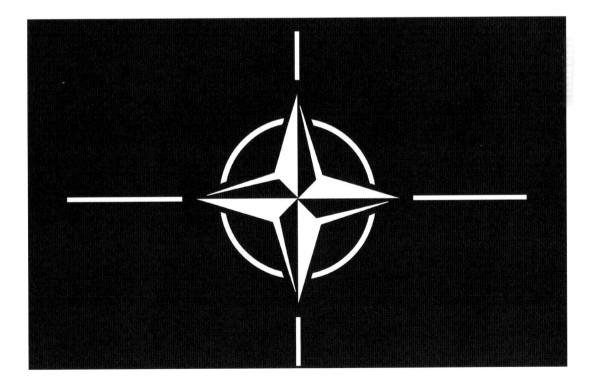

TOP: *Symbols from left to right: Wash at 40°C, Don't bleach, Item can be tumble-dried, Iron at medium heat, Don't dry-clean.*

LEFT: *Symbols from left to right: Wash at 30°C, Iron at low heat, Don't bleach, Item can be dry-cleaned without use of certain solvents, Item cannot be tumble-dried, Dry flat.*

Washing instruction symbols
(1956)

We all take for granted the care instructions on labels sewn into almost every item of clothing, even if we don't know what they all mean. They have offered their advice for nearly seventy years and they have their origins in the clean, fresh, alpine pastures of Switzerland.

Man-made fibres have been around since 1855 when Georges Audemars, a Swiss chemist, first synthesized rayon. He called it artificial silk, but the process of dipping a needle into a pulp of mulberry bark to draw out the thread was too laborious to be cost effective. The invention of nylon in 1938 made artificial fibres commercially viable, and nylon stockings, introduced in 1940, opened up the market – 64 million pairs were sold in 1940–41.

New textiles presented new problems for washing machine manufacturers. To compete with synthetic materials, natural fibres were also changing, undergoing new processes to increase their comfort and durability. Early washing machines had only two settings – 95°C for whites and colourfast items, and a cooler 60°C wash for colours likely to run. Now a multiplicity of programmes was required, but knowing which one to use was another matter. Some clothing carried written instructions, but if it was imported they might be in a strange language.

In Switzerland the Arbeitsgemeinschaft für das Textilpflegezeichen (Swiss Association for Textile Care Labelling, SARTEX) began to address the issue in 1956. They designed a series of simple pictographs which could communicate care advice without words. After consumer testing and revision, they were first circulated in Switzerland in 1958.

In the 1960s synthetic textiles were not only widespread but fashionable. SARTEX was superseded in Europe by the International Association for Textile Care Labelling, GINETEX, based in France. GINETEX further developed SARTEX's original designs and launched them in 1963. By the 1970s they had been widely adopted by most clothing manufacturers producing in Europe or exporting to the continent.

GINETEX has twenty-two member countries from South America to Asia. North American labelling is, however, dictated by the American Society for Testing and Materials (ASTM), a national body with an altogether wider remit. It was founded in 1902 after a spate of railroad accidents to regulate the quality of the steel used in the rails. Its standards are formed by committees – one for each area of interest – and today there are over 140 ASTM committees considering everything from nuclear materials to pipeline maintenance.

ASTM's textile care symbols are broadly similar to GINETEX's, and between the two they account for the small variations which occur on labels of the now-global textile trade. Both organizations regularly revise their marks to take account of the unstoppable march of technology, covering all aspects of laundry from cleaning to drying to ironing.

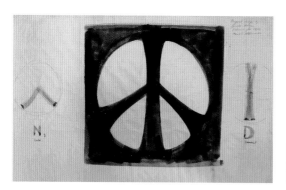

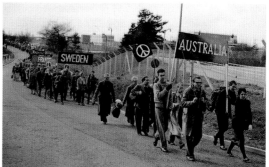

TOP LEFT: *The original Gerald Holtom drawing.*
TOP RIGHT: *The Aldermaston March, first undertaken in 1958,*
became an annual protest.
ABOVE: *Holtom's legacy is a symbol that is still used in protest today, both to*
campaign for peace and for nuclear disarmament.

Campaign for Nuclear Disarmament

(1958)

An internationally recognized symbol of peace began life as a badge of honour for thousands of protesters marching against nuclear weapons. It was designed by an artist who found himself in despair at the folly of the nuclear arms race.

The initial Aldermaston march was organized in 1958, by the Direct Action Committee Against Nuclear War (DAC), which had been formed the previous year in response to Great Britain's nuclear tests in the Pacific. The demonstrators walked for four days over Easter from Trafalgar Square in London to the British government's Atomic Weapons Research Establishment near the village of Aldermaston in Berkshire.

The DAC commissioned Gerald Holtom, an artist and passionate opponent of nuclear weapons, to design a symbol under which the Aldermaston marchers could gather. Holtom was a conscientious objector during World War II who now found himself horrified by the proliferation of atomic bombs.

He presented his idea to the Committee in February 1958. He had originally considered placing a Christian cross inside a black circle, but the Church's position on warfare was often less than pacifist, such as the blessing by a US chaplain of Enola Gay, the B-29 bomber which dropped the atomic bomb on Hiroshima.

Instead, Holtom created an amended cross by combining the semaphore signals for the letters N and D, standing for Nuclear Disarmament. The resulting image reminded him of a human figure in despair with outstretched arms. Later he would express regret that he had not created a more optimistic symbol, and wished that he had drawn it with the arms raised up in hope.

The DAC were delighted with the design. The Aldermaston March attracted thousands of people opposed to nuclear weapons, and Holtom's symbol was widely pictured on national newsreels. The march was supported by another new pacifist organization, the Campaign for Nuclear Disarmament (CND), and later in 1958 CND adopted the symbol as its own.

Before the end of the year its use had spread to America, when Albert Bigelow sailed his boat into the danger zone of a US nuclear test with the CND logo on a banner. The design was taken up by anti-Vietnam protestors in America in the mid 1960s and became a more general symbol of peace in the hands of ex-servicemen and hippies by the end of the decade.

It has joined an already well-stocked gallery of peace symbols. The Greek goddess of peace, Eirene, was represented by an olive branch, as was her Roman equivalent, Pax (from which we get the word 'peace'). In Christian iconography the dove of peace was a sign that the catastrophic flood waters in which Noah sailed were receding. The flood was associated with baptism by water, and thus the dove became associated with the peace of the Holy Spirit which descended on the baptized.

White poppies were first distributed by the Women's Co-operative Guild in 1933 to counter the perceived commemoration of war by red poppies. The two-fingered V-sign was originally used in World War II to mean 'Victory', but was adopted by anti-war hippies in the 1960s to confer peace on each other. The now widespread rainbow peace flag was first used on another protest march, from Assisi to Perugia, organized by Italian pacifist Aldo Capitini in 1961.

Beside its widespread adoption as a universal symbol of peace, the CND logo is still used in its original anti-nuclear meaning. In the twenty-first century, protests against Britain's use of the US Trident missile system have used an image of Gerald Holtom's peace-laden symbol breaking a missile that has crashed through it. After 2,500 years of peace icons, the need to gather under banners to oppose war remains as strong as ever.

World Wildlife Fund panda

(1961)

The World Wildlife Fund (WWF) was founded in London in 1961 to campaign for the protection of natural wildlife habitats. In their search for a symbolic animal to represent all endangered species, the WWF didn't have far to look.

A series of articles by Sir Julian Huxley, the first director general of UNESCO, in *The Observer* newspaper in Britain in 1960 drew attention to the destruction of habitats in East Africa. An existing organization founded by Huxley, the International Union for the Conservation of Nature (IUCN), was struggling to attract funding for its projects, and Max Nicholson of the Nature Conservancy saw an opportunity to stimulate financial support for them. He and more than twenty other individuals founded the WWF and immediately set about fundraising for the cause. High on their agenda was the need for an immediately recognizable symbol for their activities.

Chi Chi, a female giant panda, had arrived at London Zoo in 1958. She was not the first: five wild pandas were captured and donated to the zoo in 1938. But in the optimism of post-war Britain, where rationing had only ended in 1954, Chi Chi quickly achieved celebrity. The slow-moving bear with its striking black and white coat represented novelty on the eve of the swinging sixties.

Gerald Watterson, a Scottish naturalist who had just been appointed Director of the IUCN, made some pen and ink studies of Chi Chi at the zoo. Sir Peter Scott, another naturalist, renowned wildlife artist and son of Scott of the Antarctic, drew a logo for the WWF based on one of Watterson's sketches. Its success is reflected in the fact that sixty years later, with a few small changes, it still represents the organization.

The WWF panda is an object lesson in good design. It is instantly recognizable and embodies its message of wildlife conservation. It contains no letters and can therefore be used internationally with no changes.

And it is a simple black and white image, without shading, so it can be reproduced cheaply on the most basic of printing equipment, or even by stencil.

It has been revamped on several occasions, most notably in 1986 when the image was simplified by the removal of some outlines and detail. The panda's claws had been omitted from 1970, and as Jerry Kuyper, Design Director for the changes, recalls: 'We looked at a dozen ways to add details to the eyes before realizing the obvious – the solid black shapes were the most engaging and open to interpretation.'

The WWF had immediate and notable success. Two years after its foundation, China, which occupies most of the panda's natural habitat, established its first panda reserve. It now boasts over forty, many of them contiguous to enable a broader exchange of DNA between formerly isolated breeding groups. The population has risen from as little as 1,000 to over 3,000, and the panda's conservation status has been downgraded from 'endangered' to 'vulnerable'.

A panda is an expensive animal to keep in captivity – one panda costs a zoo five times as much as an elephant to look after. Nevertheless the popularity of the animal, thanks in large part to the success of the WWF logo, has made pandas a lucrative draw for zoos. Chi Chi was destined for Brookfield Zoo in Illinois, but the US refused her entry into the country because of a political boycott in place at the time. Instead she lived a long life in London. She died in 1972 and was mourned by the entire nation.

China has capitalized on the popularity of the species with so-called 'panda diplomacy'. The country no longer sells pandas overseas, but leases them for up to $1 million a year for periods of ten years to nations seeking trade or political ties with China.

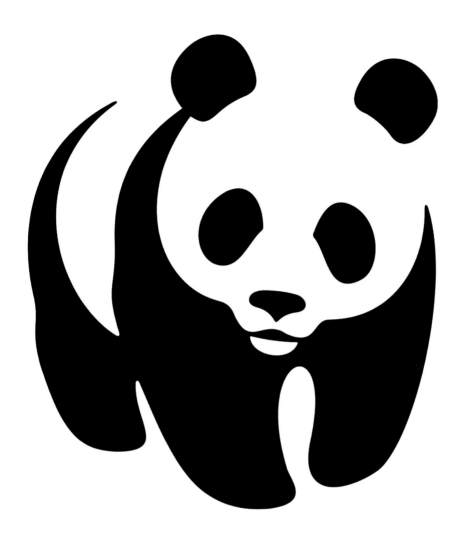

ABOVE: *The modern streamlined logo.*
LEFT: *Chi Chi with her keeper, Alan Kent, at London Zoo in March 1960.*
OPPOSITE: *The original panda from 1961 was more bow-legged and had claws. A 1970 makeover removed the claws and smoothed the outline, while in 1986 it became a much simpler and perhaps less endearing animal.*

The Smiley

(1962)

One of the most recognizable and flexible of symbols, the Smiley face has taken on many different meanings since its creation in the 1960s. From the Peace movement of the 1960s through the high-energy dance culture of the 1980s, the Smiley has evolved into an entire language of emotional expression.

The ability to recognize faces is a fundamental human trait. And we find faces everywhere – in rock formations, random markings on food, dappled sunlight, a curiously shaped tree stump. Finding them where none exist is a phenomenon called pareidolia and today we have taught our computers to recognize faces using the same tricks as pareidolia – looking for the simple pattern made by a mouth and two eyes.

That's all it takes to make us think we see a face, and humans have been drawing faces that way for thousands of years. When they reassembled the fragments of a Hittite drinking jug from 1700 BCE, archaeologists found a Smiley drawn on the side of it with a thumb dipped in black ash: one curve, two dots. In seventeenth-century Slovakia one lawyer used to mark documents with a smiling sign of approval, one curve, two dots, inside a circle, beside his signature.

The curve and two dots in a rough circle appeared on a yellow background for the first time in 1962 – on a yellow T-shirt, to be precise, as if daubed with a paintbrush, in a marketing campaign by New York radio station WMCA, with the slogan, 'Be a good guy'.

A year later the Smiley arrived in the form we recognize today – a perfect yellow circle containing two little oval dots for eyes and an irregular wide smiling mouth with dimples at either end. It was designed by Harvey David Ross, a Massachusetts graphic designer charged with boosting workforce morale at an insurance company. Ross deliberately drew the features by hand to give the Smiley some character. This design was picked up by other companies, including one producing novelty items, thanks to whom some fifty million Smiley button badges spread the image around the world. They were accompanied by the slogan 'Have a

happy day', which eventually became 'Have a nice day'.

Such well-meaning wishes were in tune with the mood of 1967's hippy-led Summer of Love and the Smiley entered popular culture. As pop music diversified into other genres, the Smiley was sometimes used satirically or subversively. The cover of the Dead Kennedys' 1979 debut single 'California über Alles' used a scene reminiscent of a German Nazi Party rally, but with the swastikas replaced by Smileys.

Some say that the dance culture of the 1980s adopted the Smiley when one DJ, Danny Rampling, used it to celebrate the birthday of another, Paul Oakenfold. However, this was the era of Acid House music, and Smileys were among several icons printed onto acid tabs – small squares of blotting paper soaked in the hallucinogenic drug LSD – to denote individual doses.

With the rapid expansion of communication by text instead of by voice in the 1990s it became all too easy to misunderstand the mood or emotion of a message. Scott Fahlman of the Language Technologies Institute at Carnegie Mellon University first suggested in 1982 the use of :-) and :-(to show whether a typed remark was a joke or not. Yahoo Messenger became the first to incorporate Smileys, as status indicators of the moods of its users, in 1998; and they became commonplace characters within text messages from 2001 onwards.

Today these emotion icons, emoticons for short, have expanded to include facial expressions for all occasions and moods, and symbols for objects and events of all kinds, to the extent that whole messages can be written and understood without the use of words at all. At their core are the Smileys, which continue to make us smile just as they did the Hittites 3,700 years ago.

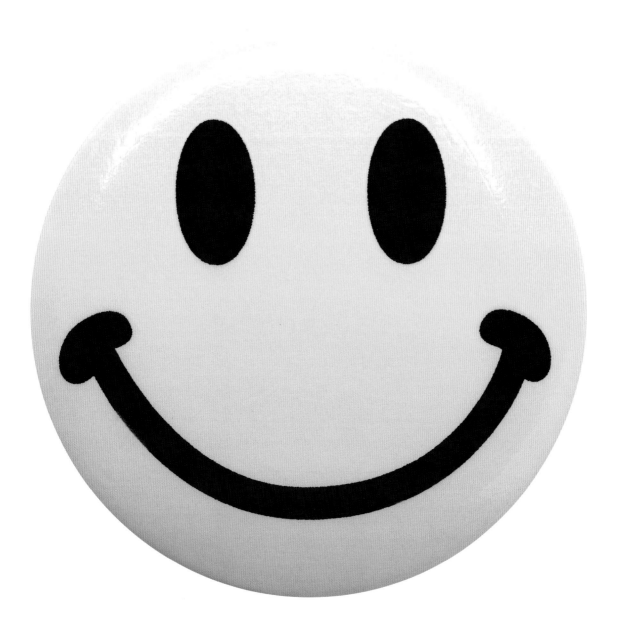

ABOVE: A morale booster from the Hittites to hippies, the standard Smiley has been embellished to convey every form of emotion in text messages.

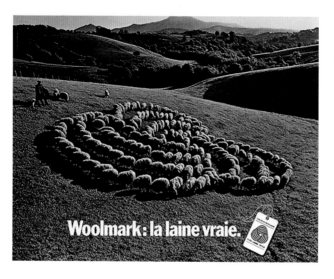

ABOVE AND OPPOSITE: The strength of the Woolmark is that it hasn't been changed since its introduction.
LEFT: A clever French magazine advert reinforcing the brand above any individual product.

Woolmark

(1964)

Faced with the rising tide of synthetic fabrics, traditional woollen clothing was under threat in the early twentieth century. A group of wool producers in Australia – a country built on sheep farming – wanted to distinguish their natural product.

Swiss chemist Georges Audemars invented rayon, the first man-made fibre, in 1855. It took near forty years for someone – English manufacturers Charles Cross and Edward Bevan – to devise a way of producing it commercially. Using a patented process of 1892 to imitate the way in which silk worms produce silk thread, they brought artificial silk to the textile market.

Hitler's Germany invested heavily in rayon. From 9,200 tons in 1934, Germany was on course to produce 90,000 in 1937. That was the year in which the Australian Wool Corporation linked up with similar organizations in South Africa and New Zealand to form the International Wool Secretariat (IWS). The IWS promoted the sale of wool and encouraged research into its properties, in the hope of elevating it to the status of a luxurious and natural material.

The IWS's fears were exacerbated by chemical giant Dupont's announcement of the invention of nylon in 1938. The war which broke out the following year had the side effect of popularizing nylon in the form of nylon stockings given by American servicemen to their girlfriends in Europe.

By the 1950s the IWS had offices in every wool-producing country in the world, with headquarters in London and from 1968 a technical research centre in the very heart of England's traditional wool industry, Ilkley in Yorkshire, decorated with a large-scale mural called *The Story of Wool*.

Artificial fibres were becoming more and more adept at imitating natural ones and the IWS ran a competition in 1963 to design a symbol which would identify pure wool as such. Among the entrants was

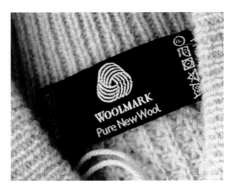

the leading Italian graphic designer Franco Grignani. To his embarrassment, Grignani was also invited to be on the judging panel for the competition. He found himself having to vote on his own design, which had been submitted under a false name by a friend at an advertising agency before he was appointed. He claimed later to have voted against it; but if so he was overruled by the other judges. In 1964 his design was unveiled as the Woolmark symbol.

It remains unchanged today. A simple set of curves reminiscent of a ball of knitting wool and suggesting softness and strength. After various name changes, it is now administered by the Woolmark Company, and has been joined by two variations – one for fibre blends of which wool makes up more than 50%, and another where the wool content is 30–49%. The Woolmark Company has broadened its brief to include care products such as laundry detergents which are kind to woollen textiles, and to apparatuses which are similarly gentle – washing machines for example. To date the Woolmark has been applied to over five billion products since its launch.

The Woolmark was ranked Best Logo Ever by British magazine *Creative Review* in 2011 and 11th best of the previous fifty years in 2017 by US arts journal GDUSA. Franco Grignani (1908–1999) became widely known for his vibrant black and white op art and won many prizes for poster and typography designs. Although he did sometimes work in colour, his use was limited by the fact that he was colour blind and entirely depended on the advice of friends and family about which colour went with which.

Olympic pictograms
(1964)

A sporting festival in which all the nations of the world are invited to take part presents unique challenges of communication. Yet it wasn't until the 18th Olympiad that the organizers took the use of non-verbal symbols seriously. In Tokyo, in 1964, the Olympic icons were born.

It is not practical to make signs in all the languages which might be spoken at the Olympics, and when few people can speak the language of the host nation at all, or read its script, a new visual language is called for. English may be the most commonly understood language on the planet, but choosing one language over another was politically unacceptable (especially to the French).

Although it is widely understood that Tokyo faced a unique challenge and came up with a unique solution, two earlier Olympiads had made efforts to introduce pictograms into their signage. Berlin in 1936 and London in 1948 both introduced symbols for sports, although they were not endorsed by the Olympic Committee.

Berlin benefited from the then-current Art Deco fashion in graphic design. Its pictograms were consistent in approach, making use of stylized elements of each sport set on a bold background circle which spectators would quickly have learned to look out for. London's post-war efforts looked, as one commentator has said, hand-drawn, the sort of thing a talented schoolboy might have sketched in the back of a text book. The approach was heraldic, with literal representations of sports equipment framed in the sort of shield more usually seen holding the coats of arms of the English nobility.

Japan, like many Asian nations, had a visual language quite different from that of Europe. In 1964 it had still not adopted the international traffic sign system put forward by the United Nations in 1949. The Tokyo Olympics Committee was determined to be modern, and in particular to look west for inspiration.

Isotype (standing for the International System of Typographic Picture Education) was being developed at the time by Viennese graphic designer Gerd Arntz based on the philosophical principles of Otto Neurath.

It was a series of pictograms designed to break language barriers in industry, demographics, politics and economy, and thereby to 'emancipate the working classes through knowledge and information'. By the time of his death Arntz had designed over 4,000 of these icons, which reduced situations and concepts to brilliantly simple figures, augmented by small but visually significant details.

This was the approach that the Japanese design team of Yoshiro Yamashita and Masaru Katzumie adopted. The simple silhouettes which they produced are very much in the Arntz mould, but go further in capturing the movement and grace of Olympic athletes of all disciplines. The Tokyo 1964 icons were successful not only individually but as a collection of pictograms which emphasized the diversity of the events brought together under the Olympic banner. They were updated, but not substantially redesigned, by Japanese designer Masaaki Hiromura for the 2020 Tokyo Olympics.

Sports symbols have been a feature of every Olympiad since 1964, their design often used as an opportunity to express the character of the host nation in a way that the Tokyo set did not. Mexico in 1968 introduced hot colours and reduced the icons to as little as a single limb in action, in an Aztec style. Munich 1972 stylized the figures further, in one of the most memorable sets of Olympic symbols, so that all the angles were either 45° or 90°.

Barcelona departed from the norm in 1992 with figures drawn in a few ragged brushstrokes, and the Lillehammer Winter Olympics of 1994 presented symbols in the style of a 4,000-year-old figure on skis discovered on the walls of a Norwegian cave. Sydney incorporated the form of a boomerang into its figures in 2000, and the designs for Athens 2004, shaped like fragments of pottery, harked back to the figures of athletes painted on the sides of Greek vases in the time of the original Olympic Games.

LEFT: *The Olympic pictograms from Tokyo, 1964.*
OPPOSITE: *One of the official posters for the 1964 games.*

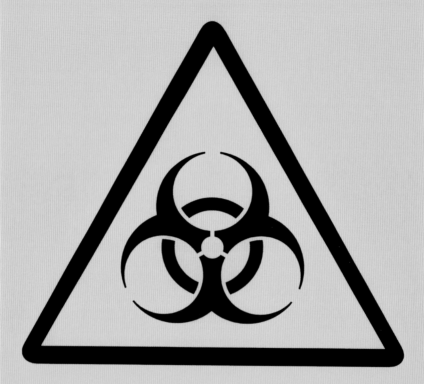

DANGER

BIOLOGICAL HAZARD

ABOVE: *Dow Chemicals were in the business of creating noxious poisons, and so a universal warning symbol would be a very useful precaution for goods in transit.*

Bio Hazard

(1966)

The Covid-19 pandemic which stopped the world in 2020 was an unwelcome but perfect illustration of the dangers of an uncontrolled biological hazard. The warning symbol on containers of such deadly material was created by a company which itself supplied death on a grand scale to the US government.

The Dow Chemical Company manufactured napalm and Agent Orange for the US Army to use in the Vietnam War. At the height of that conflict, in 1966, a Dow employee became concerned that the company dealt in many dangerous chemicals, whose containers might carry any number of different warning symbols. This was sometimes confusing and potentially dangerous. Charles L. Baldwin, an environmental health engineer at Dow, saw a need for a universally recognized symbol which would inform people at a glance what they were dealing with.

Baldwin discussed the need with Robert S. Runkle at the US National Institute for Health (NIH), then presented Dow's packaging design department with a closely defined brief. The symbol must be:

- Striking in form to draw immediate attention
- Unique and unambiguous, not to be confused with symbols used for other purposes
- Quick to recognize and easy to recall
- Easy stencilled
- Symmetric, in order to appear identical from all angles
- Acceptable for groups of varying ethnic backgrounds

The design team delivered some forty ideas from which the final striking icon was chosen. A focus group was shown it among a number of familiar symbols and naturally its members did not recognize the new design. However, when the same group was shown it again a week later with an expanded selection of common signs, everyone was able to identify it correctly.

Baldwin and Runkle set about publicizing the symbol with articles in newspapers and scientific journals. They wanted it to be devoid of meaning, so that its message

could be explained correctly from the beginning. Although it is undeniably different, there is symbolic meaning in its elements for those who wish to see: from a central circular container, something which could give you a nasty bite or sting is escaping in all directions. All its curves are arcs of perfect circles.

The biohazard symbol does have a 'right way up', dictated by the fact that it is only symmetrical on one axis. But as Baldwin intended, it is strong enough to be recognizable from any direction and at any angle. Its triangular arrangement is distinctive but not unique – it has something of the quality of the prehistoric triple-spiralled triskele. In modern times it also owes something to the radioactive warning symbol. It challenges the human brain, which is always looking for symmetry, and that challenge makes it memorable.

Ease of stencilling requires that the biohazard symbol be monochrome. There is no stipulation about background colour, but it is most commonly printed as black on yellow or orange. That combination has been found most distinctive in tests during Arctic expeditions, when eyesight is affected by extreme cold and by snowblindness.

The symbol is now in common use on all biological hazards which may be bacterial or viral, borne by humans or by animals, or contained in medical waste. It has undoubtedly saved the lives of lab technicians, sewage workers, farmers and others who habitually deal with dangerous organic compounds. It is in the public domain, free for use, and has occasionally found other applications. In the late twentieth century it became a popular if ironic tattoo design among people living with the HIV virus.

International Symbol of Access

(1968)

The familiar symbol of a figure in a wheelchair has been guiding those with limited mobility to accessible routes for over fifty years. As its use has broadened to indicate access for others with different forms of disability, many are beginning to question its fitness for purpose.

The great design theorist Victor Papanek (1923–1998) was born in so-called Red Vienna, at a time in the wake of World War I when the city was run on strongly socialist principles. He believed that symbols by their very design conveyed political and social attitudes as well as their more obvious practical messages of direction or instruction. He spent his life teaching what he preached; and in 1968 he was overseeing a conference on radical design in Stockholm, arranged by the Scandinavian Students Organization.

The conference was a balance of lectures by Papanek and others, and practical workshops for the attending students. Papanek was turning his attention to attitudes to the disabled at the time, and at one of the workshops the brief was to design 'a sign-symbol to mark barrier-free accommodations'. A Danish student, Susanne Koefoed, came up with a clear, stylized image of an empty wheelchair consisting of three quarters of the chair's large wheel and a simplified indication of its frame and footrests.

The symbol was exhibited at the end of the conference and around Sweden over the following year. Karl Montan, the director of Sweden's newly established Handicapped Institute, recommended Koefoed's design to a disability rights organization, at its Dublin conference in 1969. When some of the attendees remarked that it lacked human warmth, Montan simply lent across and drew a circle onto Koefoed's original. Now the chair's frame had a head and instantly the formerly empty wheelchair was occupied. Thus the International Symbol of Access was born.

It was originally intended to indicate routes in and out of buildings and other places used by wheelchairs. These routes were found to be useful to others who, although not wheelchair-bound, also benefited from paths without steps. The sign came to be used in other situations in which disabled people in general would benefit from extra help, for example in public toilets and parking spaces.

Some disability campaigners objected to the passive nature of the figure in the wheelchair, which in terms of Papanek's theories implied that the disabled were helpless. Activists Sara Hendren and Brian Glenney introduced an updated version of the design in 2014, in which the figure is leaning forward and clearly engaged in activity. This has found some acceptance, although the Koefoed original is so widely understood that many regulatory bodies, including the International Organization for Standardization, have rejected the more positive, dynamic version.

The wheelchair symbol is now applied to such a wide definition of disability that its suitability is being called into question. The World Health Organization estimates that around a billion people have some form of disability, of whom only 65 million, 15%, need a wheelchair. The success of Koefoed's symbol in raising the public awareness of disability has led, ironically, to misunderstanding. Those with less visible disabilities such as impaired hearing, sight and speech are sometimes aggressively challenged about their right to use facilities intended for the disabled, simply because they aren't using a wheelchair. Early steps to overcome this unforeseen problem have led to the design of new symbols for the deaf and blind.

Computer systems, now among the greatest innovators of symbols in our lives, have come up with their own solutions for disabled access. Although a wheelchair is no barrier to computer use, Microsoft Windows did adopt the wheelchair icon for early versions of its 'Accessibility' settings. Now it has been renamed 'Ease of Access', with a superficially similar icon in which the wheel and frame have become simple lines and arrows implying alternative routes.

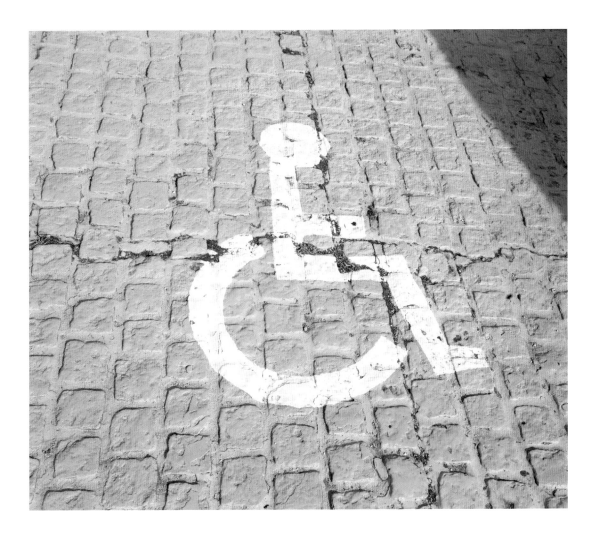

ABOVE: One logo, but slightly different transatlantic messages. Whatever the nuances of the campaign slogan, Tidyman has always been there as a helpful reminder.

Tidyman

(1969)

The familiar litter-picking icon, known as Tidyman, started life in Britain but is now recognized around the world for its clear message of environmental care. Tidyman may be well known, but until recently the identity of his creator was something of a mystery.

The design was originally commissioned in 1969 for an anti-litter campaign in Great Britain called 'Keep Britain Tidy'. The Keep Britain Tidy (KBT) organization was founded in 1955 in response to a call for cleaner streets by the British Women's Institute annual conference the year before.

The organization had an early success when the British government passed the Litter Act into law in 1958. This made it an offence punishable by a fine of £10 to drop rubbish in a public place. By the 1960s, however, a generation of newly empowered teenagers were showing little respect for their parents' attitudes to society or the urban environment. A new campaign was called for.

The brief from KBT was to create a pictogram, a simple self-explanatory symbol that could be reproduced in any colour and needed no supporting text to explain its meaning. The intention was for it to be included not only in poster campaigns but also on the sort of packaging – food wrappers and tins for example – which became the litter KBT was trying to prevent. Such packaging was often designed with international, not just English-speaking markets.

The result came to be known as Tidyman, who more than amply fulfilled the brief. He was wordless and monochrome, and his message was abundantly clear. He even looked like the litter he was campaigning against – his body like a twisted sheet of newspaper and his head a discarded lid or bottle top. He very quickly entered the lexicon of public symbols which are widely recognized and understood. In publicity campaigns he appeared alongside celebrities including Abba and the Bee Gees and forged a very successful partnership with the Wombles, rodent-like stars of a series of books and TV animations who kept their world clean by picking up litter on Wimbledon Common.

Printed on exported packaging, Tidyman won hearts around the world as other countries began to adopt him. He was given his own heart in 2011 in support of a new UK initiative to 'love where you live'. But as KBT's role expanded to include broader environmental concerns, it was felt that Tidyman's message was too narrow; and in 2014 he was dropped like an old film star for whom there was no longer a role.

His public, however, missed him, and three years later he was reinstated on KBT publicity material. His return nearly fifty years after his debut prompted new curiosity about his origins. KBT claimed that he was an American, the result of a collaboration in the 1960s between the American Brewers Association (ABA) and the Keep America Beautiful (KAB) organization. There was a rumour that he was first used in an anti-litter campaign by Budweiser Beer in the 1950s. But neither ABA, KAB or Budweiser had any record of such a story.

Peter Jones, a British industrial and environmental design consultant, launched an Internet appeal to get to the bottom of Tidyman. He got no response for three years, until in mid-2020 he received an email from Chris Wall, by now the head of his own design agency. 'The Tidyman was commissioned by Robert Worley of The Keep Britain Tidy group,' Wall wrote. 'As a freelance designer at the time, I created the original artwork for the Tidyman – and now just wish I received royalties for its use!'

Tidyman remains the figurehead of the Keep Britain Tidy campaign to this day. The maximum fine for littering in the UK is now £1,000.

Universal Recycling symbol

(1970)

If ever a symbol was needed, it's the Recycling triangle. As consumer awareness of pollution was awakened in the 1960s it took a farsighted US corporation and a Californian design student to design the sign which, perhaps more than any other, has changed the world.

Earth Day, an annual event focused on protecting the environment, was first held on 22 April 1970. It was proposed by the Democrat US senator Gaylord Nelson, who recruited the young environmentalist Denis Hayes to coordinate activities on the day. It's estimated that around twenty million people took part that inaugural year, one of the largest one-day demonstrations for a cause in human history.

The scale of the response to Nelson's proposal was evidence of the groundswell of public opinion in favour of environmental protection as the 1960s drew to a close. A major motivator was the disastrous Santa Barbara oil spill of 1969, when three million gallons of oil killed thousands of seabirds, dolphins, seals and fish along the Californian coast. Although the 1960s are often characterized as the decade of love and peace, it wasn't only hippies who were worried about Mother Earth. America's United Auto Workers trade union (UAW) gave major financial backing and practical support to Earth Day; and Container Corporation of America (CCA) ran a design competition ahead of the big day.

CCA were a large company producing recycled paperboard and they invited design students to come up with a symbol to indicate the process of paper recycling. Gary Anderson, a twenty-three-year-old student at the University of Southern California, was the winner. His design consisted of three folded paper arrows following each other around a triangle.

It showed the influence of the ground-breaking Bauhaus industrial design school in 1920s Germany, but also a more contemporary reference to the trompe-l'oeil drawings of the Dutch artist M. C. Escher, which were becoming popular in the age of hallucinogenic

drugs. Escher is the man who drew impossible eternally climbing staircases and tessellations of fish which became birds. Because one of Anderson's arrows is folded differently from the rest, they would form (if they were a continuous strip of paper) an Escheresque Möbius strip – a ring of paper with only one side.

At that time, car manufacturer Volkswagen was marking some of its recyclable components with two arrows forming a circle. Anderson chose three arrows to show process rather than simple exchange. The triangle is a more dynamic shape than a circle, and Anderson originally drew his the other way up, standing on a point, which gave the symbol an added sense of movement – although possibly also of instability. CCA chose to use it in the way we see it today.

The Recycling symbol has found applications far beyond CCA's paperboard to other recyclable materials. It indicates that an item can be recycled, but not that it has been – although sometimes it appears with a percentage figure in its centre showing exactly how much of the item is made of recycled material. At other times a figure in the middle between 1 and 7 indicates which of seven groups of recyclable plastics have been used in its manufacture.

Earth Day remained a largely all-American affair for its first twenty years. But in 1990 its organizer, Denis Hayes, established events in 140 other countries. Today it is celebrated in 193 countries by over a billion participants. Its international global importance was recognized in 2016 when Earth Day, April 22nd, was chosen as the date of the signing of the landmark Paris Agreement, a climate protection treaty agreed by over two hundred of the world's nations.

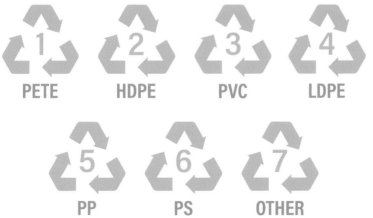

PETE HDPE PVC LDPE

PP PS OTHER

ABOVE: A three-dimensional rendering of Gary Anderson's competition-winning symbol.
LEFT: Seven grades of plastic: 1 is Polyethylene Terephthalate (drinks bottles), 2 is High Density Polyethylene, 3 is Polyvinyl Chloride, 4 is Low Density Polyethylene (plastic bags), 5 is Polypropylene, 6 is Polystyrene (difficult to recycle), 7 is everything else.

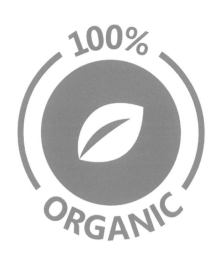

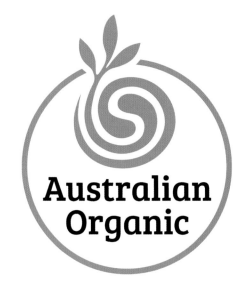

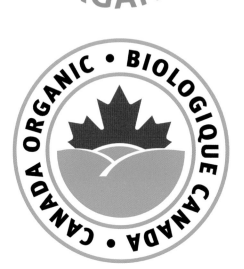

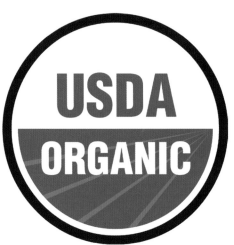

ABOVE: When dealing with discriminating consumers, it is important that the correct symbol is visible on the packaging. A collection of national organic symbols from Sweden, Australia, Canada, USA and Britain.

Organic certification symbols

(1973)

The practice of greenwashing – exaggerating the eco-friendly aspects of a product to distract from its potential environmental damage – is widespread in the age of climate change. There is a greater need than ever to have certifiable standards for those things which are genuinely kind to the planet.

Since the final decades of the twentieth century there has been a proliferation of organizations offering accreditation for environmentally friendly practices in the production of food and cosmetics. At worst they do little more than rubber-stamp a product in return for a fee. But the best such bodies are able to reassure the buying public, with their authority and experience, that items carrying their seal of approval can be trusted.

Organic sources of food have been a particular focus of public concern. The incorporation of organic guarantees into packaging design has become a common sight on supermarket shelves in many countries. An insistence that 95% of a product be from organic sources is a common standard.

Most countries have their own respected organic certifiers: in the US, the government's Department of Agriculture issues a circular symbol of approval with a stylized background of a ploughed field. The Canadian government's mark shows rolling green hills behind which the sun rises in the form of a red maple leaf. In Europe the European Commission is responsible for branding approved organic goods with twelve stars from the European flag arranged in the outline of a leaf.

In Australia organic approval is given by private companies among whom Australian Certified Organic (ACO) is recognized internationally by other countries in the region, including Korea, China and Japan. Its evocative symbol pictures a plant and its roots curled around each other in the form of the yin and yang symbol – the implication is that nature is organically in balance.

Despite the existence of such authoritative organizations and their recognition in countries other than their own, there are so far no cross-border

international agreements on universal conditions for awarding an organic certificate. There is, however, a coordinating body, the International Federation of Organic Agricultural Movements (IFOAM), commonly known as Organics International. It does not certify organic products, but it does certify certifying organizations.

IFOAM was founded in 1972 at the instigation of Nature et Progrès, a French association of organic growers, producers and consumers formed in 1964 whose logo also refers to the yin and yang symbol of balance in nature. Nature et Progrès invited four other early pioneers of organic farming to a meeting in Versailles: the Biodynamic Association of Sweden (founded in 1948), the Rodale Press (an American publishing house which launched its magazine *Organic Farming and Gardening* in 1942), and the Soil Associations of both South Africa and Britain.

The British Soil Association was set up in 1946. It is no coincidence that so many of these early organic bodies date from the 1940s. During World War II, food production around the world was disrupted. The need to guarantee supplies led to a sharp and alarming rise in the use of pesticides and intensive forms of farming which could give short-term increases in yield but at long-term cost to the environment. The Soil Association was launched to campaign for traditional farming methods as much as for organic ones. Its triangular symbol is based on the initials of its name, S and A, abstracted in a way which suggests the turning over of soil by ploughing. Since 1973 it has been the most widely recognized and trusted stamp of approval for organic products in the United Kingdom.

Power on/off symbol

(1973)

The first public electricity supply in the world was installed in the English market town of Godalming in 1881. Since then we have been connecting more and more devices to the power grid. Our need to find the on-off switch has never been more important.

Given the importance of electricity as a power supply and the massive international trade in electrical goods, it's surprising that human interaction with it is not more standardized than it is. Yes, most of the world operates on between 220 and 240 volts, but a large minority, including those key electrical markets the USA and Japan, operate on 120v. Elsewhere, some countries use 100v, while Saudi Arabia and Mexico both have dual supplies: 127v for domestic use and 220v for industry.

When it comes to our connections to the grid, there are at least fifteen different domestic plug-and-socket designs, not counting those intended for heavy-duty use. Thank goodness that at least we have agreed on a standard symbol for the humble on-off switch.

It's the one electrical component which we have to deal with on a daily basis. From lamps to kettles, from computers to vacuum cleaners, switching the power on makes them work, and in the event of a fault, switching them off promptly can save a lot of damage.

The earliest switches were unlabelled; many still are, and sometimes it's still a case of trial and error to find out which way is on and which off. Manufacturers sometimes labelled switches with the words On and Off, which is helpful for English speakers, but no-one else. Other signs have used colour signals: red for off, green for on, but that puts the colour blind at a disadvantage.

To escape language barriers and visual difficulties, the International Electrotechnical Commission (IEC) adopted a new set of symbols in 1973, which made the difference between off and on as clear as possible. As graphic markings, a straight line and a closed circle are unmistakable from each other. Rocker switches which carry the symbols are clear: users push the line to switch power on, and the circle to switch off. Although the IEC refers to the symbols as a line and a circle, they also evoke the numbers 1 and 0 of the binary counting system.

Button switches, sometimes known as 'push-to-make, push-to-break', carry one of two combinations of the line and circle. If the line is completely enclosed by the circle it indicates that off means completely off – no electricity is entering the device in question. However, most electronic products still have electrically live components even when their output is switched off, a state referred to as standby; and the symbol for their switches shows the line breaking across the circle.

The advantage of the original line and circle is that if they are engraved or in relief they are different enough to be read by touch alone. The disadvantage when the two versions are combined is that they look and feel very similar. Another standards body, the Institute of Electrical and Electronics Engineers, proposed in 2004 that the IEC standby symbol indicate simply a power switch, and that a new symbol, a crescent moon, be introduced to show that an item is in sleep mode and is still receiving electricity.

ABOVE: The broken circle indicates that there is an electric supply on standby waiting to be activated.

Leather mark

(1973)

The widely recognized sign of an animal hide accompanied by the words 'Genuine Leather' can conceal a multitude of leather-working processes which leave the hide looking and feeling anything but natural.

Over the past fifty years a variety of certificates have been introduced to reassure consumers of the authenticity or the environmental credentials of their purchases. From the Woolmark to the Forestry Stewardship scheme, symbols have sought to guide us to the genuine article or the careful producer.

The leather industry was no exception. Fashions in the 1960s embraced leather, and the resulting boom for tanners and manufacturers also attracted cheaper synthetic materials to the market. The International Council of Tanners (ICT), a consortium of leather producers' associations from seventeen European countries convened in 1973 to try to protect their industry and their product from synthetic substitutes. To this end they devised the Genuine Leather symbol, a guarantee of a natural product.

The symbol was enthusiastically and responsibly adopted throughout Europe and the USA. It was less responsibly used by manufacturers whose materials bore little more than a passing reference to leather. Split leather, for example, takes as thin a top slice of the leather as possible and mounts it on a textile backing. The shine of patent leather comes not from the leather but from a plastic coating. Corrected grain leather is leather which has been sanded down to remove imperfections before being filled and levelled off with synthetic materials and stamped with a generic leather-like texture.

Worst of all is so-called bonded leather, which uses leather dust chemically combined with vinyl. As little as 10% of the finished material may be genuine leather. Although all these leather products have their place in a cost-conscious market, buyers are too often being invited to confuse 'genuine' with 'real', 'pure' or '100%'.

As in any industry, there are also those suppliers who knowingly pass off entirely man-made textiles as genuine leather. Although there are guidelines which exclude bonded leather and heavily coated leathers from using the Genuine Leather symbol, it has (after almost fifty years of use) little power to impose them or to restrict the use of the word 'leather'. Thus businesses can offer with impunity goods made of 'genuine synthetic leather', something akin to selling 'vegan bacon'.

To make matters worse the use of the symbol has caused trade wars to break out in Europe. The ICT does not have the authority to override any nation's own legislation about leather manufacture. It advised its members to comply with local regulations and register the symbol in their own countries in order to control its use. In Europe only the body representing the Italian leather industry (UNIC) did so. Italian leather is rightly world famous, but by registering the hide symbol, UNIC was now able to protect its own members by turning away leather imports from other European countries unless they had paid a large fee for the use of the mark.

France took Italy to court in Milan and lost on appeal. The German Leather Federation (VDL) is among many European national organizations circumventing UNIC fees by inventing its own symbols. The proliferation of different signs is confusing to the public and undermines the sense of international industry standards still further – something the original Genuine Leather mark was supposed to reverse. What the hide symbol has come to mean is merely 'Contains Some Genuine Leather'.

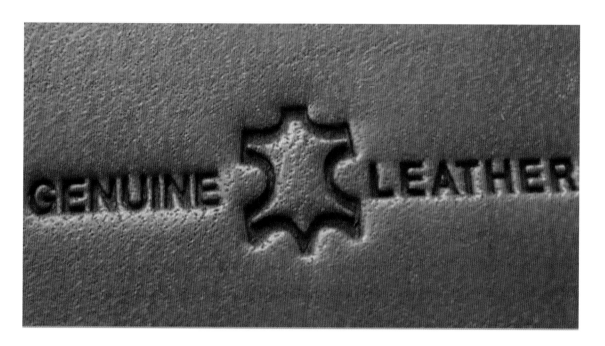

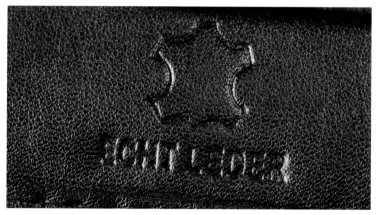

TOP: Standards symbols, such as the leather mark, are intended to build consumer trust, but it has been a tough task for the International Council of Tanners.

ABOVE: 'Echt Leder' – genuine leather mark stamped in a German purse.

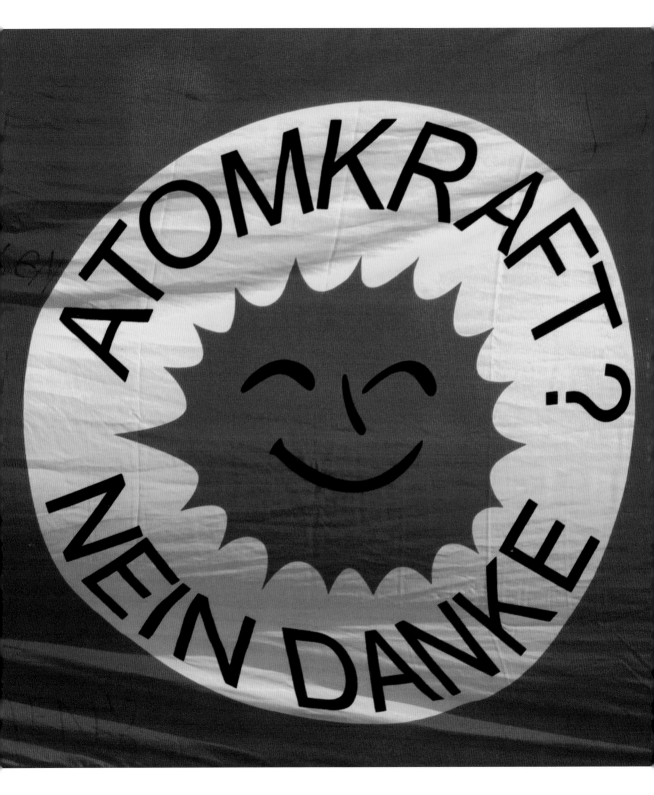

Nuclear Power? No Thanks

(1975)

The proliferation of nuclear power stations in the twentieth century was matched by rising concerns about their safety. While many groups angrily expressed their opposition, one Danish anti-nuclear organization adopted such a polite approach, it was unclear that its members were against it.

For a pressure group, the slogan of the Organisationen til Oplysning om Atomkraft (OOA), or Organization for Information about Nuclear Power, was slightly non-committal, 'Do you feel safe with nuclear power?' Even its publications were questions, not answers: it issued a leaflet called 'A Future Without Nuclear Power?' and its magazine was titled *Atomkraft?*

Denmark's neighbours in Sweden and Germany were expanding their network of nuclear power stations in the early 1970s, and Denmark's government was paving the way for the country to follow suit. OOA's strategy of conversation was effectively communicating the disadvantages as well as the benefits. However, by 1975 OOA decided that they must be more explicit in their opposition.

One member, Anne Lund of Aarhus, took up the challenge. Committed to the less confrontational stance, she wanted an image 'pretty enough for women to wear it on their overcoats,' she recalls, 'to indicate a kind, but firm "no thanks". No clenched fists, no scary images.' Instead of skulls and mushroom clouds, she sketched some alternative sources of energy – the sun, and a wind turbine. Søren Lisberg, a fellow member, recommended keeping the design simple for maximum impact, so Lund retained only the bright, colourful smiling sun, accompanied by the polite but firm message, 'ATOMKRAFT? NEJ TAK'. Nuclear power? No thanks. A question *and* an answer.

The Smiling Sun symbol was an immediate hit.

Its slogan could be easily translated for use anywhere in the world and to date there are versions in around sixty different languages. Its optimistic outlook was a refreshing change from the often downbeat messages from organizations such as the Campaign for Nuclear Disarmament (CND). While CND's iconic logo had been appropriated by the wider Peace movement, the Smiling Sun by virtue of its image and text remained resolutely, cheerfully on message.

Opposition to nuclear power swelled in Denmark in the second half of the 1970s. When the government mounted one last campaign to argue the case for it in 1978, OOA organized protest marches from all of the proposed reactor sites, which converged on the parliament building in Copenhagen. The government was forced to acknowledge that it had lost the argument, and in March 1985 it passed a motion that nuclear power would not be part of the nation's future energy plans.

Following the disaster at the Fukushima nuclear plant in Japan in 2011, a new version of Anne Lund's design was created with an even more positive slogan: 'Renewable Energy? Yes please.' The plant's cooling system failed when it was overwhelmed by a tsunami and the event sparked large anti-nuclear demonstrations. The German industrial giant Siemens withdrew from nuclear generation immediately and German Chancellor Angela Merkel announced only two months later that Germany would close all its nuclear reactors by 2022. The Smiling Sun remains a symbol of hope for the future of the planet's climate.

OPPOSITE: *'Nuclear Power? No Thanks', a slogan taken up by many German environmentalists, has to be one of the most polite slogans in the history of protest.*

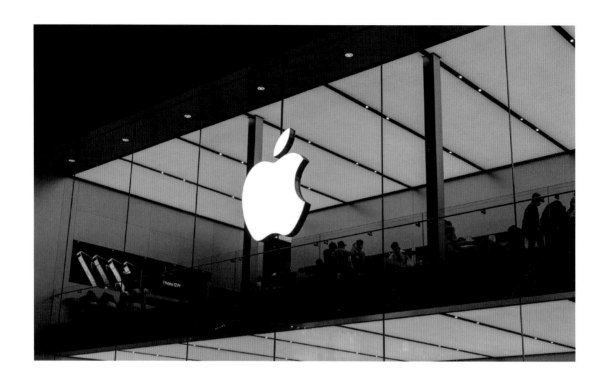

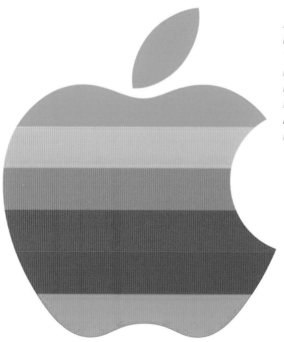

ABOVE: *The instantly recognizable brand symbol for one of Silicon Valley's greatest success stories, though it was the iPod that rescued the computer company.*
LEFT: *In the early days the Apple apple was more Sesame Street than Wall Street.*

Apple Inc.

(1977)

The Apple logo is known worldwide. Everyone wants to own a product bearing the badge. It simultaneously represents constant technical innovation and unchanging reliability, aspiration and satisfaction. The Bitten Apple symbol has remained essentially unchanged for over forty years.

When Apple was formed by two school friends, Steve Jobs and Steve Wozniak, in 1976 they brought in a third partner, Ronald Wayne, to handle the business side of things. Before Wayne famously sold his share to the other two for $800, he turned his attention to a company logo.

Like any physics geek at the time, Wayne associated the word 'apple' with one of the greatest scientists in history, Sir Isaac Newton. Newton observed an apple falling from a tree in his English garden and was moved to discover gravity; so Wayne drew a picture of the incident, wrapped in heraldic style with a ribbon bearing the words 'Apple Computer Company'. Around the edge of the picture he added some words about Newton from a poem by William Wordsworth: 'a mind forever voyaging through strange seas of thought.'

While the slogan captured the idea of ground-breaking ideas, the overall image looked more like a nineteenth-century bookplate than the logo of an innovative tech product. It was visually cluttered and indistinct, and less than a year later Steve Jobs brought in graphic designer Rob Janoff to revisit the whole idea. His brief was to come up with a logo which was simple, modern and recognizable – everything that the Wayne logo was not. Jobs is said to have instructed Janoff, 'Don't make it cute'.

Janoff abandoned the Isaac Newton connection, bought a bag of apples and drew them over and over again, reaching for the simplest representation which would still look like an apple. After two weeks he presented Jobs with the outline so familiar to us all today. Jobs, however, suggested adding the bite, to prevent any misunderstanding, in the absence of any company name, that the fruit might be a cherry. The bite, Janoff would later say, was added simply for scale.

One of Apple's early innovations was the production of the first home computer to display in colour. For the next twenty-one years the Apple apple was coloured in a set of simplified rainbow stripes – six hues instead of the traditional seven, and with green at the top to reinforce the fact that this was an apple, not a tomato.

The rainbow colours began to look a little dated by 1998 and the symbol became monochrome, in time to appear on the back of Apple laptops. The only changes to it since then have been to its graphic texture: glass-like or solid black, an apple-shaped drop of water from 2001, a chrome-plated badge from 2007. Its constancy is a considerable factor in its recognizability.

Behind the scenes, the symbol of something as ubiquitous as the apple has been the cause of international corporate litigation. Apple Corps (the billion-pound holding company founded in 1968 to manage the Beatles' interests) and Apple Inc (the billion-dollar company founded in 1976 by Jobs and Wozniak) fought in the courts for nearly thirty years over its use. Large sums of money changed hands in both directions as a result of perceived infringements of copyright and other agreements before peace broke out in 2007. In the same year Apple Inc copyrighted the leaf component of the logo as a separate entity; and in 2010 Beatles music became available for the first time on iTunes.

There has been one different, unofficial revision of the Apple. When Steve Jobs died in 2011, the Apple-using world went into mourning. Hong Kong graphic artist Jonathan Mak Long produced a version of the logo in which the bite took on the profile of the late founder's face.

Anonymous mask

(1982)

The sinister mask worn by anonymous anti-government protesters around the world from London to Hong Kong has its roots in a graphic novel written in 1982, which in turn took its inspiration from a notoriously unsuccessful anti-government protest in 1605.

When a group of thirteen Jesuit conspirators failed in their attempt to assassinate the Protestant King James I of England by blowing up the Houses of Parliament in 1605, they were sentenced to be hanged, drawn and quartered for their treason. One of them, Guy Fawkes, escaped the fate of his brothers in arms only because he fell off the scaffolding and broke his neck before they could put a noose around it.

Perhaps this is why he became the poster boy for the group, remembered on the anniversary of the plot every November 5th. On that day he is burned in effigy on bonfires throughout Britain, accompanied by fireworks to signify the gunpowder which it was his job to guard before it was detonated.

Writer Alan Moore and artist David Lloyd began to create their graphic novel *V for Vendetta* in 1982. The central character, V, is a revolutionary, dedicated to bringing down the fascist government in the near-future Britain of a post-nuclear holocaust. V is an anti-hero: not for him the usual trappings of a comic book superhero. Instead he wears a mask with the face of Guy Fawkes, a fellow anti-establishment figure.

The three volumes of *V for Vendetta* were eventually picked up by DC Comics, who sold (in America alone) over half a million copies. Inevitably the series caught the eye of the movie industry and a film adaptation was released in 2005, carrying the image of the vengeful, subversive disguise around the world.

In an age when the politics of government has become as polarized as at any time since the mid-twentieth century, the romantic figure of a secretive saboteur caught the public imagination. Demonstrators against all manner of perceived social ills began to wear the mask, defeating authoritarian surveillance and standing up for what they believed.

The mask has become particularly associated with Anonymous, a decentralized, anarchistic movement best known for its online hacking activities and its public demonstrations against the Church of Scientology. Anonymous emerged in 2003, before the release of the film adaptation, and the Guy Fawkes mask was a good fit for their brand of unidentifiable revolution.

Whether you support Anonymous's activities probably depends on whether you have been a victim of their attacks. They have campaigned against child pornography, large financial corporations and the suppression of democracy in the Middle East, but also undermined western governments and military agencies and supported the work of Wikileaks. Their antipathy towards law enforcement agencies makes the wearing of the mask not only apt but necessary.

Today the *V for Vendetta* mask has become a widely recognized symbol of subversive activity, worn by would-be plotters who may be unaware not only of the work of Anonymous but also of Moore and Lloyd's graphic novel and of the failed English revolutionary whose image they wear.

Anti-capitalists who wear the *V for Vendetta* mask may be disappointed to learn that Warner Bros, who made the film, hold the rights to the image and get royalties from each sale. It is the best-selling mask on Amazon.

OPPOSITE: An engraving of the conspirators of the Gunpowder Plot.
RIGHT: A V for Vendetta mask hung up for the evening outside a protester's tent, during the Occupy Exeter protests in 2012.
BELOW: A scene from the 2005 film V for Vendetta.

LEFT: Early Windows was a simple design relying heavily on the name with the symbol as an adjunct.

ABOVE LEFT: The Windows logo from 1992–2001 was bold and colourful, using the primary colours beloved of Google.

ABOVE RIGHT: A less garish look for Windows from 2012 onwards, and a reversion to the original colour – although there have been subtle shade changes since.

Windows

(1985)

The history of Microsoft's Windows symbol is a case study in small changes. In essence it has remained the same since Windows was launched – a window with four panes – but little adjustments with each new release have, over time, made the latest version very different from the first.

The Windows window has been with us since 1985 and Windows 1.0. Its regular updates have been in line with trends in design and are intended to show us that there's a new, still-modern Windows.

From a distance of almost forty years that first version looks very old-fashioned. It was blue and asymmetric, a flat-on view of a window with four panes of different sizes, and its corners were rounded. The lettering of 'Microsoft Windows' was all in capitals in a font with a distinctive W to emphasize the new name; and the font was a serif one to demonstrate the new system's authority: Windows, this classical look announced, was legitimate and reliable. It meant business, at a time when business users were the most likely buyers of computers.

Windows 3.0 brought the first changes. The corners became sharp, the panes were equal, and the muntins – the parts of the frame which separate the panes – now became a simple cross with a bolder, stronger impact. The whole device was shown in graded greyscale, giving it a shiny new metallic look. It still meant business, but already the idea of having a computer in the home was taking hold.

Home computers really took off with Windows 3.1, for which in 1992 the window underwent the biggest transition of its life. It was now in bright primary colours, each pane different to highlight the variety of uses for all the family. It seemed to be moving through space from left to right, leaving a pixelated stream in its wake. Now your home could be connected to the Internet.

This part-window, part-flag image was retained for the next eight years, but even so there were subtle changes. From Windows 3.5 onwards the word Microsoft was posted in lower case, on its side and almost hidden beside the capital W of Windows. If the company was heading towards removing its name altogether from Windows it lost its nerve; for Windows 95 the word was back on top and both words were in a new font with no serif, changing the message from classical to contemporary.

Windows 2000 and the disastrously bug-ridden Windows ME put the now-familiar flag logo inside the foremost of several overlapping square windows, to demonstrate that you could have several Windows windows open at once. The company name was reduced in impact again.

The unpopularity of Windows ME put pressure on its 2001 successor, Windows XP. It had to be different, and it distanced itself with a new take on the four coloured panes. No longer portrait-orientated rectangles, the individual panes and the whole window were now square. Although they still rippled, gone was the pixel trail; gone was the heavy black frame and the bold primary colouration, and even the boldness of the word Windows was taken down a notch. The company name was enlarged again – Microsoft wanted to show that it was still in charge, but this new softer look proved they could respond with understanding to the problems of Windows ME in the new millennium.

For Windows Vista in 2006 the word Windows was no longer bold, but Microsoft finally went through with it and removed their name altogether. Vista, and Windows 7 which followed it, had instead a subtle glow behind the flag, representing the invisible but still-present authority of Microsoft behind the systems.

Everything went (almost) full circle with the introduction of Windows 8 in 2012. Once again we were looking at a simple window, albeit in perspective, divided by a perfectly right-angled cross and all (including the word Windows) in a plain blue only slightly different from the very first design of 1985. There was no Windows 9, and the only change for Windows 10 was a darker shade of blue.

Windows is now a subscription service on the lines of Apple's iOS. Continual updates of the system may mean fewer revisions of the Windows windows, which has been a constant companion in the computer age.

ABOVE: *Originally used by Mothers Against Drink Driving, the red ribbon
has had far greater exposure since for AIDS awareness.*
OPPOSITE: *David Bowie performing at the Freddie Mercury Concert for AIDS Awareness
at Wembley Stadium in 1992.*

AIDS red ribbon

(1991)

Ten years after AIDS started to spread through communities of all kinds, the disease and its victims were still stigmatized and misunderstood. In New York, the Visual AIDS Artists' Caucus met in 1991 to discuss ways of shining a light on victims and on the compassion which their suffering inspired.

Visual AIDS, a coalition of organizations and individuals concerned about the impact of AIDS on the artistic community, was formed in 1988. Its first campaign, launched the following year, was A Day Without Art, to raise awareness of the disproportionate impact of AIDS on people working in the creative industries. A Day Without Art has become an annual, global event, now called A Day With(out) Art to acknowledge the work of artists living with AIDS as well as those who have died with it.

As its name implies, Visual AIDS was driven by a desire to make the impact of AIDS visible. In 1991, twelve artists convened to discuss new ways of doing this. Among them were New York artist Patrick O'Connel, a co-founder; Paul Jabara, an actor, singer and composer of disco megahits such as 'It's Raining Men' (the Weather Girls); and a costume designer named Marc Happel.

Happel had been out driving in upstate New York that afternoon and been struck by the huge yellow ribbons tied around trees in honour of US troops then fighting in the Gulf War, a revival of a nineteenth-century tradition among families of men serving in the US Cavalry. Could not a similar device work to raise the visibility of AIDS victims, so often left to disappear from the public eye? The meeting liked the idea, discussed it and settled on the colour red, for blood and life, and a simple inverted V which could be made easily and invoked the shape of a heart.

It was not the first red ribbon campaign, though. The pressure group Mothers Against Drunk Driving, MADD, had been encouraging drivers to pin one in their cars to remind them to drive sober from 1986. The organization had been formed by

Candace Lightner after her 13-year-old daughter, Cari, had been killed in a hit-and-run accident by a drunken driver. Their campaign was to raise money and bring attention to state legislators to impose tougher sentences for the crime.

Visual AIDS wanted to repeat that success. Through the involvement of members like Jabara from show business, VA sent ribbons to anyone and everyone involved in the TV presentations of the 45th Tony Awards that year. When co-host Jeremy Irons walked on stage wearing one, VA were delighted with the national exposure. When the first Award of the night went to Daisy Eagan, who was also wearing a red ribbon, they knew they had started something; and when in the course of the evening magicians Penn and Teller and actor Kevin Spacey also sported the symbol, the idea firmly entered the public consciousness. Unexplained in front of the cameras, the red ribbon became the object of feverish speculation in the next day's newspapers.

And it certainly wasn't the last. So many awareness-raising campaigns have since adopted a folded ribbon as a symbol that there aren't enough colours to go round. A teal ribbon, for example, has been used to draw attention to Tourette's syndrome, to bullying, to ovarian cancer, and to the victims of a tsunami.

Every year Visual AIDS presents the Bill Olander Award to art workers or artists living with HIV. William Olander was senior curator at the New Museum of Contemporary Art in New York City and a co-founder of VA, who died in 1989. Paul Jabara died in 1992, Patrick O'Connel in 2021. All three, and many more, died from causes related to HIV/AIDS.

Forestry Stewardship Council® – FSC® symbol
(1993)

The FSC symbol is awarded for the ethical harvesting of timber and for sustainable practices in the production of timber products. Its introduction highlights the tension between wealthy, environmentally aware nations and those economies which rely on forestry or the land that forests occupy.

Concerns about the destruction of the world's rainforest habitats in the 1980s were part of a growing mistrust of the industrial exploitation of the planet's resources. Frustrated at the voluntary nature of a series of international measures and declarations, a number of environmental organizations set up the Forestry Stewardship Council (FSC) in 1993. Among them was the World Wildlife Fund, founded in 1961.

The WWF was successful in its own sphere of concern and understood the value of a good logo: its well-known panda symbol has effectively raised awareness of the threat to species of human industrial activity. Its contribution to the FSC was not only its involvement in the design of the FSC symbol but in helping to devise a new approach to the problem of deforestation.

Hitherto, the reaction of many activists to the issue had been to boycott the products of irresponsible forestry. But that had the unintended consequence of devaluing forest land, which encouraged producers to turn it over to other uses – by deforesting it. In working with those activists, WWF identified the need to encourage not only sustainable forestry practices but an entire chain of trustworthy processes between tree and product. For example, a book begins life as a tree, but it also involves pulping, paper-making, paper distribution, book and cover design and, finally, the book's printing and distribution. All these stages hold potential risks for the environment.

The FSC symbol is therefore used to certificate not only the management of a forest but all the companies who handle the wood in all its subsequent forms – a sequence which the FSC calls the Chain of Custody.

That's why the symbol can be seen everywhere from the timber yard to the stationary store and on the imprint page of this book. Its meaning is clear without the need for words: as far as trees are concerned, this product has been approved with a tick.

The FSC's approval comes in three forms: 'FSC 100%' confirms that a product is made with sustainable materials and processes fully certified by the organization; 'FSC RECYCLED' items can include sawdust from the originating sawmill or repurposed patio furniture; 'FSC MIX' allows for a mixture of certified and recycled material along with a third category – so-called controlled wood. While FSC cannot absolutely guarantee the provenance of such timber, it has satisfied itself that there is a low risk of illegal logging, of violation of local civil rights, or of other unsustainable forestry practices, in its production.

The standards which the FSC applies along the Chain of Custody are difficult to police and to assess. The FSC is now active in seventy-nine countries, but the timber-producing forests which it has certified represent only 7% of the Earth's total. Many parts of the world do not have the luxury of time or an environmental conscience: either they need the money now which felled timber can bring; or they need the land now which felled timber will release.

Nevertheless, FSC certification is the gold standard in the industry, a force for good in the environment and a guide for consumers. An old philosophical joke asks whether a tree falling in a forest makes any noise if there's no one to hear it. The FSC is our eyes and ears on the world's forests.

ABOVE: *An FSC logo branded onto wooden furniture.*

LEFT: *The FSC logo jostles for space with the recycling symbol, the royal coat of arms, and Tidyman on a box of tissues.*

Internet browser symbols

(1994)

The Age of the Internet has created a demand for new symbols unprecedented in history. Icons are designed to draw your eye quickly to where you, or the app's creators, want you to go. The ability to stand out from the crowd on a cluttered phone screen is a vital skill.

Historically, symbols acquire their significance gradually, sometimes over centuries. The Internet does not have that luxury. Its symbols must convey their meaning immediately and to do so they adopt existing visual language – colour, shape, lettering – to communicate.

The first mainstream Internet browser was Netscape, launched in 1994. Its logo, a large N straddling the horizon of the planet, was explicit: Netscape was on top of the world-wide web. Like early versions of the Windows logo, it used a serif font to emphasize business-like reliability. Netscape at its peak was the browser of choice, used on over 90% of home computers in the mid 1990s.

By 2006 Netscape's share had fallen to less than 1%. Microsoft launched its Internet Explorer browser in 1995, which had the great advantage – some said too great – of being distributed in bundles with Windows and other Microsoft products. At the end of what some have called the First Browser War, Internet Explorer was enjoying the same dominance, 90%, over Netscape using a similar approach to its icon – a large initial 'e' for explorer became the whole planet, indicated by the trail of a comet or satellite encircling it.

Internet Explorer remained the dominant browser for many years but ultimately met the same fate as Netscape, falling to less than 1% by the time it was retired in 2015. Microsoft's closest competitor, Apple, was relatively slow to enter the browser market, but did so with Safari in 2003 – when Internet Explorer still had 95% of the market. Safari, with an explorer's compass as its symbol, now accounts for 10% of the market. Perhaps the Internet now seems more like a jungle of junk than a planet of possibilities.

Amidst concerns about how much our lives were being tracked by browsers, Mozilla Firefox was launched in 2004. Mozilla, an open-source community, inherited Netscape's codes and reinvented them as the Gecko browser engine, with an emphasis on privacy and security. The browser's project name was Phoenix, emerging as it did from the ashes of Netscape, but when it launched as Firebird (another name for the phoenix), Linux's Firebird database program objected and it became Firefox, a nickname for the red panda. Its logo is a fox-like red panda which symbolically encircles a tiny world. At its height the red panda was the browser of choice for over 30% of Internet users.

It was only a matter of time before Google, dominant in so many aspects of our Internet lives, launched its own browser. Chrome appeared in 2008, with a logo showing three segments gripping a central blue disc remarkably like Firefox's central world. Overall its use of the four primary colours of Google's logo made it unmistakably a Google product.

Chrome currently holds 65% of market share ahead of Safari's 10%, while Firefox has fallen to a little over 8%. It's unlikely that any browser will again achieve the dizzy heights of Netscape or Internet Explorer, not least because Google has released the Chromium codes behind most of Chrome as an open-source resource. More than twenty-five other browsers have since been launched using Chromium, including Microsoft Edge, the successor to Internet Explorer, currently used by 7.5% of the market.

Who will challenge Chrome for supremacy? One dark horse, Opera, was launched in 1995 and is still going strong, now based on Chromium codes. Its symbol is the simplest circle of all, an O.

ABOVE: Browser icons, starting from the top left: Google Chrome, Netscape Navigator, Mozilla Firefox, Safari and Internet Explorer.

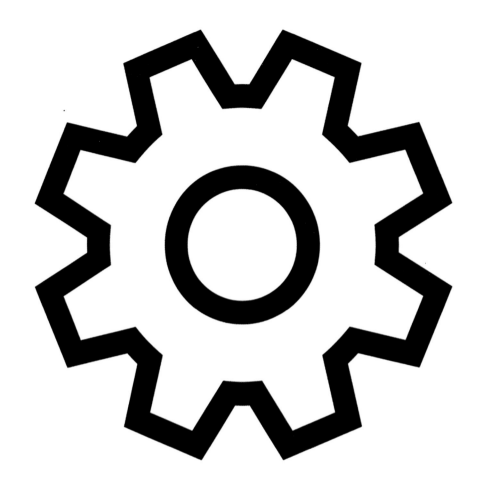

TOP: The ubiquitous 'settings' cog.
ABOVE: Vintage icons from the Xerox Star computer, the first consumer machine with a graphic user interface.

Settings icon

(1995)

For over forty years computers have had an increasing role in everyone's life. As apps take over more and more tasks, their icons have become vital links to the functions they control. These symbols now form a universal visual language as familiar as any alphabet.

We think nothing of clicking on an image of a camera to take a photograph, or an envelope to get an email, or a telephone handset to make or end a call. Yet few of these things are still involved in the actions they represent. For most, a camera is just a lens on a cell phone. Emails don't use envelopes. And telephones haven't had those bone-shaped handsets for half a century. Why do icons use such old-fashioned language?

Strangest of all is the Settings symbol. Computers haven't been made with cogs since World War II, and yet almost a quarter of the way through the twenty-first century the image for the inner workings of a computer is an icon of the three-hundred-year-old Industrial Revolution.

The word 'icon' was adopted for computer symbol because of its original meaning as an image of spiritual significance. Religions use icons to encapsulate abstract concepts of their belief systems; and computer designers choose symbols in the same way, to explain complex apps and functions in a way that can be simply grasped.

The first icons – a graphic user interface (GUI) to use the technical term – were devised by Xerox in the early 1970s for a large research computer called Alto. The Xerox Star, the first consumer computer model to include icons, was launched in 1981. Among the Star's icons were document, folder, printer and trash can symbols which are still familiar today. The Alto inspired Apple's Lisa model, which appeared in 1983. Lisa introduced the clipboard for copy-and-paste, and had a Settings icon called Preferences which showed a monitor screen sitting on a desktop computer.

It was Lisa's successor, the Macintosh, which appeared in 1984, that really put desktop icons on the (bit)map. The model owed much of its popularity to its range of helpful symbols, designed by graphic artist Susan Kare, who also created many of the Mac's typefaces. Kare approached the icons as if they were road signs, whose clarity and meaning must be instantly understood by users. As the only artist in a team of programmers, her lively, playful character helped to shape the ethos of the Mac, both among her colleagues and for the public at large.

Kare went on to design the icons for Windows 3.0, Microsoft's breakout operating system, in 1990, and she has since worked for IBM, Facebook and Pinterest, among others. She draws her inspiration from Japanese kanji symbols and from the signs used by hobos during the Great Depression. 'I try to optimize for clarity and simplicity,' she has said, 'even as palette and resolution options have increased.' She has pointed out that there is no need to constantly reinvent the Stop traffic sign, for example; if a symbol works, changing it is disruptive.

This is why we still use icons based on the very technologies which computers render obsolete. Most computer users don't know how they work, so icons are employed as metaphors, referring to technologies that people can understand – a clipboard, a pair of scissors, an analogue camera, a waste paper bin, an old-fashioned watch or the cogs of an engine.

Windows 95 was the first to introduce a cog image, pictured on a spindle interacting with a computer check box, for an icon that enabled users to change their system settings; and with Windows 8, Microsoft introduced the Settings app for user-changeable parameters. Macintosh adopted multiple cogs for its Systems Preferences icon in 2003. When Google's Android system launched in 2007 it was determined to go its own way. It used a cog icon for its Developer Tools, and a hammer and wrench icon for Settings. Android 2.0 Settings were represented by a dial one might find on a stove or amplifier. Android 4.0's Settings abandoned the dial for an image of three slider controls. But with Android 4.4 (KitKat), Google finally fell in line and represented its Settings app with a simple cog – just like everyone else.

Euro

(1996)

Most of the world's currencies have evolved over time. In the complex marketplace of modern finance, the European Community's ambitious plan for a currency common to all its member states had to be launched fully formed, with an eye to image as well as functionality.

The brief for the design of the euro sign was more like that of a company logo than a typographical symbol. It specified the specific shades of blue and yellow to be used, and even the overall proportions of the design – something which caused problems after the winning symbol had been chosen.

The design was put out to tender and thirty-two initial submissions were received. The selection process was secretive, in a bid to avoid controversy over the Commission's choices: it claimed that it was an internal process and therefore not open to public scrutiny. Technically, even the identity of the winning graphic artist is not known.

The thirty-two were whittled down to ten, then to two. The creator of the winning logo is believed to be Alain Billiet, a Belgian who had previously produced designs for the promotion of the EU at the Barcelona Olympic Games. His euro symbol was legible in both Latin and Cyrillic alphabets, resembling the Greek letter epsilon. The two horizontal strokes, optional in other currency symbols such as the $, £ and ¥, were essential to distinguish it from the epsilon itself and to identify it as a currency symbol. The double lines, it was suggested, conveyed a subliminal message of stability.

The overall circular nature of the €, like a full belly, also implied wealth. But that very fullness, prescribed by the EU, ruffled the feathers of an important group: typeface designers. The big round € was simply too big, too wide for the uses to which a currency symbol was normally put. The £, ¥ and $ are all usually the same width as a number, which facilitates the alignment of columns of numbers in printed accounts. The full-bellied € was also hard to adapt to the styles of existing fonts. In practice most typeface designers have ignored the EU's prescribed proportions and created an € that fits in.

An indication of the importance of image is that, following the decision to implement the euro under the Maastricht Treaty in 1992, the launch of the euro symbol in 1996 was the first tangible evidence of the currency. Trading in the euro did not begin on stock exchange floors until 1999, and the coins and flat notes of the currency were not issued until 2002.

OPPOSITE: A fully rounded euro symbol, something that typography designers have carefully squeezed.

Fairtrade

(1997)

Amid rising concern for the conditions in which produce is grown, in the 1980s consumers began to seek assurances that their purchases were not bought at the cost of the environment or the labour force. What price your morning cup of coffee?

Western consumers first began to discover their purchasing power in the 1970s, when they were called on to boycott the produce of Israel and South Africa for their treatment of the Palestinians and the apartheid regime.

The idea that consumers could make a difference depending on which products they bought caught on, and enlightened buyers began to consider other issues. The use of child labour, they discovered, was prevalent in developing countries; natural environments were being destroyed to make way for profitable crops; big business was forcing down the price paid to farmers in order to maximize dividends to shareholders. Coffee was a particular focus of early campaigners.

It fell to individual shops to salve the consciences of those early campaigners. Small traders began to stock foods and textiles from workers' cooperatives around the world. In Britain, the charity Oxfam also took up the cause. In the Netherlands, a country with a long imperial history of coffee production in its colonies, a group of dedicated individuals set up the Max Havelaar Foundation to offer the world's first Fair Trade certification mark.

Max Havelaar is a fictional coffee broker in Java, the central character in a nineteenth-century novel critical of colonial practice in the Dutch East Indies. A 1976 film of the novel was banned in Indonesia until 1987; and the first Max Havelaar certificate was awarded not in Indonesia but to coffee produced by a Mexican coffee cooperative. Among the conditions for awards to distributors were the guarantee of

a minimum price to farmers, a premium to be invested in local social enterprises, and reduction in the stages of the supply chain so that less income was lost to middlemen.

The Max Havelaar Foundation flourished in northern and western European countries, and another – Transfair took off in central Europe, North America and Japan. Other national brands blossomed in individual countries. While Havelaar and Transfair worked together on common standards for individual products, there was no forum for global standardization.

Fairtrade, formally the Fairtrade Labelling Organizations International, was set up in 1997 to overcome this, acting as an umbrella organization to coordinate values and promotion. The Fairtrade symbol is now a familiar sight on everything from bananas to T-shirts, from gold to roses. It is deliberately open to interpretation. The Fairtrade sign clearly owes a debt to the ancient yin-yang symbol of Taoism, evoking balance and fairness. The circle speaks of the globe. The bright green and sky blue colours suggest a clean environment. The black elements (white when only some of the ingredients have been fairly sourced) can be seen as a waving worker, or as a trade route across a landscape.

Fairtrade's symbol now appears on over 30,000 products sold fairly in 125 countries of the world. Sales under the Fairtrade logo increased by 1000% in the first decade of the twenty-first century, a reflection of increasing demand for ethically sourced goods – if there were no public demand, no distributor would be interested in purchasing a certificate.

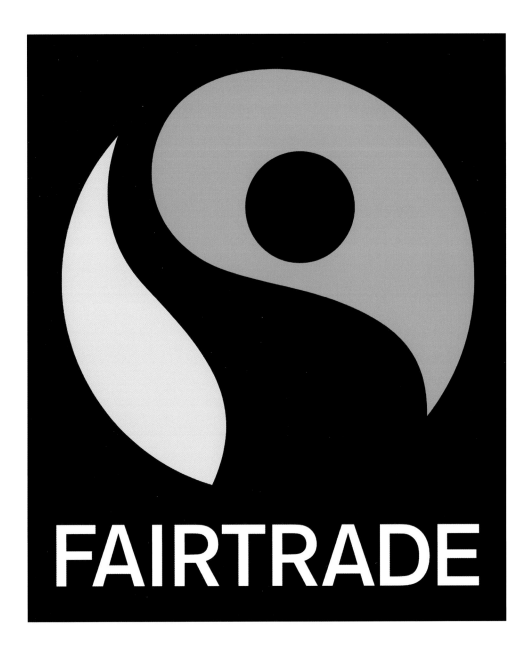

FAIRTRADE

ABOVE: With a teardrop shape overlain by a black circle integral to the design, there is a strong resonance with the yin-yang symbol.
OPPOSITE: A mono version of the Fairtrade symbol alongside a Carbon Neutral logo (a much trickier concept to get across).

GHS – Flammable sign

(2003)

Fire has been a blessing and a curse to mankind since the first bolt of lightning created the first forest fire. In an age when we are more dependent than ever on combustible hydrocarbons, its dangers lurk everywhere from paint cans to material, from fuel to furniture.

Even before the petrol age, fire presented one of the greatest threats to life and livelihood. Such was the risk that in Tudor England the powerful learned to build their kitchens with extra thick stone walls and at a distance from the rest of the castle or palace. Despite that, in the Great Fire of London in 1666, much of the city was burned down because of a fire in a bakery.

Similar conflagrations before and since have haunted villages and towns around the world. Despite man's best efforts to make the home and workplace safe, there are products used in the home that carry the risk of spreading fire. Manufacturers and legislators discharge their responsibilities by attaching warning signs for the consumer; and the symbol for a fire hazard is a simplified blaze.

Or a burning match. Or an exclamation mark. Or the word 'fire' in any one of a hundred languages. In red. Or orange. Or black. For most of the twentieth century there was no international agreement about what even constituted a fire hazard, let alone how to indicate it. Considering that the international trade in chemicals was worth $2.1 trillion in 2020, a common set of standards and the symbols to indicate them is highly desirable.

At the Earth Summit in Rio de Janeiro in 1992, world leaders began to work on such a system. The result was the Globally Harmonized System of Classification and Labelling of Chemicals (GHS), which built on a list of hazardous substances already compiled by the United Nations. The GHS identified nine kinds of hazard: explosive, flammable, oxidizing, toxic or corrosive materials; compressed gases; substances harmful to health or the environment; and acutely harmful materials of all kinds.

Along with a database of the properties of hazardous materials and how to test and treat them, the GHS launched a corresponding series of nine pictograms in red diamond frames in 2003. The one for a fire hazard is, obviously, a fire. These symbols, it hoped, would replace all the diverse national labelling schemes.

Unfortunately, no international treaties exist in which adoption of the GHS labelling scheme is compulsory. Take-up of the GHS standards, known as the Purple Book, has been slow, although the US and the UK were early adopters and the European Union made the GHS system its own in 2015. Many materials in homes and workplaces remain dangerously flammable, but at least now they are clearly labelled.

OPPOSITE: *The message is explicit and the fire graphic amply shows the risk that is present.*
BELOW: *A load identification plate on a British tanker indicates that should an accident or spillage occur, extreme care should be taken.*

Android (robot)

(2007)

There are two kinds of corporate symbol. Some companies constantly update theirs to keep them in the forefront of their customers' minds. Others never do, to project stability and reliability. Android's little green robot has been the face of the operating system since its launch in 2008.

When Google decided to enter the competitive marketplace of operating systems (OS) for mobile devices, it didn't start from scratch. Android Inc was a 2003 start-up which was already developing an OS when Google bought it in 2005. They had planned to design a system for digital cameras, but changed course when they realized that the days of stand-alone cameras were numbered.

The system went to beta-testing in 2007, and Google commissioned its art department to come up with a logo, which must include a robot. Staff member Irina Blok drew numerous sketches, one of which was adopted unofficially by the rest of the department – a little green robot with stick arms and legs which owed something to *Star Wars*' R2-D2, and something to a vintage Atari video game called 'Gauntlet'. Blok herself says it was inspired by the figures of men and women on the doors of public restrooms. If androids needed toilets, this would be their symbol.

The character was known around the office as Andy, a reference to Android founder Andy Rubin who had come with the company to Google. Google bosses loved Andy the android, although officially he is known only as the Bugdroid, and he became the operating system's mascot in time for the commercial launch. He remained more or less intact until 2019, when his presence was reduced, for the time being, to just his head.

Google took the decision from the start to make the Android OS open-source, available to developers free of charge. Android is based on the Linux open-source OS and this has helped popularize Android and the apps based on it – which is where Google makes its money back. The Bugdroid has benefited from this free access too. Irina Blok insisted that Andy should enjoy the same freedom as the OS and he has enjoyed makeovers at the hands of many designers dressed as everything from Hello Kitty to Superman, from Frankenstein to the Monopoly Millionaire. From 2011 to 2020 Google even offered an app called Androidify, which enabled users to personalize the Bugdroid in their own image.

ABOVE: A full-length Andy, who is frequently reduced to a 'head section' for display space purposes.

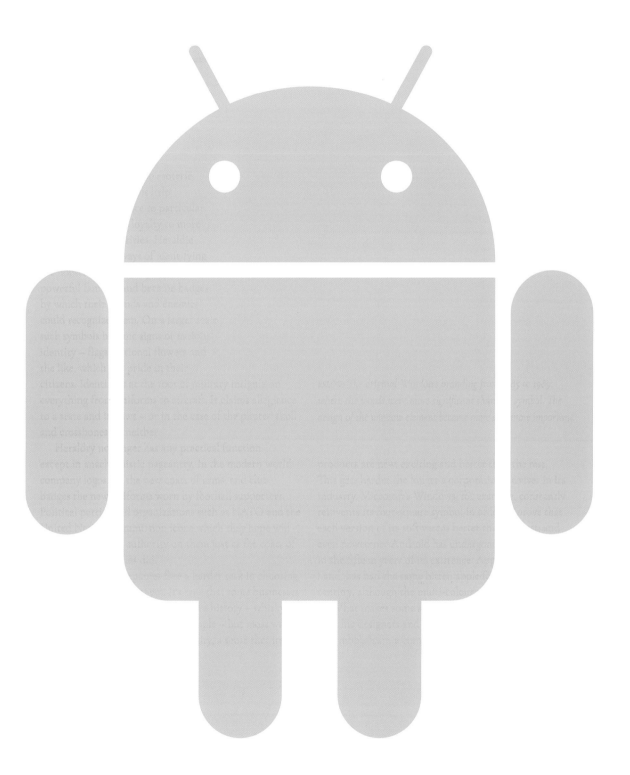

Spotify

(2008)

The Spotify app was founded in Sweden in 2006 and launched in 2009. It is now one of the world's leading music-streaming services. The Spotify icon is strikingly simple and an interesting study in the language of symbols – how they can be used to project subliminal messages.

Ahead of the 2009 launch, designer Christian Wilsson was given the job of creating the original logo. When the company was planning an expansion of the brand in 2013, it significantly revamped the 2008 design under the guidance of Andreas Holmström. And after only two years that version underwent small but significant change, resulting in the image with which we are all familiar today.

It's useful to look at the different elements of the logo and the alterations to them which have refined the company's message to consumers. The shape of the design was the biggest change in the 2013 remodelling. In 2008 Wilsson set the whole design in a large square with rounded corners. In design terms, squares are solid and dependable. Their sides are all the same length, implying reliability; and the view is the same in all directions, suggesting that its owner is ready for the future, wherever it comes from. Rounded corners soften the sharp right-angles for a friendlier impact.

But squares are also, well, square – old-fashioned, predictable, with no sensuous curves or exciting details. Holmström got rid of the square in 2013. He separated the lettering from the image, which he reduced to a simple circle containing only the graphic elements of the 2008 design. Despite the equal sizing of the circle and the name of the company, it is the bold circle which catches the eye. Circles are powerful shapes associated with the sun and the moon which regulate our lives, but they also represent the strength of a community, holding hands to support each other. Circles offer protection and integrity and an unbroken circle goes on forever, like the best music.

Spotify's use of colour is interesting. Green traditionally represents nature and peace, not things one necessarily associates with all genres of music. But through association with nature, it also conjures images of growth, prosperity and renewal – in Spotify's case an ever-expanding library of its listeners' new favourite tracks. In its first two incarnations Spotify used a comforting leaf-green shade, but since 2015 it has chosen a less natural colour somewhere between jade and neon.

Unexpectedly, it is the graphic element of the Spotify logo that has caused the most problems. Christian Wilsson drew them by hand, and their unsymmetrical irregularity has been a source of irritation for some critics. Nevertheless, Spotify has stuck with them and indeed made more of a feature of them by making them the only design element within the circle.

Wifi, soundwaves, streaming and even dancing are all part of the experience of using Spotify. What matters most to music fans is not the logo, or even the company behind it, but the music itself. What matters most to Spotify is that they get their music from Spotify; and whatever the fans see in its symbol, it works.

ABOVE AND OPPOSITE: *Like the Windows window and the Twitter bird, what started out in life as a graphic add-on to the name has come to represent the brand on its own.*

ABOVE, LEFT AND OPPOSITE: *Three images from the 'Endangered 13' project sponsored by Tower Hamlets council in 2016. Street artists were given a railway arch to portray a threatened element of nature, including whales, wild bee populations and coral reefs. The Extinction Rebellion logo was a perfect fit.*

Extinction Rebellion

(2011)

The symbol which we now associate with the anti-capitalist protesters of Extinction Rebellion was created seven years before that organization was founded. Its anonymous designer, known only as ESP, is a sculptor and printmaker with a history of environmental activism.

ESP's awareness of an environmental crisis was awoken during a trip to Sumatra in the 1990s, when he saw large-scale destruction of forests being enacted for the sake of a monocultural palm oil crop. As someone who had grown up playing outdoors in the countryside of England, he understood the impact of this loss of environment for indigenous species.

His response was to produce art which drew attention to species under threat. By 2008, however, he had learned enough about the environment to feel that mere art was not equal to the task. Artists work in isolation, but for environmental campaigners there is strength in numbers. While many countercultural groups have their own flag under which to rally – anarchists and anti-nuclear protesters, for example – ESP realized that there was no unifying symbol for environmentalists.

It was while sketching ideas for one in early 2011 that he hit upon what is now known as the Extinction Symbol. Like the best symbols it is diagrammatic, an illustration of its meaning. The unbroken circle is the planet we live on, and the lines within the circle combine to form an hourglass. Time, the symbol proclaims, is running out for the Earth.

ESP offered the symbol to organizations and pressure groups that he thought would be interested in using it. None were interested and it fell to ESP to promote it himself. When some onlookers guessed its meaning while he was marking it in chalk on a wall in London's Brick Lane, he knew that his design had captured his message. Slowly other artists and campaigners began to use it in their work.

When Extinction Rebellion (ER) was coalescing into an organized group in 2018, it approached ESP for permission to use it in their graphic material. ER uses acts of mass civil disobedience to bring towns and cities to a standstill, in order to draw attention to the environmental damage being inflicted on the planet by human activity. It's not an approach that appeals to all those concerned about the climate crisis, but it has certainly attracted considerable support. It remains to be seen whether ER's disruptive tactics will have the desired effect of prompting global action, or if the general public will lose patience with interruptions to its daily routines.

The Extinction Symbol was ideal for ER. Not only did it embody the urgent need to address the way we abuse our world: the perception of an X in the hourglass of ESP's design strengthened the connection between the symbol and Extinction Rebellion's name. It has become exactly what ESP hoped for it, a universal sign of environmental protest. ER has spread from England to all the corners of the world, taking ESP's work with it. There is no copyright on the design, and ESP continues to encourage its widespread use by all interested parties, not just Extinction Rebellion.

Twitter

(2010/2012)

The ubiquitous bluebird icon leads to Twitter, the world's original micro-blogging medium when it was conceived in 2006. Whether you're a clucking chicken or a squawking crow, nearly one and a half billion of the world's population have a Twitter account. Yet the bird was an afterthought.

Twitter is the watercooler of apps, around which we all gather to swap gossip, discuss last night's TV, and express our horror at the state of the world. It was conceived during a one-day brainstorming session at the Odeo podcasting company, and trialled internally as a way of getting quick answers to questions between departments. The founders chose the name because the dictionary defined it as 'a short burst of inconsequential information'. It's also the sound a bird makes when communicating with others.

During development its project codename was twttr, reflecting the use of five-character short-codes in American SMS services. In preparation for going public in July 2006, co-creator Noah Glass came up with a logo which spelled out the vowel-less name in 3D-effect letters, which looked like nothing so much as twttR (with an inconsistent capital R) written in green slime by a literate slug. The name, whose pronunciation was unclear without vowels, was rapidly rethought. Linda Gavin, a Swedish graphic designer then working in San Francisco, was asked to deliver a new design in twenty-four hours.

The Gavin logo helpfully spelled out the name of the new company in full, keeping the rounded style of Glass's effort but rendering it in simple, two-dimensional sky-blue. The shortcut icon for phones and laptops was a plain, lower-case t in a square.

Although not an official element of the company's ID, the website included cartoon images of a bird, based on a piece of bird clipart by British designer Simon Oxley which Twitter bought from a stock image company for $15. It was simplified by graphic artist Philip Pascuzzo in 2009, becoming a blue silhouette with feathery wings and a headcrest. The new logo was known in the Twitter offices as Larry, after Larry Bird, the Boston Celtics basketball player, and 'Larry' graced the Twitter website until 2012, overseeing the company's exponential expansion to over 140 million accounts.

Larry's work was done. By 2012, Twitter had become so successful that it was one of a select few companies able to identify itself by logo alone. As Doug Bowman, Twitter's creative director, declared that year: 'Twitter is the bird; the bird is Twitter.' Gone was Linda Gavin's lettering; gone was the lower case t icon on your phone; gone was Larry. Bowman unveiled a more stylized bird, drawn entirely from the perfect arcs of circles of different diameters – the Twitter bird we know today.

ABOVE: *No need for any accompanying lettering; anyone with a phone knows that this is the Twitter logo.*

OPPOSITE: *Like the WWF panda, as the organization gained profile, so the original 'Larry' became a more simplified shape.*

Wild Atlantic Way

(2014)

For 2,500km (1,600 miles), Ireland's Wild Atlantic Way skirts the inlets and peninsulas of the country's rugged west coast. For all such leisure routes, good, clear signs are essential, not only for directions but as representations of the character of the journey.

The Wild Atlantic Way was launched in 2014 by Ireland's tourism body, Fáilte Ireland, in response to a worrying decline in visitor numbers to the republic in the first decade of the twenty-first century. The effort to boost tourism from abroad was made in consultation with the communities through which the route passes. It was intended from the start to benefit the tourism industry along its entire length, not only at a handful of obvious tourism honeypots such as Kinsale, Killarney and the Kerry Ring.

The marketing strategy was threefold: the adventure of the unfamiliar, the culture of lives shaped by the Atlantic Ocean, and the dynamic landscape where sea meets land. The brief for a logo was given to Red & Grey, a design consultancy based in Dublin. It had to act not only as a waymarker for the route but as a promotional hook on publicity material in at least seven European languages, and as an embodiment of the spirit of the Way.

The solution, by Red & Grey's Bob Gray and Clare Lynch, was a deceptively simple bold horizontal zig-zag which, on closer inspection, covers all the aspects of the brief. It is monochrome, so it can be reproduced easily in a variety of contexts. It is bold enough to be shown not just in solid colour but with textures hinting at the ruggedness of the journey. Its boldness makes it easy to spot on road signs. Its character, like two rows of gnashing teeth, is full of wildness. Its imagery combines rough ocean waves and jagged mountain peaks, both features of Ireland's Atlantic coast.

Very cleverly, it is composed of the diagonals of the letters W, A and W, the initials of the route. On literature in other languages it is always accompanied by the full name of the route in English, subtitled in one of German, French, Spanish, Dutch, Italian and Irish Gaelic. Red & Grey also specified a palette of colours for the design which reflected the deep Celtic shades of the coastal landscape – rich ocean blues, warm stoney pinks and botanical greens. The whole package is designed to symbolize the whole experience of driving the Wild Atlantic Way.

It has worked spectacularly. Two years after the initial launch of the project, Red & Grey were able to boast that the nine coastal counties on the route from Donegal to Cork had provided 3.6 million international bed-nights, worth €1.9 billion to the Irish economy. On many levels, the Wild Atlantic Way is a symbol that works.

OPPOSITE: *For those tourists following the Wild Atlantic Way, the wave-like squiggle is a welcome reassurance that they are on the right track. It also bears a striking resemblance to an Egyptian hieroglyphic on the black sarcophagus of Ankhnesneferibre, from 530 BCE, displayed in the British Museum.*

ABOVE: The NHS rainbow was a phenomenon of the Covid lockdown in the UK, with rainbow pictures posted in windows and chalked on driveways.
RIGHT: Mark Cavendish wears the coveted Rainbow Jersey given to the Cycling World Champion – who gets to wear it all year.
FAR RIGHT: A sign of the times, policemen enter the spirit of a York Pride parade in 2016 with a rainbow-jacketed participant.

Rainbow symbols: Cycling, Gay Pride and celebrating the NHS

(2020)

An ancient symbol of hope after storms was given urgent new purpose in Britain during the Covid-19 pandemic. The adoption of the rainbow as a sign of support for the hard-pressed doctors and nurses of the country's National Health Service (NHS) was not universally welcomed, however.

The first cases of Covid-19 in Britain were diagnosed in a Chinese student and his mother in the city of York, on 29 January 2020. They had relatively mild symptoms and were discharged from hospital three weeks later. The first death from Covid on British soil happened on 6 March, and by the time the country was put in lockdown on 24 March, 400 more had died. By the end of the year the government had recorded 82,709 Covid-related deaths. Many believed the figure to be higher.

Britain's experience of the pandemic was at this stage far less severe than Italy's, where the traditionally close extended family unit was causing the virus to spread at a terrifying rate. A Facebook group of mothers in Bari, in southern Italy, came up with a way of raising local spirits. They encouraged their children to paint rainbows and display them in the windows of their homes with the slogan *Andrà tutto bene* ('Everything will be alright').

It was a turning point for public morale in Italy. The action spread throughout the country, and when news of it reached Britain, an artist in Yorkshire, Kezia Roberts, promoted the same thing in her neighbourhood. Again the gesture spread through the country, and when on the first night of lockdown the government encouraged millions of people to come out of their houses and 'Clap for Carers' – literally, to applaud the workers of the NHS – many brought along their homemade rainbows.

Although the hand-painted signs were intended as a way of cheering up frightened children unable to go to school and meet their friends, the weekly Clap for Carers initiative resulted in their association with the NHS. Rainbow signs began to appear all over Britain with slogans of support and thanks for NHS employees who were the nation's front line of defence against the virus.

Not everyone was pleased to see the rainbow symbol being used in this way. A six-coloured rainbow flag has been a symbol of gay pride since 1978, when Harvey Milk, California's first openly gay elected official, asked artist Gilbert Baker to devise a banner under which all homosexuals could gather. Since then the rainbow had come to signify a place where homosexuals could feel safe from homophobic attack. Now, the gay community complained, it could no longer trust a rainbow to mean that, and the situation was made worse by unscrupulous merchants re-labelling distinctive gay pride flags as NHS ones.

Although the NHS had not initiated the rainbow connection, it was blamed for it by some sections of the gay community. However, the rainbow is such a ubiquitous emblem that it has been employed in many different media over the years. British children's television show *Rainbow* ran for over a thousand programmes from 1972 to 1992, while the Rainbow Jersey is the distinctive jersey worn by the reigning cycling World Champion since 1927.

The rainbow is a cheerful way for people to express their appreciation for the sacrifices which a National Health Service has made to keep a nation safe. It has been suggested that the LGBTQ community move to adopt the different and more inclusive Progress flag, designed in 2018 by Daniel Quasar. It's a version of the six rainbow stripes with added chevrons of black and brown to acknowledge LGBTQ people of colour, and of pastel pink and blue to represent those on the trans gender spectrum. That way, the rainbow can remain a symbol of hope for everyone, after every personal, private or public storm.

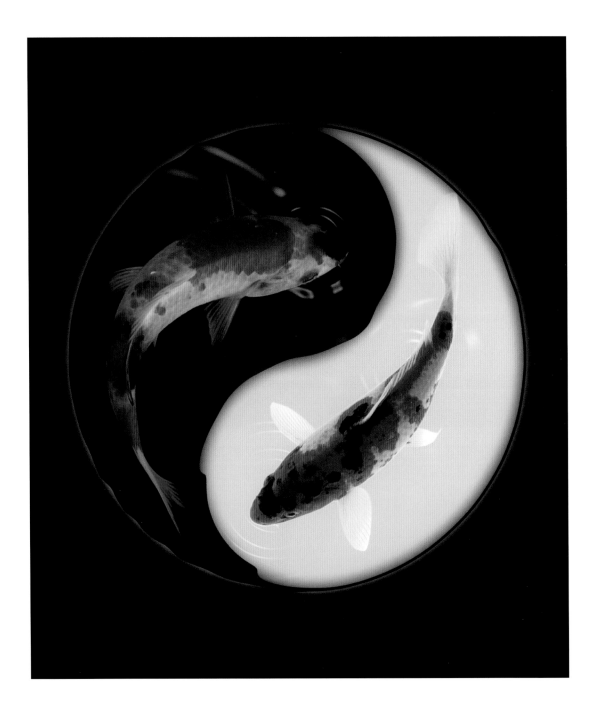

ABOVE: The Yin-Yang symbol has often been compared to two Koi Carp circling each other.

Index

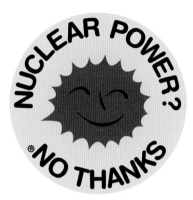

ABOVE: Anne Lund designed the 'Smiling Sun' in 1975, but global warming has since placed nuclear power generation back on the agenda.

ABOVE: The standard 'access' symbol, seen the world over. But there are more active variations to be found.

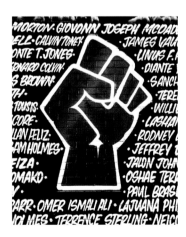

ABOVE: The BLM's clenched fist symbol, along with George Floyd's dying words, "I can't breathe" makes for a powerful message.

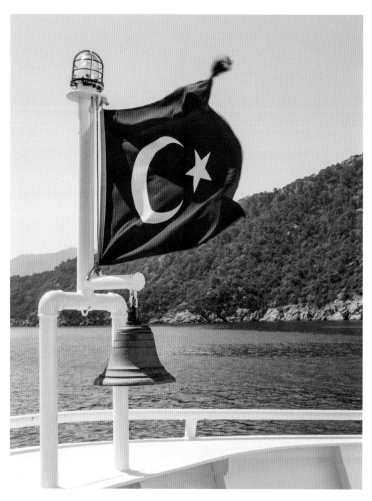

ABOVE: *The symbolism of Turkey's national flag has its roots in a siege of Byzantium (Istanbul) in 339 BCE.*

ABOVE: *The hammer and the sickle represented agriculture and industry driving the Soviet economy forward.*

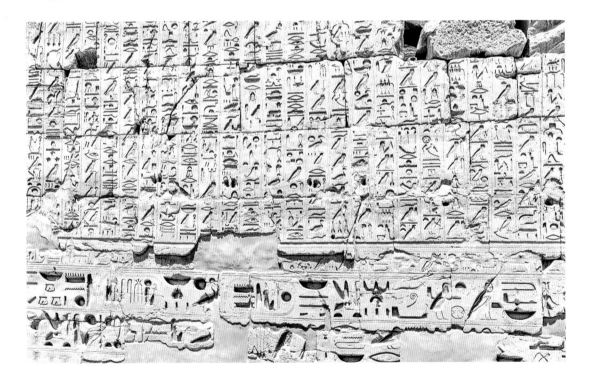

ABOVE: *There are some 1,000 Egyptian hieroglyphs with logographic, syllabic and alphabetic elements. The script is read from right to left.*

ABOVE: London built the world's first underground commuter train service, and the stations' identifying symbol was also designed to last.

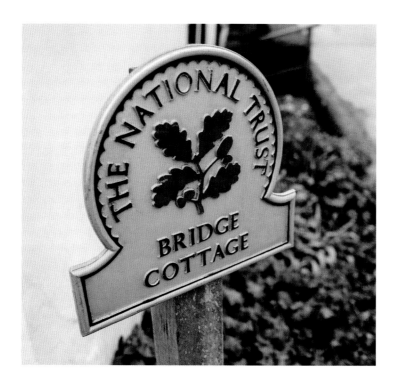

ABOVE: Four oak leaves and some acorn clusters has long been the symbol of England's largest heritage organization.

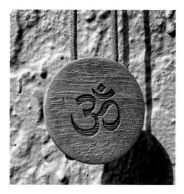

ABOVE: Om is one of the most important spiritual symbols. In Hinduism it represents the essence of Ultimate Reality.

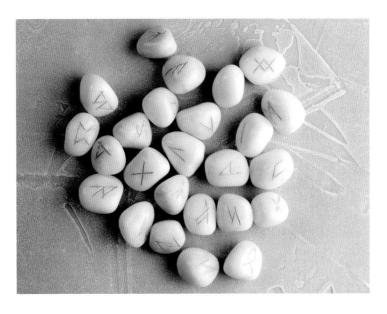

ABOVE: *Easily carved by an axe, the runic alphabet has had a twenty-first century application, dedicated to Harald Bluetooth.*

ABOVE: Each nation has its own variations of traffic warning symbols for animals, and the symbol at far left is the giveaway for this country.

Acknowledgements

Photo credits: Alamy, pages 2-3, 10, 11 (top), 13, 14, 15, 16 (bottom left), 18, 19, 20, 21, 22, 24, 25, 27, 28, 30, 31, 32, 34, 35, 36 (top), 38, 39, 41, 42, 43, 44, 47, 49, 50, 52, 54, 56, 57, 59, 62, 63, 66, 67, 68, 69, 70, 73, 74, 76, 77, 78, 79, 82, 83, 85, 87, 88, 89, 91, 93, 94, 95, 96, 97, 98, 101, 105 (top), 106, 111, 112, 113, 114, 117, 118 (bottom), 121, 125, 126, 128, 129, 130, 133, 135, 138, 139, 140, 141, 143, 145 (bottom), 148, 149, 150, 151, 155 (top), 156, 158 (top right), 158 (bottom), 161 (bottom), 163, 168, 171, 179, 181 (bottom), 182, 187, 190, 191, 193, 200, 202, 203, 208, 209, 210, 212, 213, 214, 219 (bottom). Hossen27, page 223. René Houdry, page 60. Library of Congress, pages 9, 11 (bottom), 12, 36 (bottom), 100, 105 (bottom), 186. Unsplash/Meric Dagli, page 218. Unsplash/Phil Hearing, page 221 (top). Unsplash/Karin Hiselius, page 220. Unsplash/Cole Keister, page 64. Unsplash/Sven Konig, page 48 (right). Unsplash/B.P. Miller, page 217 (bottom right). Unsplash/Jakub Pabis, page 217 (bottom left). Unsplash/Agus Prianto, page 216. Unsplash/Rohan Reddy, page 221 (bottom). Unsplash/Tabrez Sayed, page 199. Unsplash/Peter Sidorov, page 222. Unsplash/Cedric Streit, page 137 (top). VisionsofthePast, 48 (left). Bangyu Way, page 184 (top). Xerox, page 196.

Also in this series:

100 Children's Books That Inspire Our World ISBN: 978-1-911641-08-7
Colin Salter (2020)
100 Posters That Changed the World ISBN: 978-1-911641-45-2
Colin Salter (2020)
100 Science Discoveries That Changed the World ISBN: 978-1-911663-54-6 Colin Salter (2021)

About the Author

Colin Salter is a history writer with degrees from Manchester Metropolitan University, England and Queen Margaret University in Edinburgh, Scotland. His most recent publications are *100 Science Discoveries That Changed the World*, *100 Posters That Changed the World* and *100 Childrens Books That Inspire Our World* . He is currently working on a memoir based in part on letters written to and by his ancestors over a period of two hundred years.